New York City's HART ISLAND

A Cemetery of Strangers

Michael T. Keene

THE
History
PRESS

Published by The History Press
Charleston, SC
www.historypress.com

First published 2019

Manufactured in the United States

ISBN 9781467144049

Library of Congress Control Number: 2019945074

Then Judas, who betrayed him, seeing he was condemned, repented himself, and brought again the thirty pieces of silver to the chief priests and ancients, saying; "I have sinned in betraying innocent blood." And casting down the pieces of silver in the temple, he departed, and hanged himself. After the chief priests took counsel, they took the pieces of silver and bought with them the potter's field, to be a burying place for strangers.

—Matthew 27:6–7

CONTENTS

CONTENTS

Thank you to Melanie, who first alerted me to this story, and to Lorraine Lucciola and Michael Leflem, who were instrumental in helping bring it to life.

INTRODUCTION

Superstorm

What would become the largest Atlantic storm on record swirled violently from the Caribbean, creating a devastating oceanic force that at its zenith reached nine hundred miles across and one thousand miles long.[1] This hurricane, or superstorm as it was later characterized, was about to lay waste to the most populated corridor in the United States. This hotter-than-usual Caribbean weather pattern met the icy North Atlantic waters and intensified into a hybrid colossus both tropical and arctic. Perhaps responding to rising global temperatures, or perhaps mythically overdue for a battle with the land, the storm was whirling and building—huge and slow—hundreds of miles out at sea. At one point it exhibited the lowest barometric pressure ever recorded on the Atlantic seaboard.[2] The first harbinger of destruction was 115-mile-per-hour wind gusts.[3] Across the eastern United States, people evacuated from the front lines of the inevitable destruction by the millions, responding to nationally declared states of emergency. They bought food, water and fuel and boarded up their homes and businesses, gearing up to sit out the deadliest weather event to ever hit the East Coast. For this monster storm, which would cause $65 billion in damage in the United States and kill at least 233 people,[4] preparation was futile. For many, the impact of this superstorm would be too great to overcome. The name of the storm was Sandy.

The hurricane made landfall as a category two in Brigantine, New Jersey, bombarding the Northeast with a vortex of wind and water, spreading its massive wingspan to punish communities with rain, snow, flying debris and

rising storm surges at quantities and velocities hitherto unseen in this part of the world. After drowning dozens in the Caribbean days before,[5] Sandy set its sights on the most populated area on the continent, sending surging water up to and beyond thirteen feet in the country's most storied island: Manhattan. The storm destroyed property, eroded shorelines—in some cases destroying 50 percent of beach sand in barrier islands—dumped ten million gallons of sewage into the water and killed twenty-five people.[6] Hurricane Sandy revealed deep flaws in one of the world's greatest metropolises, demolishing long-standing structures and proving that even this pinnacle of society stood no chance against this most ruinous of meteorological events. It took years, but eventually New York recovered.

BONES BEACH

About a mile east of Pelham Bay Park and City Island off the coast of the Bronx lies 130 acres of land known as Hart Island. In April 2018, approximately six years after Superstorm Sandy, an official from the Department of Corrections, which oversees jurisdiction of the island, alerted a well-known Hart Island activist to skeletal remains that had been seen scattered on the beach—some even protruding from the shoreline! After arranging a boat, the activist and a *Newsday* reporter confirmed and photographed the sighting.

The following day, a forensic anthropologist from the New York City Office of the Chief Medical Examiner conducted an investigation that resulted in the recovery of 174 human bones, including six skulls. The remains discovered that day unearthed a secret kept hidden for more than 150 years. Lying beneath the ground of this nondescript, tiny island were the remains of nearly one million people, who were buried in wide, deep pits dug by convicts from nearby Rikers Island. The dead included stillborn babies, unclaimed paupers, Union and Confederate soldiers, the insane, the addicted and the unidentified. The bones would reveal tales of war, abuse, fraud, epidemic and mental illness, which would tell the stories of New York's most forgotten people.[7]

After nearly a century and a half, as the result of recent advances in DNA and fingerprint technology and forensic anthropology, and with access to previously withheld burial records, we can identify some of these anonymous lost souls and reveal the hidden history of Hart Island—America's largest mass graveyard.

THE BURIAL CRISIS OF 1822

By the early 1800s, New York City boasted a population of more than two hundred thousand, qualifying it as the largest city in the Western Hemisphere. As New York City's population grew, so did its number of dead. What has been referred to as the "1822 Manhattan burial crisis" evolved into one of the city's most troublesome and hazardous social frenzies and failings.

The three-hundred-year-old Trinity Church graveyard on two and a half acres of land in Lower Manhattan was the idyllic resting place of many, including Alexander Hamilton after losing his historic duel with Aaron Burr in 1804.

Today, workers in the Financial District may visit the site on breaks or lunch hours for a green, peaceful respite from offices and elevators. But in 1822, *no one* wanted to stroll through the cemetery. In fact, residents of the neighborhood found other routes to their destinations to avoid the place.

Why was this important in 1822?

The smell.

The all-encompassing stench.

The definitive, pervasive odor of hundreds of decomposing bodies in graves that were hastily interred only two or three feet underground.

The number of interred bodies in Trinity Church's graveyard in 1822 was estimated at 120,000, but it was just that—an estimate. The truth was that the massive number of bodies buried in that year alone could not be tracked.

July 1822 saw the highest death rates from yellow fever in New York City, particularly in areas south and west of the church. The Common Council and Board of Health passed a resolution in August to prohibit further burials in the graveyard because of vehement complaints of "offensive exhalations." Visitors to the church and graveyard, casual passersby and residents in the surrounding streets found the source of the stench unmistakable: the smell of death.

Dr. Rosa, who was prominent for investigating the causes of the yellow fever epidemic, hired workers to cover the graveyard in quicklime to speed up the process of decomposition. The men worked through the night, retching and heaving from the repulsive task.

How could Trinity Church, along with Manhattan's twenty-one additional burial grounds, possibly keep up with the city's rapidly growing death rate? By 1822, Trinity was surrounded by thriving commercial communities, and its modest graveyard barely encased a century's worth of bodies.[8]

Death's Head Tombstone in Trinity Church Cemetery. Opened in 1697, Trinity Church remains the only active cemetery on the island of Manhattan. *Courtesy of hyperallergic.com.*

TOO MANY BODIES

New York City was facing an unprecedented crisis at an unprecedented speed. Other grounds within a close radius of Trinity Church—North Dutch Church, Middle Dutch Church and St. Paul's—faced the same problem.

Burying the city's dead surpassed the geographical burial boundaries imposed by the city. In 1839, that boundary extended to Fourteenth Street, and by 1859, it expanded uptown to Eighty-Sixth Street. The city also began to bury its indigent dead in potter's fields outside the city limits in what is now Washington Square Park and Bryant Square. By 1831, two

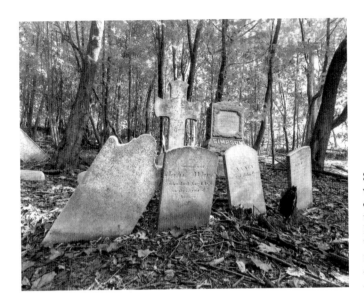

Sometimes bodies were buried only eighteen inches underground. People noted that "the stench was terrible." *Courtesy of New York Public Library.*

nonsectarian burial grounds were formed: the New York Marble Cemetery in the Bowery and the New York City Marble Cemetery, which was a block away from the first. Multiple stacked burials were created underground in thick family vaults.[9]

GREEN-WOOD CEMETERY

In 1878, Green-Wood Cemetery was planned and developed in Brooklyn by David Bates Douglass. It began on 178 acres of land and was later increased by 300 acres. The graveyard was modeled after Mount Auburn in Boston and Laurel Hill in Philadelphia. Douglass, who also served as the cemetery's first president, designed Green-Wood as "the ideal romantic landscape." It was a rural creation of sculpted hills, planted trees and curving paths with fanciful names. In 1876, *Harper's Weekly* called Green-Wood "the largest and most beautiful burial place on the continent."

Green-Wood also charged for burials, which resurrected the anger of city officials, who maintained that New York City still had not come to terms with burying its indigent and impoverished. In a fiery letter to the editor of the *New York Times*, these officials described "the coffins, skulls, and decayed bodies lying exposed on the corner of 50th Street and 4th Avenue," which was the location of one of the city's smaller potter's fields.[10]

View from Green-Wood Cemetery, 1881 by Rudolph Cronau. *Courtesy of Brooklyn Historical Society.*

In 1869, New York City purchased Hart Island as its official public gravesite. The rising number of the city's dead would be buried well underground. But they would have their own problems—perhaps later than sooner.

One hundred sixty years later, while uncovering the shroud of mystery surrounding the United States' largest mass gravesite, almost identical descriptions of the ghoulish discoveries in the Trinity Church Graveyard would come to nest on Hart Island, jarring our attention and sensibilities.

HART ISLAND: DOES ANYONE CARE?

In 1775, British naval cartographers chartered what they originally named "Heart Island" because of its general shape, which seemed to resemble a human heart. Other historic reports claim that the island was named after deer, or harts, hunted there.

It's ironic that the nature of the business of Hart Island seemed to lack just that: heart—the emotional kind—until a few short years ago, when public outcry brought attention to the severe erosion of gravesites and the subsequent exposure of human remains. Just as a grisly assortment of bones and human skulls seeped out of their resting places, so did the emotions of family members and friends of those buried in the largest potter's field in America.[11]

HART ISLAND

By 1798, it was listed on maps as "Hart Island" and was approximately a third of a mile from the City Island shore. It measured about a mile long by a third of a mile wide at its broadest point.

This island was the ancestral home of the Siwanoy Indians, who first hunted, fished, lived and died there. The land was purchased by Thomas Pell. Upon Pell's death, the land passed to his nephew, John Pell of England. In 1774, his heirs sold it to Oliver Delancey, a Loyalist politician, soldier and merchant during the American Revolution.

Commanding officers occupied their own cottages and officers lived in a large building at the south end of the island. Every evening at five o'clock, a military dress parade was held here. This space also included a library and a concert room, where musically inclined soldiers performed with the regimental band. The first concert was performed on November 14, 1864.[12]

When visitors and family members of the recruits came to Hart Island, they were required to get a pass from General Dix's office on Bleecker Street in Lower Manhattan (Greenwich Village) and had to pay fifty-five cents to board the ferry, *John Romer*, before it sailed twenty-one miles from the Battery to Hart Island.

Leaving the island was more difficult than landing on it. Visitors were hurried onto their return boat trip as the ferry docked only a half-hour before sailing back to Manhattan. Once travelers accomplished this part of their trip, they would board a tugboat to New Rochelle and hire a rickety carriage at twenty cents per person to take them to the designated railway station in Manhattan. The railway charged fifty-five cents for the next part of the trip to the Twenty-Seventh Street station, which was the last stop. From here, weary riders would disperse before finally reaching their homes. Any

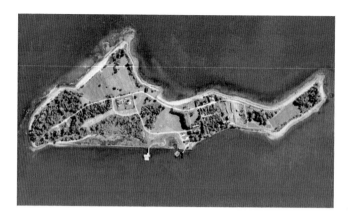

Aerial photo of Hart Island in 1946. Although it is only one mile long and a third of a mile wide, it claims nearly one million mass graves. *Courtesy of New York Daily News Archives.*

leftover enjoyment from a day spent on Hart Island was soon overshadowed by fatigue and empty pockets.

Many soldiers who occupied the island during wartime died in the line of duty, but many also died from disease. They were, of course, buried on Hart Island. In 1916, their remains were removed and reinterred in the Soldiers Cemetery at West Farms in the Bronx. The remains of another group of Civil War veterans were disinterred from Hart Island in 1941 and moved to the Cypress Hills National Cemetery in Brooklyn, which is the only United States military cemetery in New York City. The remains of more than twenty-one thousand veterans and civilians are buried there.[13]

In 1864, as the Civil War gained momentum, construction of barracks began at the southern tip of the island to hold approximately five thousand prisoners of war. In 1868, the City of New York, under the auspices of the Department of Public Charities and Correction, purchased Hart Island from the John Hunter family for $75,000. The island was used as a training facility for new soldiers. Between two thousand and three thousand raw recruits were initially expected, but more than fifty thousand men ultimately trained on the island.

Forty-five acres at the northern end were designated as a potter's field in 1869. The first burial would be soon.

LOUISA VAN SLYKE

The ship lurched in the heavy North Atlantic swell, its bow plunging deep in the troughs as it pitched sharply. Its seasick passengers crammed into the small hold, clutching anything nearby as they considered their recent decision to leave Europe. A simply dressed young lady was another anonymous face in the crowded ship. She kept to herself, as she'd always done. She was alone, without child or family, as she'd been for most of her life. But the New World beckoned, and in some sense, anything had to be better than what she'd left. She tried to think about that—the rumors she'd heard about New York and this far off place called America. People said that it was different. She tried to focus on that thought as the dim hold rocked to and fro. Above deck, the ship's crew posted watch, adjusted sails to meet the wind and carried on through the chilly night toward the distant shore.

Her name was Louisa Van Slyke, and little did she know how short her stay would be. In 1869, she would die of yellow fever alone in New York City's Charity Hospital on Blackwell's Island. With no friends or relatives to claim her, she would become the first of almost a million to be laid to rest in the potter's field on Hart Island.

YELLOW FEVER

In the summer of 1795, New York was struck with an outbreak of yellow fever—one of the first in a long line of infectious diseases that would find

their way to a city that quickly was becoming an international beacon for the impoverished. Measures that had been placed on the back burner, as more important infrastructural projects took precedent, now came to the fore, as public welfare and the security of the city became issues of life and death. One researcher noted the time as:

> *Health was very much a civic issue among the rival Atlantic seaports. Baltimore had a new health committee, new quarantine laws and a hospital at Hawkins Point outside the harbor to receive sick sailors and immigrants. In New York, news that fever had appeared in the West Indies in the spring of 1795, prompted passage of a rule that made the port's pilots responsible for reporting ships that presented a health hazard. The city also purchased a house called Bellevue about a mile up the East River to serve as a fever hospital. Philadelphia began planning a quarantine hospital south of the city. The College of Physician asked the state legislature to give physicians more control in responding to an epidemic. It predicted that whenever yellow fever broke out in the West Indies, it would get into Philadelphia no matter the precautions. Once in the city it would again be "highly contagious."*[14]

As was the case in the city of brotherly love, what began as a few isolated cases of people touched by the disease's strange and rapid onset, soon turned into a wholesale outbreak in New York City.

The first reported cases of yellow fever in Philadelphia appeared in 1793. Because the contagion was in such close proximity to New York, the city decided to form the Board of Health Department to systematically assess the risk and spread of the virus. While this was partially successful, by 1795, Manhattan hospitals, like Bellevue, started receiving the first patients whose characteristic jaundiced pallor proved otherwise. It was here, and there was little the city could do besides attempt to contain it. The outbreak lasted until 1803 and varied in severity. It reached levels of true virulence in 1795 and again in 1799, and by 1803, thousands had died from its insidious compromising of internal organs like the liver. An expert described it as:

> *Upon infection, most victims would experience headaches, followed by severe exhaustion, high fever and slowed heart rate. This period was followed by a remission stage and then by delirium. During the delirium stage, victims acquired a characteristic yellow hue on their skin and pupils. In final stages, a vomiting of black bile occurred and was followed by death.*[15]

Without treatment, almost half of those suffering from yellow fever died.

New York officials' reluctance to publish the outbreak—possibly for fear of spreading panic and losing business related to the city's reputation as a place of opportunity—was largely to blame. Without knowledge, patients could not have seen it coming, and doctors who might have benefited from a warning by preparing triage units with appropriate tinctures and trained staff were often unaware of what they were treating. As medical knowledge in the late eighteenth century was quite primitive by modern standards, questions of yellow fever's origins abounded. Speculations ranged from spoiled rotting coffee beans to West Indian slums to errant mosquitoes. Few understood that the virus was even contagious, as only a limited review was ever undertaken to assess its spread. For most of the physicians and city officials connected to the Board of Health, mum was the word. As one researcher argued:

> *Epidemics, it was assumed, were a part of life. The fact that disease caused significantly greater suffering in the poorer neighborhoods of New York City contributed to the blasé responses of city leaders. Disease could be and was written off as punishment for the moral laxity and intemperance of poor New Yorkers. Why else, in an era before medical science fully understood the linkages between sanitation and disease, would poorer neighborhoods be hit the hardest? Contemporary notions of mortality and morality influenced the responses of city leaders in politics and business to the outbreak of disease.*[16]

SMALLPOX

His speech filled the newly christened ward's halls on a chilly December night in 1856, and the crowd seemed pleased as he drove his last point home before retiring to mingle with the people from the city who had crossed the channel to inspect this curious new facility. Isaac Townsend ended his speech saying:

> *It must be borne in mind that our metropolitan population is by no means permanent, that its general character is precisely otherwise; there is a moving stream of human existence not exclusively of the poorer classes. And, whether a sufferer from this dire infliction be a poor immigrant, a resident in the Five Points, or a wealthy denizen of the Fifth Avenue; whether*

he mingle in the crowd at the Astor or Metropolitan, or occupy the dark damp basement of some wretched lodging-house, in either, in any case, it is equally necessary he should be instantly removed.[17]

Ethically, this was controversial. Practically, it amounted to just about the only thing the community could do given the technological limits of nineteenth-century medicine. In any event, it was done.

Isaac Townsend, the chair of the Renwick Smallpox Hospital, situated on what was once called Blackwell's Island (Roosevelt Island today), was a critical advocate of one of New York City's first major attempts to address the issue of infectious diseases and viruses. Between the end of the first major outbreak of yellow fever in 1804 and Mr. Townsend's speech nearly fifty years later, New York housed multiple acute episodes of typhoid fever, typhus and cholera.

Cholera, transmitted by contaminated food and water, would often induce uncontrollable diarrhea and vomiting so severe that death by dehydration was possible if symptoms were left untreated. Originating in India, it made its way through Europe, Canada and finally down the Hudson River Valley to New York City in the summer of 1832. Thousands of people died within weeks of contracting cholera until doctors learned how to better identify early signs and take preventative measures to stop its exacerbation. Two of the worst outbreaks of cholera occurred in 1849 and 1866, which led to thousands more being buried.

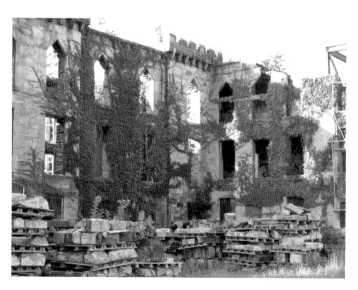

Renwick Smallpox Hospital (1856–86). This one-hundred-bed hospital treated more than 7,000 smallpox patients each year. Roughly 450 patients died annually, and many of them ended up in Hart Island. *Courtesy of Andro Constantine.*

Similarly, smallpox claimed thousands of New Yorkers before it was contained through a half-hearted public welfare initiative. A truly horrifying condition, those afflicted suffer not only the devastating physical toll of a compromised immune system, potential internal bleeding and loss of vision if the pox put pressure on the eyes, but they live with the shame and embarrassment of the virus's pustules, which cover most affected people's faces. After the first week, the pustules generally become raised and firm to the touch. A few days later, they fill with fluid and become dangerous transmitters for anyone in close proximity to the patient. A few weeks later, in most cases, those stricken are relieved to see the scabs falling off but are shocked by how scarred their faces are. Those who perish are usually struck down by complications arising from respiratory failure, pneumonia or bacterial infections of the skin due to patients scratching their itches in the agonizing and futile weeks before any serious smallpox vaccine was widely available.

One of the only ways societies could reliably deal with the crisis was by crude inoculations like variolation, a technique intimately described and lauded by English Lady Mary Wortley Montagu on her visit to Turkey in the early eighteenth century. She wrote,

> There is a set of old women who make it their business to perform the operation. Every autumn in the month of September, when the great heat is abated, people send to one another to know if any of their family has a mind to have the small-pox. They make parties for this purpose, and when they are met (commonly fifteen or sixteen together) the old woman comes with a nutshell full of the matter of the best sort of small-pox and asks what veins you please to have opened. She immediately rips open that you offer to her with a large needle (which gives you no more pain than a common scratch) and puts into the vein as much venom as can lye [sic] upon the head of her needle, and after binds up the little wound with a hollow bit of shell, and in this manner opens four or five veins....The children or young patients play together all the rest of the day and are in perfect health till the eighth. Then the fever begins to seize them, and they keep their beds two days, very seldom three. They have very rarely above twenty or thirty in their faces, which never mark, and in eight days time they are as well as before the illness....There is no example of any one that has died in it, and you may believe I am very well satisfied of the safety of the experiment since I intend to try it on my dear little son.[18]

By the mid-eighteenth century, smallpox reached most of the world, excluding Australia and several isolated islands. It was the leading cause of death in Europe in the mid-1800s, with an estimated four hundred thousand killed each year. In New York, where the Statue of Liberty welcomed Europe's "teeming huddled masses yearning to breathe free," the potential for contamination shot up exponentially, particularly in neighborhoods near seaports, where goods and foodstuffs were handled. As horsepower was the primary mode of transportation until the advent of the automobile, many medical officials of the age believed that horse manure, which could be smelled on almost every corner of New York, could be the cause of certain outbreaks. Public health and city officials made some efforts to address this. For example, in 1752

> *Boston selectmen allocated extra funds to clean the streets because of the fear that street dirt might contain smallpox infection, and in 1795, during the yellow-fever season, town officials invited neighboring farmers to collect the manure from the streets free of charge. The city fathers of New York, faced by the threat of cholera in 1832, made special efforts to cleanse the cobblestones, thereby divesting the city "of that foul ailment on which pestilence delights to feed."*[19]

Quarantine was another attempt to handle the problem, and politicians decided to act after concerned citizens and business owners applied pressure. Built over the course of two years and completed in 1856, architect James Renwick's Smallpox Hospital was a tangible, practical solution to the episodic outbreaks. Located at the southern tip of Blackwell's Island, its looming Gothic-revival spires and austere entrance evoked the somber, almost medieval, mood of public health at the time. It remained the city's only designated quarantine and treatment center for smallpox for decades. As Roosevelt Island's Historical Society recalled,

> *The construction of a new hospital was under consideration in 1850, at which time smallpox victims were cared for in what Resident Physician William Kelly described as "a pile of poor wooden out houses on the banks of the river." Unlike numerous other medical institutions built by the city on the island in the 19th century, the Smallpox Hospital was not planned exclusively for charity cases. Because of the seriousness and the contagious nature of the disease, paying patients were also admitted.*[20]

The Smallpox Hospital had room for one hundred patients divided between two main floors. Charity cases were on the lower level and paying patients on the upper tier. Maintaining a relatively strong treatment profile and described as an admirable endeavor by most city officials who were happy to finally have a place—however limited in scope—to house those afflicted by the virus, the Smallpox Hospital's short run came to an end in 1875. After much deliberation, the Board of Health assumed control of the facility, which had previously been run by the Commission of Charities and Correction, rebranding it to be the Home for the Nurses and the Maternity and Charity Hospital Training School. Smallpox patients were transferred to nearby Brother's Island, just a short ferry ride away, and Blackwell Island's seven thousand healthy residents could breathe a sigh of relief.

Originally christened *De Gesellen* (the brothers/the companions) in the native Dutch of the seventeenth-century settlers of Manhattan, North and South Brother Island are respectively twenty- and six-acre plots of barren scrub tucked away between the Bronx and Rikers Island in the East River.

The town of Morrisania in the Bronx bought North Brother in 1871. The Sisters of Charity set up a tuberculosis treatment center on its secluded, windswept shores. In 1885, New York City purchased the island, closed the facility and began to build a new hospital for the broader treatment of infectious diseases, which were racking up an alarming death toll. Patients with smallpox, measles, scarlet fever, polio and, most famously, typhoid fever were all housed on this isolated island. A ferry that embarked staff, patients and medical supplies at 132nd Street in the Bronx was the only means of reaching North Brother, and until 1894, the island was entirely cut off from telephone and telegraph communication.

Housing more than one thousand patients during a late-nineteenth-century outbreak of typhus, accommodations were crude, to say the least. Woodburning stoves and hastily erected tents proved a deadly combination, and many fires sprung up in the cold winter nights when attendants dozed off or forgot to check them due to the overwhelming task they faced out in the channel. As one journalist observed, "The location and use of North Brother Island, as a quarantine hospital, also speaks about the city's social geography and how it was organized much differently than it is now. Back then, less savory people, activities, and neighborhoods were relegated to the peripheries of the city, like the waterfront and islands."[21]

TYPHOID MARY

In August 1906, at their luxurious rented vacation home near the beach, Charles and Mrs. Warren's young daughter became suddenly ill. When they were visited by a physician, it was determined that she had typhoid fever. The same week, five more people in the house exhibited symptoms: Mrs. Warren, a second daughter, the family's two maids and their gardener. Long Island's Oyster Bay, where the house was located, was an affluent and well-to-do neighborhood. It was a far cry from the Five Points or the Bowery at the turn of the century, where slums and tenements were frequently blamed as the breeding ground for contagions. A popular vacation spot for wealthy New Yorkers, Oyster Bay was perhaps best known for hosting President Theodore Roosevelt, who lived in beautiful brownstone during the summer, just steps from the water. Mr. Warren was a wealthy banker and his wife a stay-at-home mom for their two children, none of whom had any contact—so they believed—with anyone even remotely sick. The case presented a truly bizarre problem for public health officials and local landlords who desperately needed to contain any hysteria that could jeopardize Oyster Bay's lucrative rental business and long-term reputation. Not to mention, its proximity to New York City proper was a terrifying problem should the community become contagious.

George Thompson, who owned the house, knew that if the issue was not solved, his extremely costly estate would not be maintained—he could not afford to live at the Warrens' address even though he owned the property. Desperate for a solution, he reached out to friends and local officials to run a trace of suspected sources of the infection. As chef and author Anthony Bourdain described in his excellent book on the case,

> *Drinking water was analyzed. The single indoor toilet, the cesspool, manure pit, and outhouse were all examined and ultimately rejected as the possible source of infection. Dairy products were inspected. An old woman who lived on the beach was considered a likely suspect. She had offered the family clams for sale, and these were scrutinized minutely, but no one else in the town that had eaten shellfish from the same source had fallen ill. Thompson, unsatisfied with the inconclusive results from local health authorities on the scene and from his hired experts, reached out to friends in New York City, looking for someone, anyone, to help him with his embarrassing problem.*[22]

On a cool day in March 1907, a plainly dressed man walked up the steps of a Park Avenue brownstone and knocked on its heavy door. Admitted into the foyer, he slowly made his way to the kitchen, passing attendants, cleaning ladies and the like before he found the woman he was looking for. She was about five foot six, around forty years of age and shapely with a determined, striking gaze that the man would always remember. Her penetrating blue eyes betrayed little emotion as he introduced himself. Moving closer, he asked her name. She seemed guarded but answered forthrightly. She said her name was Mary Mallon. He told her he worked for the city and just needed a few things from her: a urine and stool sample and maybe a little blood. The woman tensed up, and as he later recalled, "It did not take Mary long to react to this suggestion. She seized a carving fork and advanced in my direction."[23]

George Sober was the sanitary engineer assigned to investigate the typhoid outbreak at the Warrens' rental house in Oyster Bay, Long Island. He'd been sent there after suggesting a radical idea at the time: that Mary Mallon, who he deemed patient zero for New York's typhoid epidemic, was responsible and that her removal was paramount to warding off a catastrophe. He was not a medical doctor but something of a hands-on public health sleuth, who had a keen sense for detail and a dogged persistence in seeing his theories born out.

He had just arrived on a train from Oyster Bay, where he'd just spent a short time with the Warrens, taking copious notes in his ledger and speaking with recovering family members and aides. A preliminary medical team had left notes with its analysis of the Warrens' trash and septic tank, but the real breakthrough was Sober's insistence that a guest list be provided to him. Remarkably, Mrs. Warren had kept a log of all visitors and all those employed by the family. The log dated back almost ten years. Sober eyed it somberly, looking for a pattern to find the outlier. None of the medical records for the guests or attendants suggested typhoid. Then it hit him:

Typhoid's incubation period was known to be ten to fourteen days long, so he focused on a time on or before August 20. Sober was intrigued by the news that on the fourth of the month, the Warrens had seen fit to change cooks. More significantly, the new cook, a Mary Mallon, was now missing, having left without notice or explanation some three weeks after the sickness began.[24]

Mary Mallon, also known as Typhoid Mary (September 23, 1869–November 1, 1930). She was incarcerated for more than thirty years but did not evidence any symptoms of typhoid. *Courtesy of Science Source.*

Later that day in New York City, after dodging Sober's request and locking herself in a storage space after he left, Mary was taken into custody by city officials, who discovered her hiding place by spotting a scrap of her dress that had caught in the door as she hurried to close it. When her test results returned positive for typhoid bacteria, the Department of Health forcibly removed her from her job and placed her in the quarantine center at North Brother Island. She would remain there for two years in a cordoned-off cabin with little access to the outside world and only the occasional letter. As one biographer noted:

No one ever attempted to explain to Mary the significance of being a "carrier," instead they had offered to remove her gallbladder, something she had denied. She was unsuccessfully treated with Hexamethylenamin, laxatives, Urotropin, and brewer's yeast. In 1910, a new health commissioner vowed to free Mary and assist her with finding suitable employment as a domestic but not as a cook. Mary was released but never intended to abide by the agreement. She started working again in the cuisines of her unsuspecting employers, threatening public health once more.[25]

Five years later, she was arrested after being found cooking in a local restaurant. She was once more exiled to her island cottage, and she remained there until her death in 1938—almost twenty-three years later. While she was later determined, by modern analysis and etiological review, to have been one of thousands of people who carried typhoid

without exhibiting symptoms, her plight in New York serves as a valuable window in the panic-driven nature of the times. Outbreaks were still viewed in an almost biblical sense given their virulence and ability to rapidly destroy communities.

PANDEMIC

Mary Mallon was born in Ireland in 1869—the same year Hart Island became the official burial site of New York City's unclaimed and Louisa Van Slyke was interred. Like tens of thousands of other unknown and unclaimed people who died in this century of widespread pestilence and epidemics, figures like Louisa remain mute witnesses to some of New York City's most trying times.

As city planners and medical professionals attempted to deal with the seemingly unending onslaught of infectious diseases, plagues and scourges that struck the city, the disposal of the poor and the homeless—who were often hit the hardest—required that difficult decisions be made. These

Tombstone dedicated to those interred in the potter's field cemetery on Hart Island. *Courtesy of Claire Yaffa, AIDS Photograph Collection and New York Historical Society.*

decisions ranged from the creation of the mass trench under the potter's field on Hart Island to Mary Mallon's arrest and banishment. But the worst was around the corner. As World War I raged, militaries from all over the world fought on shell-strewn battlefields drenched in the blood of millions. A terrifying, world-threatening pandemic loomed—one for which no one was prepared. It was the great influenza epidemic that killed between fifty and one hundred million people worldwide and tens of thousands in New York City alone. The gaping maw of the common trench waited, solemnly prepared to accept its new denizens.

3

POTTER'S FIELDS

When detectives and forensic scientists were called to investigate the Hart Island remains, any of them could have been unwittingly treading on additional mass graves hidden beneath the city's parks, buildings and sidewalks. Hart Island may be New York City's largest mass grave, but it wasn't the first. While many of these sites are bathed in fame, others stand quiet and nearly forgotten beneath the crushing grind of growth and change.

AFRICAN AMERICAN BURIAL GROUND

Because modern Americans believe in "one person one grave,"[26] one can imagine how passersby at Broadway and Reade Street would react upon realizing they're standing over twenty thousand graves. Today, the Tom Weiss Federal Building located at 290 Broadway is commonly associated with its primary occupant, the Internal Revenue Service. Little does anyone realize that this parcel of land is also the burial ground for thousands of former slaves.

Long before New Yorkers sided with the Union army, the Dutch West Indies Company imported the first African slave into New Amsterdam in 1626. When England took control in 1664, Africans comprised about 40 percent of the population of New York City. In that era, both imperial powers allowed slaves to buy their freedom.[27]

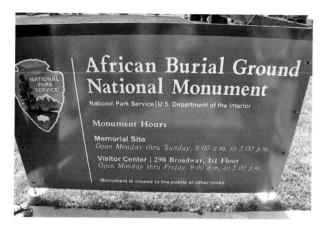

The African American Burial Ground National Monument. Historians estimate that there may have been as many as twenty thousand burials in what was called the "Negroe Burial Ground." *Courtesy of National Park Service.*

The first African was likely buried near 290 Broadway in the 1630s. At that time, the area was outside the city and featured a large ravine where local authorities permitted slaves to congregate and uphold their cultural practice of nighttime burials.[28] Among the most objective records of the site is the Maerschalk Map, which was produced in 1755. Its creator prominently marked the area as "African Burial Ground," which confirms common knowledge of the site's historical use.[29]

Given society's apparent attitudes toward African Americans and black people, the burial site seemed reserved for the least valued decedents. Thus, when British troops interred dead rebel prisoners of war there during the American Revolution,[30] one can reasonably conclude they intended the burial site as an eternal insult to the prisoners and their new African neighbors. An additional insult came to the site in 1788, when local African Americans petitioned New York Hospital to demand its medical students stop stealing bodies.[31] Burials ceased by 1795 when the land's ownership changed hands. With its ravine now filled and leveled, the site was subdivided and sold as residential housing lots.

In 1989, archaeologists began extensive research to prepare for a proposed federal project. Federal construction regulations designed to prevent negative cultural, historical or archaeological impacts led to the discovery of 419 bodies beneath thirty feet of earth. The broad significance of their exhumation prompted President George H.W. Bush to halt construction in 1992 and dedicate $3 million for the site's memorialization.[32]

Ironically, on October 4, 1993, all of the site's recovered remains were transferred to Howard University for analysis, despite the student body's alleged thefts two centuries earlier. Howard University researchers' conclusions offered incredible insight into the lives of black people in early

New York. Both free and enslaved black people had been buried there, and the bodies of American-born blacks showed greater suffering than their African-born ancestors. Despite pervasive racial injustice, they were allowed to continue some cultural practices. The alignment of the graves confirmed religious and familial associations and permitted the dead to face the eastern sun when they arose in the afterlife. Some coffins retained detailed artwork and symbolism consistent with specific African cultures.[33] Researchers concluded that the site held as many as twenty thousand bodies.[34]

Various stakeholders negotiated for years to resolve the site's complex issues.[35] In 1993, it again became known as the "African Burial Ground" and was designated as a New York City historic district and a United States national landmark. On October 4, 2003, Howard University returned 419 exhumed remains for reinterment. Each had been individually placed in hand-carved coffins made from wood felled in Ghana and were solemnly lowered into the African Burial Ground.[36]

When President George W. Bush used a presidential proclamation and the Antiquities Act of 1906 to declare this site a national monument on February 7, 2006,[37] it became the first such site dedicated to early New York's African population and Americans of African descent. By 2010, workers had completed the permanent national monument and memorial, which includes a visitor's center and a library.[38]

MADISON SQUARE PARK

Diners near Madison Square Park at Broadway and East Twenty-Third Street might not find the area's history all that appetizing. While noshing on made-to-order burgers and handspun shakes, few would relish a history lesson on the approximately thirteen hundred corpses that lie in eternal rest nearby.

In the early 1800s, fear of a new war with England helped the U.S. Army acquire the burial site as an artillery training ground. In 1814, the square was renamed after James Madison, the fourth president. Within a few decades, the area developed into a tony neighborhood filled with pricey brownstones and residents such as Theodore Roosevelt. In 1873, P.T. Barnum's famed Hippodrome occupied part of the site, and in 1879, it held the first Madison Square Garden. The original Garden was razed in 1889 and replaced with an elegant, $3 million Moorish structure. As the second-

Madison Square Park, named after James Madison, was home to New York City's first potter's field from 1794 to 1797. *Courtesy of Brian Zak.*

tallest building in the city, the new Garden eventually housed apartments, a concert hall, Westminster Kennel Club shows and a rooftop cabaret. Although the Garden departed Madison Square in 1925, the neighborhood still boasts some of New York's most iconic structures, including the Flatiron and MetLife buildings.

For more than two hundred years, New York's dead have silently witnessed Madison Square Park's transitions from beneath the soil. Made forever anonymous by their burials, they've watched the slow churn of social progress and periodic renovations of the ground atop their forgotten bodies.[39]

WASHINGTON SQUARE PARK

Located adjacent to New York University, Washington Square Park has played a critical role in modern history and current events. It is known for celebrating all manner of nonconformity, including the artists, street performers and students unaware of the twenty thousand bodies that lay beneath the fountains, landscaping and arch.

In the seventeenth century, Dutch settlers used the area for farming, while nearby land was donated to Angolan settlers to create a buffer between New Amsterdam and the Native American tribes. In exchange for a portion of their proceeds, the Dutch West Indies Company granted part of the eventual Washington Square Park to freed slaves in 1643. This ultimately led to greater African American settlement in the area, which

became known as "Land of the Black" and "Little Africa." When England controlled the area, much of the freed slaves' land was forfeited to wealthy Dutch and English landowners.[40]

By 1797, city authorities required yet another potter's field. Research by the New York Public Library revealed that officials acquired the land beneath Washington Square Park for a mere $4,500. At the time, it seemed ideally suited for its intended purpose, as it lay in a northern suburb and bordered established church cemeteries.[41]

Soon after the establishment of the burial site, the city's sheriff constructed a hanging gallows near the park's present-day fountain. Newgate Prison—less than a mile away on the Hudson River—added "another source of supply for field and noose."[42]

Along with the indigent, unidentified and convicted, many of Washington Square Park's dead were victims of the last few outbreaks of yellow fever.[43] During the late 1790s, public officials sought to downplay outbreaks and their risk to the population. Although New York's health committee eventually adopted Philadelphia's practice of publishing daily death tolls, it couldn't help but attempt to explain away the figures. In

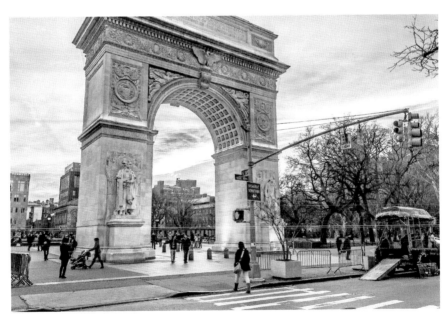

Washington Square Park was designated as New York City's second potter's field from 1797 to 1826. It is seen here in a 1964 photograph surrounded by the buildings of New York University. *Courtesy of New York Public Library.*

one such example, the committee declared "a large proportion of the deaths hitherto reported have fallen among emigrants lately from Europe, strangers, and other transient persons."[44]

By 1825, the site had run out of usable burial space. Combined with a barrage of complaints from residents of posh neighborhoods emerging in the area, city officials took action.[45] Mayor Philip Hone began legal proceedings to repurpose the burial site and increase property values in the surrounding area.[46] On the fiftieth anniversary of the Declaration of Independence in 1826, New York City officials renovated the cemetery into a drilling installation for the city's volunteer militia units.[47] However, no bodies were removed or relocated in the process[48] that transformed the potter's field into the Washington Parade Ground.[49]

In 1827, local courts agreed with Mayor Hone and declared the square a public space. High-end construction and landscaping soon allowed the parade ground to elicit a sense of privilege and prestige among the well-heeled residents who lived along three of its borders. The original Gothic structure of New York University soon occupied the fourth.[50] Then known as the University of the City of New York, it paid $40,000 for lots overlooking the parade ground in 1832. This allegedly left the university with less than $100 in operating funds. Although valued at only $4,000 six years earlier, the lots provided NYU with a 240 percent increase in property value by 1837. This likely brought substantial relief to the institution, which had paid its expenses only after mortgaging the library's book collection.[51]

Officially renamed Washington Square Park in 1871, the current site comprises 9.75 acres. New York Public Library researchers cite a document from the New York City Parks and Recreation Department, 2005 Archaeological Assessment of Washington Square Park, which confirmed the corpses buried beneath the park grounds "possibly numbered as many as 20,000 and it appears these burials remain under varying depths of fill."[52] It is only a matter of time until Washington Square Park gives up its dead in the same manner as Hart Island. The distinct difference, of course, is that it's not an isolated barrier island unvisited by throngs of New Yorkers. When they are discovered, Washington Square Park's skulls will be mere feet from its artists, street musicians, food vendors and college students.

JAMES J. WALKER PARK

As ballplayers slide into home plate at James J. Walker Park, few realize the diverse history that land has endured. Like most of the city, it has been revamped, reconstructed and renamed over time. Long before workers leveled its first athletic field, this was the final resting place for more than ten thousand New Yorkers, most of whom remain entombed there today.[53]

In 1812, St. John's Chapel of Trinity Church acquired the land for its congregational cemetery. For forty-six years, an average of 217 bodies came to rest there annually. In 1834, a large, rectangular, marble sarcophagus placed near the center of what is now the park commemorated the deaths of two Engine 13 volunteer firemen, Eugene Underhill and Frederick A. Ward. Both men died on their first tour of duty when a burning house collapsed on them.[54] The sarcophagus remains onsite but has been moved near the bocce courts.[55] In 1858, the cemetery closed to new burials,[56] but the grounds and its occupants remained, as the city's prominent and wealthy took up residence nearby.

In 1895, New York City officials seemed insistent on renovating the cemetery into a park with a more pleasant, and therefore profitable, view. Despite receiving a reasonable offer for an alternate site nearby, authorities adamantly pursued St. John's instead. A writer at the time equated the efforts to the Hebrew story of King Ahab and his wife, Jezebel,[57] who were said to have had a vineyard owner, Naboth, killed for his land.[58] The writer stated, "The political children of Naboth are determined to have that particular spot, by force of law if necessary, even though its occupation by them shall tear the dead from their graves and compel the destruction of the trees that have twined their roots around the coffins and boxes of the buried thousands who sleep there."[59]

After prevailing because of eminent domain, the city condemned the cemetery, took ownership and renamed it Saint John's Park. Although it was widely publicized that the bodies were moved, only the prominent deceased actually were moved.[60] The remaining tombstones were overturned and buried to make way for higher real estate values.[61] In 1896, architects redesigned the space, already renamed Hudson Park, and constructed an ornate Italianate park with sunken gardens, a lagoon, walking path and gazebo. Despite its grandeur, the city again renovated the park in 1903 to create space for "active recreation."[62]

Not long after, James "Jimmy" Walker, the park's current namesake, won the 1910 New York city council race. A former student of law, he passed the

bar exam in 1912, joined the state senate in 1914 and became mayor of New York in 1925. While in office, he "founded the Department of Hospitals, preserved the nickel subway fare, and rooted out corruption in the Police Department and Department of Health."[63] Ironically, in 1932, Walker faced corruption charges for accepting bribes for municipal contracts. He responded by resigning his office, divorcing his wife, marrying his mistress and moving to Europe for the next three years.

In 1939, soon after Walker's return, proof of Hudson Park's still-interred masses was discovered. During an early playground renovation, workers found a small cast-iron coffin made to resemble a mummy. The unusual coffin identified its contents as Mary Elizabeth Tisdall and featured a glass window, which allowed the workers to view the blonde girl's remains inside. Trinity Church records revealed that six-year-old Mary had died of "brain congestion" on April 14, 1850, and was the daughter of Elizabeth Anne Clute and Fitz Gerald Tisdall, who emigrated from Bristol, England. The pair married at St. John's Chapel in 1837, had a son in 1840 and had Mary in 1844. Fitz served as grandmaster of the St. John's Masonic Lodge, wrote poetry and worked as a coal merchant. Mary's brother, also named Fitz Gerald Tisdall, eventually taught Greek at City College.[64] The story of Mary Tisdall and her family is, of course, an anomaly that may have been lost to time.

In 1940, then-mayor Fiorello D. LaGuardia appointed Jimmy Walker to serve the city as a labor arbiter. Walker died in 1946, the same year that a baseball diamond was added to Hudson Park. The city council voted to rename the site in Walker's honor in 1947 and renovated the space in 1972 and again in 1996.[65]

Through all of the renovation, name changes and related political dealings, James J. Walker Park still holds more than ten thousand anonymous, forgotten bodies beneath its surface. They patiently wait to join Mary Tisdall and be known, remembered and honored.

CENTRAL PARK

Most of the thousands of visitors who pass the Central Park entrance at Mariner's Gate on West Eighty-Fifth Street have no idea they're surrounded by thousands of unknown graves.

In the 1850s, Seneca Village was a predominantly black neighborhood. The African Union Methodist Church once stood on the south side of West

Eighty-Fifth Street. Across Eighty-Fifth, near what was West Drive, stood the African Methodist Episcopal Zion Church Cemetery. The All Angels' Church and its cemetery were located farther west, closer to present-day Mariner's Gate and West Central Park Avenue.[66]

Despite being the oldest church in Seneca Village, very few records remain from the African Union Methodist Church. Its deacon, William Mathews, purchased the church's land on Eighty-Fifth Street in 1837 and Colored School No. 3 was soon held in its basement.[67]

Founded in 1796, the original African Methodist Episcopal Zion Church (AME Zion) was located at Church Street and Leonard Street. Comprising an independent congregation, its outspoken members aligned themselves with abolitionist ideology. Nationally, AME Zion congregations became known as "Freedom Churches" because of their frequent use as Underground Railroad stations, which included abolitionists Sojourner Truth, Harriet Tubman and Frederick Douglass.[68] Although decedents from the church were initially buried in vaults in the adjacent churchyard, fear of yellow fever forced the church to use the potter's field at Washington Square. Upon the closure of that space, AME Zion purchased and used several large burial sites in Seneca Village between Eighty-Fifth and Eighty-Sixth Streets until an 1852 ordinance prohibited new burials below

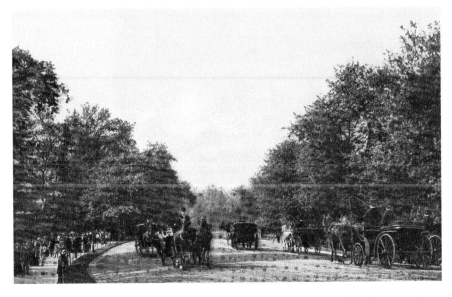

Nineteenth-century painting of Central Park titled *Carriage Ride in Central Park. Courtesy of Ephemeral New York.*

Eighty-Sixth Street. The congregation then buried its dead in Brooklyn's Cypress Hills Cemetery.[69]

Founded in the 1840s, All Angels' Church originally stood at West Eighty-First Street and West End Avenue. The neighborhood contained a diverse population of immigrants, whose ancestry mostly began in Africa, Ireland and Germany. As a missionary parish, All Angels' served the working poor and allowed "black and white and all intermediate shades [to worship] harmoniously together."[70] The church had buried its dead in an adjacent cemetery and recorded significant events, such as births, weddings and deaths, in its parish register.[71]

By 1857, city officials had seized the land in Seneca Village.[72] All Angels' continued services in a nearby home until it secured a new property in 1859.[73] The AME Zion Church remained in its location at Church and Leonard until 1864. As New York's developing affluence pushed the black community farther north, the church sold its half-block lot and followed the majority of their congregation into present-day Harlem.[74]

No significant evidence or documentation has supported local efforts to move the Seneca Village graves. The church cemeteries, now seemingly populated with the inconvenient dead, would merely be covered, their grave markers destroyed and their identities largely stolen. As though to contradict any reinterment theories, Central Park workers have occasionally discovered remains in the area. In 1871, workers uprooting a tree near Mariner's Gate uncovered a coffin that contained the remains of a juvenile member of the All Angels' congregation who died in 1852. In the following decades, Central Park gardeners unearthed more coffins believed to have been buried in one of the original church cemeteries.[75]

With the disappearance of the first church that buried its dead near Mariner's Gate more than 160 years ago—and the dispersal of the adjacent congregations—there remains little probability that any additional graves exhumed from this site can be identified. The remains of thousands who rest under Central Park will have to be content to exist in anonymity—their lives and experiences forgotten and lost to social progress and the passage of time.

NATIONAL SEPTEMBER 11 MEMORIAL AND MUSEUM

On September 11, 2001, foreign terrorists attacked the United States and forever altered the landscape, perceptions, activities and emotions associated with the World Trade Center and New York City. Although not on the same historic timeline as the previously reported mass cemeteries, the September 11 Memorial deserves its place among our most hallowed.

The National September 11 Memorial Museum opened its doors at Ground Zero on May 21, 2014, and included a collection of artifacts, photographs and oral recounts of the 1993 and September 11 World Trade Center attacks. Despite mixed emotions and opposing reactions, the museum also includes a repository that stores human remains from some unknown portion of the victims who perished in the towers. The site, which occupies half of the former World Trade Center's sixteen acres, may "perpetually play out the tensions between its roles as memorial landscape, history museum, forensics repository, cemetery, and tourist site."[76]

In the years following the attack, 21,906 pieces of recovered human remains were sent to the Office of Chief Medical Examiner (OCME).[77] In August 2011, they retained jurisdiction of more than 9,006 such remains. Many of these items were small pieces of bone and tissue about the size of "a Tic Tac."[78] By February 2013, it still retained 8,354.[79]

The demolition and rehabilitation of Ground Zero took years. Families of the unrecovered and unidentified victims struggled to have their diverse voices and wishes simultaneously heard and respected. Disagreement over what to do with the site led to prolonged dialogue, negotiations and compromises between stakeholders and victims' families. When plans were revealed to include the recovered and unidentified human remains from the September 11 attacks inside the museum, groups such as Respect Human Remains at the September 11 Memorial organized and petitioned for a reprieve. Their objections included expectations for the remains to be located in a landscape similar to the Tomb of the Unknowns in Arlington National Cemetery.

Other groups and individuals expressed support for the proposed repository amid the September 11 Memorial and Museum. "That is where they died, that is where there is a proper memorial for them, and to me it is a good, safe and holy place," one supporter told the *New York Times* in 2014. "One thing that has struck me over the years is that when you have almost 3,000 people die, there is a whole lot of family members attached to everyone, and they all have different opinions on everything."[80]

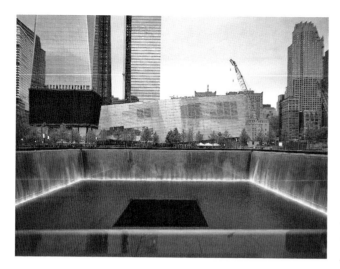

The National September 11 Memorial honoring the 2,997 people killed on September 11, 2001, and the 6 killed in the 1993 World Trade Center bombing. *Courtesy of Jin Lee.*

Over some continued objections, the organizers moved forward with the plans and construction. Placed at bedrock below and between the former sites of the two towers, the repository falls under the control and jurisdiction of the OCME. As an official New York City facility, its design meets the office's professional needs and specifications, which include secured, limited access and environmental controls to preserve the remains still stored inside.[81] The repository stands behind a blue tile wall emblazoned with a quote from Virgil: "No day shall erase you from the memory of time."[82]

On May 10, 2014, 7,930 items of human remains were returned to Ground Zero.[83] Accompanied by what a city official called a "solemn, somber, respectful procession" of vehicles from the New York Police Department, Fire Department of New York and the Port Authorities of New York and New Jersey, OCME workers moved the remains in a "ceremonial transfer" from its main office on the East River. Although the OCME continues to identify the remains, there are no genetic or identification testing facilities inside the repository. The final design and construction of the repository includes a private reflection room. Located adjacent to the repository, it's exclusively reserved for use by families of the Semptember 11 victims. Neither space is accessible to the general public and families of the victims never have to pay for admission to the reflection room or museum.[84]

CONCLUSION

Much like the city itself, the history of mass graves and burial sites in and around New York is long and complicated. Spanning nearly four hundred years, the roots of these sites and cemeteries began from a myriad of causes that range from the practical to the malicious. Racial injustice and hatred segregated the least among us to specific, unwanted burial sites. Socioeconomic despair and disease often conspired to ensure a lonely and penniless demise. Political maneuvering, especially when motivated by social and economic opportunities, demanded deceased congregations form the bedrock of our urban development and renewal. Municipal authorities have always borne the burden of working to best ensure public health, but constituents reluctant to devote substantial resources to the indigent while they're living are often unwilling to do so after their passing.

4

DAWN POWELL

Does the name Dawn Powell mean anything to you?

I didn't think so. But you're not alone.

Just as millions of people knew nothing about Hart Island, millions of people never heard of Dawn Powell, who, by the way, is also buried there.

Born in Gilead, Ohio, American writer Dawn Powell (1896–1965) wrote fifteen novels; more than one hundred short stories; numerous stage plays, book reviews and radio, television and film scripts; hundreds of letters and diary entries (which, in the opinion of some readers and reviewers, are the best things she wrote) and a smattering of poems.

How can we *not* know her?

Somehow, sometime, somewhere surely *something* she wrote crossed our paths…or not. Her literary output has only been loved and lauded after death—a common phenomenon.

It's rather startling, in a humorously dark way, to learn about the circumstances surrounding the demise of Dawn Powell and her burial befitting, well, a pauper. She died of colon cancer on November 14, 1965, during the week of the Great Northeast Blackout, which left eight hundred thousand people without electricity. At the time, every one of her books had gone out of print. A spooky foretelling, perhaps?

Upon her death—as she requested—her body was donated to the Cornell Medical Center for research. Within five years, her remains were to be returned to designated family or friends for burial. The individual contacted for this sobering task was her publicist, Jacqueline Miller Rice, who swiftly

Dawn Powell (November 28, 1896–November 14, 1965) was an American author, who spent the better part of her career in New York. Gore Vidal called her "America's best comic novelist" and the *Wall Street Journal* dubbed her "America's most brilliant satirist." She was also described as one of "the best writers nobody ever read." *Courtesy of Richland Source.*

refused custody of the remains. She may have even said, all too quickly, something about burying the once-prolific Ohioan in the New York City cemetery on Hart Island, post haste.

A SAMPLING OF GENIUS

In 2015, author and reviewer Victoria Patterson wrote:

> *Last year I bought Dawn Powell's novel* A Time to Be Born *for less than two dollars from a used bookstore. I didn't know much about Powell or her work, but I somehow knew her name. The opening paragraphs hooked me, as they captured the sense of World War II looming for Americans and set the scene at once broadly and intimately.*

Patterson was made a fan by powerful words from Powell's *A Time to Be Born*:

> *This was no time to cry over one broken heart. It was no time to worry about Vicky Haven or indeed any young lady crossed in love, for now the universe, nothing less, was your problem. You woke in the morning with*

the weight of doom on your head. You lay with eyes shut wondering why
you dreaded the day; was it a debt, was it a lost love? — And then you
remembered the nightmare. It was a dream, you said, nothing but a dream,
and the covers were thrown aside, the dream was over, now for the day.
Then, fully awake, you remembered that it was no dream. Paris was gone,
London was under fire, the Atlantic was now a drop of water between the
flame on one side and the waiting dynamite on the other.[85]

Patterson next read *Turn, Magic Wheel*, which Powell called her "best, simplest, most original book."[86]

"It has an appealing, breathless energy," wrote Patterson. "Set in Manhattan, the humorous and melancholy novel introduces Dennis Orphen and Andrew Callingham, two novelists who will reappear in other books by Powell."

Patterson's favorite book was *The Diaries of Dawn Powell.* In it, Patterson finds "Powell's need to write, her grit, her piercing intelligence, her humor… and a satisfying dose of literary gossip."

MINDING OTHER PEOPLE'S BUSINESS

Maybe Powell's fate was linked to her credo: "I contend that a writer's business is minding other people's business."[87] For all the bits and pieces of humanity that surfaced in her works—her surgically prepared nuggets of real life and angst—there were no takers when Cornell had finished dissecting and repackaging Powell for her heavenly journey. It would be a no-frills boat ride to Hart Island, where she would eternally and unpoetically be known as No. 81772519.[88] Was this spiritual payback by creative muses or unamused, jealous rivals? For what might have seemed like a literary hiatus on earth, Dawn Powell had something to say, said it brilliantly and then, at the age of sixty-nine, she was gone.

Powell moved from Ohio to Manhattan's Greenwich Village in 1918 and immediately began writing many of the fine works that would be rediscovered after her death. The location brings to mind a particular kind of lifestyle, or *free* style, of living. People who lived or spent a lot of time in the Village were thought to align with a looser lifestyle, which was displayed in their work as artistic and social rebellion and sexual freedom. In essence, this described Dawn Powell.

Her maternal aunt in Ohio, Orpha May Steinbrueck, had the most influence on Powell in her high school years. Orpha May was an independent and unconventional thinker and was well beyond her time in her views about society and sex.

Powell's childhood was dismal, almost Dickensian, according to Victoria Patterson. Her mother died when Powell was six, and her father remarried a woman with severe mental illness, who was abusive to young Dawn and her two sisters. This frightening stepmother burned all of the stories Dawn had penned, even at an early age, and wouldn't allow her to attend high school. Powell ran away from her family home and moved in with Orpha May. She graduated from college, then took off for New York City. She always considered herself "a permanent visitor."[89]

Her first date with successful advertising executive Joseph Gousha was a ride on the Staten Island Ferry, and they married soon after. He and Powell were both heavy drinkers. Their dynamic was not one of wedded bliss but acceptable tumult. Both had affairs and both prompted and quieted marital troubles, though they remained together for forty-two years.

Their only child, a son named Joseph R. Gousha Jr., or "Jojo," was falsely diagnosed as "retarded" in the day's vernacular. He was highly intelligent but autistic (by today's clinical standards) and schizophrenic. He spent a lot of time in hospitals and institutions. He once beat his mother so brutally that she ended up in the hospital for weeks. Powell's biographer, Tim Page, wrote, "[Jojo] was the great joy and the great tragedy of Dawn Powell's life."

Powell shared the creative themes of many of her New York contemporaries in that the most pressing and relevant examples of her writing were often fueled by alcohol—a lot of it. This made tearing down social norms and institutions, pillars of pomposity (both ideas and people) and hypocritical lifestyles and deeds the order of the day.

The effort and end results were applauded and nurtured by an eccentric coterie of *intelligentsia*, which unilaterally proclaimed the standards for good or bad artistic attempts and achievements. Her cheering section included English novelist, playwright and social commentator J.B. Priestley; authors John Dos Passos and Ernest Hemingway; writer and critic Edmund Wilson; writer and "public intellectual" Gore Vidal; and lifetime biographer, Pulitzer Prize winner, *Washington Post* music critic and professor at the Annenberg School of Journalism and the Thornton School of Music at the University of Southern California Tim Page. In 1995, Page purchased Powell's diaries, letters and papers for $35,000, then edited and published them and wrote *Dawn Powell: A Biography.*

D.P. vs. D.P.

We're all fools: you, me, all of us together, none better than the other.[90]
—Dawn Powell, Minding Other People's Business

Powell's contemporaries were well known in elite social, artistic and intellectual circles and metaphorically slammed the doors behind themselves when they walked into rarified places of gathering. Powell aligned with the New York Intellectuals. Her satiric rival, Dorothy Parker, was a member of the famous Algonquin Roundtable.

Dawn Powell had become a successful author—*novelist*—despite herself and the fact that her talent never produced sustainable income. She only made the distinction about her particular literary title as *novelist* when she was compared to the *other* D.P., Dorothy Parker, who was well published but had written no full-length novels.

American literary critic Diana Trilling (a member of the New York Intellectuals along with her husband, Lionel Trilling) said Powell hated discussions that included both her and Parker at the same time, claiming that "she made the jokes Dorothy Parker got credit for."[91]

The comparisons between them, of course, would pop up throughout each woman's career. However, Powell's voice on the human condition—astute, unpretentious and painstakingly real—was inherently empathetic and a bit more softly, if not more wisely, satirical.

The White Horse Inn located near Dawn Powell's home on Christopher Street. It became one of her favorite watering holes during the 1950s and 1960s. Many of her contemporaries also frequented the White Horse, including Dylan Thomas, James Baldwin, Jack Kerouac, Alan Ginsburg and Norman Mailer. *Courtesy of Wikipedia Commons.*

While Powell may have laughed uncontrollably and chastised someone caught in a tree, she'd get a ladder and offer it to the bird-brained daredevil. Later, she would have agreed that this was something she probably would have done, too, and would have toasted their mutual idiocy over cocktails.

Parker would have verbalized many expletives, comparing the poor soul in the tree to the dumbest examples of humankind ever invented. She would have made a cocktail for herself, gotten someone else to find a ladder and shot it out from under the fool in the tree, then made *them* pay for celebratory cocktails later.

"MEN REALLY DISLIKED LITERARY WOMEN"

If you were a woman writer, the proving ground was all the more treacherous. Although many of her friends and colleagues were men, Powell wrote, "In order for a genius to be a genius, he must have a selfless slave between him and the world…. One reason women (and some men) writers are kept back is that they spend their brains and heart on writing but their fighting ability they must use for others—to protect, advance, heal, feed, support."[92]

When her friend Edmund "Bunny" Wilson gave her a curt, lukewarm book review, she responded in like fashion. She wrote, "Men really dislike a literary woman (especially if she is good) and prefer not reading works of their women friends, hoping and even saying they must be bad."[93]

Powell knew that her name would not ring for decades in the gilded halls of important American literature, nor would she ever be filthy rich from her endeavors. She was realistic and continued working through all the fits and starts of a less-than-fulfilling marriage and the demands of a severely autistic son—topics she chose not to discuss or share in public.

Powell wrote in her personal diary, "As for his [Joseph's] death, this is a curious thing to say but after 42 years of life together— much of it precarious and crushing—we have been through worse disasters together, and I'm sure Joe would feel the same way about me."[94]

A year before her death, she was awarded the American Institute of Arts and Letters' Marjorie Peabody Waite Award for lifetime achievement. She had also previously been granted an honorary doctorate from her alma mater, Lake Erie College for Women.

> *Satire is people as they are; romanticism, people as they would like to be; realism, people as they seem with their insides left out.*[95]
>
> —Dawn Powell

FIVE POINTS

This was it! The one they'd been waiting for. The boys at Five Points couldn't contain themselves after hearing the news and shook their heads in disbelief. Yankee Sullivan, the pride of the Irish bare-knuckle boxing circuit, was finally going to meet his match and fight Englishman Billy Bell. They put the tattered flyer down but nervously picked it up and read it again. It said, "$300 a side, winner takes all, meeting place need-to-know, to-be-determined."

The stagnant summer air in Five Points was unpleasantly leveled by the familiar smells of the notorious slum with the numerical name. The area consisted mainly of a group of four streets that spread out like spokes of a wheel until they all intersected at a public park called, of all things, "Paradise Square."

On this night, even the stray dogs roaming the streets seemed too hot to bark or growl as usual. Children who should have been in bed sat perched on the sills of open windows and whined loudly when they were told to come inside. Older kids lazily tossed a ball or carried trash bins to the street.

But nothing could dampen the excitement of Five Points's bare-knuckle crowd. They read the news about the fight on their garbage-ridden corners and in their dimly lit dive bars—all set against the tall shadows of the run-down tenements looming in the waning light.

At a time when bare-knuckle prize fighting was barely legal in New York, this upcoming fight was a dream come true. Although frowned upon and

subject to boisterous raids and routine police harassment, any no-holds-barred match, often set deep in some secluded wood, was a gift from the heavens to eager fans of the sport.

Fights between opposing fans often broke out before the real match. Soused with enough whiskey to fire them up, fans of both sides drunkenly placed bets, talked trash and hurled popular ethnic epithets, contributing to something that looked and sounded like a garish circus sideshow. This show before the show packed a social punch, clearly revealing the larger divide between New York's new Irish immigrant community and its established native population.

ABOUT THE BOUT

In the days leading up to the fight, the contenders participated in the customary coin toss to decide the place for the fight. Sullivan won. He had a few spots in mind but one in particular seemed to fit the bill. He said he knew just the place and told his men to get it ready. It was going down.

On the fateful morning of Monday, August 24, 1842, thousands lined the western shores of the Lower East Side with enough food to last the trip to the destination and through the long day ahead. Naturally, other libations were packed to keep things social as they hunkered down for the trip to the main event. In the predawn darkness, hordes of fans gathered, anxiously looking in the distance for larger ships, smaller launches, dinghies and other rudimentary crafts to appear on the horizon and slide into place for boarding on the banks of Long Island Sound.

The larger ships rounded the bend as the sky lightened. Around seven o'clock in the morning, they embarked, joining the veritable fleet of vessels—including the boats carrying the contenders—in the watery exodus to Hart Island, then known as Hart's Island.

Some suggested launching their smaller boats, which held just four or five passengers, from the larger cutters and sail-ketches but soon realized how long that might take. Shuttling people back and forth could take forever. The hype for the event was huge so there was no time to waste. Some travelers who had tapped into the liquor they brought with them were drunk enough to begin small fights with people on other boats that had gotten too close. Others simply jumped into the water, swimming frantically to the muddy banks of the island.

The previous night, the wind had churned up the channel's waves. This morning was ideal with balmy breezes gently blowing off a flat, calm sound and plumping the colorful sails on the water. As one contemporary account of the crossing described, "at 9 o'clock all were afloat, and the Westchester [Sullivan's boat], Napoleon [Bell's], Superior, Saratoga, Wave, Williamsburgh, Boston…with their heaped up masses, rocking to and fro in the stream, looked like some infernal cortege seeking the waters of the Styx, or a savage eruption bursting forth for ravage and for plunder."[96]

By half past ten in the morning, the motley band of vessels lay abreast of Hart Island, drifting closer in the shallows. Coxswains nervously asked their boats' masters where to land since the tiny islet had no docking structure, pier or even an approachable beach for a safe embarkment. The shores were too steep, rocky and slippery with mud. For a short time, folks wondered just how the showdown was going to take place if landing on the island was a problem.

When all was said and done, the bare-knuckle fans and the two bare-knucklers found their way onto Hart Island, dripping wet. Once on the island, and after wringing out shirts and trousers, they trekked single file through thick shrubbery and pesky thorns until they found the spot.

Deep in the woods, an uneven clearing was hastily smoothed over so the fighters could stand on something approaching an even playing field. This tiny patch of Hart Island was the perfect escape for this particular group of free-minded people whose city was notorious for harassing them. The city was happy too. It was reported that New York's crime rate plunged dramatically during the day and night of the fight.

Primitive is the only way to describe the actual space where the men would fight. A makeshift circle to define the ring was drawn in the dirt with rough markers, and stakes were dug in for fastened ropes. This was far from a sophisticated event. Seating was on a first-come, first-served basis, which left fans scrambling to grab a spot to catch a decent view of the action. One fan observed:

> At last, with our knees forced devotionally two or three inches in the soil, our shoulders bearing the weight and press of three or four sweaty proximitants, with the sun pouring down his fiercest rays upon our uncovered caput [sic], and boiling the effluvia thrown off from the neighboring bodies into a floating lava of most execrable odor, we saw the gladiators enter the ring.[97]

Yankee Sullivan

James Ambrose was born in Banon, County Cork, Ireland, in 1811, and his adopted moniker, "Yankee Sullivan," seemed to suit him just fine as he became world renowned.

From a young age, he was a troublemaker in London's East End, where he grew up and became a fighter. He was arrested and shipped halfway across the globe to Australia—England's penal colony for miscreants. He was sentenced to twenty years but served only eight before being granted leave for good behavior while he worked building roads and local infrastructures. He settled in a district of Sydney called The Rocks.

The Rocks was considered to be the most dangerous waterfront area in the world. Yankee Sullivan had found his niche. He got involved in more dangerous crimes with a local razor-blade gang that was known to rob and murder wealthy Australians, soldiers on shore leave and easy targets leaving bars and restaurants late at night. He continued to hone his skills as a prize fighter during this time. While no official records exist of his fights in New South Wales, anecdotal stories followed him claiming Sullivan as the undefeated opponent of anyone who was foolish enough to fight him.

In 1840, he moved to New York, where he allegedly owned a saloon called the Sawdust Horse. It wasn't long before Sullivan would go to state prison—this time for two years—for promoting a fight that resulted in the death of one of the contenders. He was pardoned after serving one year on

James Ambrose, also known as Yankee Sullivan (March 10, 1811–May 31, 1856), was a bare-knuckle prizefighter and boxer. He is depicted fighting former champion Tom Hyer. *Courtesy of Herbert Hallas.*

the condition that his acquaintances bail him out for a sum of $200. He also had to agree not to fight for two years, or he would be arrested again.

It could have been worse. In fact, Yankee Sullivan got out of his native Ireland just in time. A history-making agricultural blight known as the Irish Potato Famine struck hard in the early decades of the nineteenth century, just around the time he arrived in New York City.

THE LOWLY POTATO: BLAME IT ON THE "LUMPER"

One-third of the Irish population depended on the potato for sustenance. On an average, an individual ate between forty and sixty potatoes per day. Potatoes have a significant calorie count, so they were a cheap source of energy. They were also used as the main livestock feed.

The cause of the full-blown Potato Famine had to do with Ireland's dependence on its only strain of potato: the Irish Lumper. Unlike varieties grown in other parts of Europe, which provided options for eating, Ireland was stuck with its one type of potato. By late 1845, almost 40 percent of Ireland's potato crops had been wiped out. By 1846, three-quarters of the harvest was destroyed and the first deaths from starvation were reported.[98]

At the time, England was still Ireland's colonial overlord and attempted to provide basic relief in the form of grain. Ireland, however, lacked the sufficient number of mills to process it. Panicking families were literally starving to death and began packing their bags for America.

The famine was a painful lesson in economics, finance and sheer survival. Peasants who were unable to pay rent were evicted from their working farms and homesteads by absentee landlords. Poorhouses were soon dotting the bleak Irish landscape with fetid boarding rooms that bred pestilence.[99]

As the British Parliament increased taxes on Irish farmers (with the intention of paying itself back for their "benevolence"), hard-working peasants were subjected to a double strike on their livelihood. Their options were few: starve in Ireland or subsist in abject poverty in a hostile Britain and remain indebted beyond their means while living in urban squalor.

Modern researchers have concluded that a strain of a crop virus called HERB-1 was the culprit responsible for the Irish Potato Famine. It wasn't until the early twentieth century that improvements in crop breeding led to potato varieties that were resistant to the deadly virus.

The Fight

Meanwhile, on Hart Island, Yankee Sullivan looked and acted like a hard fighter. He was "the picture of a pugilist—small Gladiatorial head—quick, bright eye...round, deep in the chest—clean-limbed and possessed altogether of a frame which gives remarkable indications of activity and strength."[100]

Yankee Sullivan stretched out and bounced in the tiny sheltered arena, eyeing his opponent. He was described by a bystander as entering the ring with a "half-careless, half-reluctant swagger, which showed that he was not perfectly at ease."[101] Sullivan flexed and tensed as he shook Bell's hand. His fans cheered. Bell nodded courteously, his long hair blowing slightly in the mild breeze.

The anticipation was palpable among the gangs, ruffians and thieves who looked on. Among the crowd was Sullivan's friend, Bill "The Butcher" Poole, one of the Five Points gang leaders, who hacked drying racks of beef in his meat shop by day. His after-hours activities were more sinister, including armed robbery, theft and even murder.

Sullivan made the first move. He advanced in the bright sun and opened the bout with a terrific jab to Bell's face, catching him just below the left eye. Bell countered with a quick blow to Sullivan's cheekbone. Sullivan responded by rushing Bell and throwing him to the ground, pouncing on him in the dirt as cries and hurrahs from the vast crowd filled the air. Some stood and started pushing drunkenly through clumps of others, to see over the person in front of them. By the end of the first round, Sullivan's fans claimed "first blood" as a slightly shaken Bell smiled back at his fans, sporting a purple half-moon under his eye.

And so, it continued to "round 19th [*sic*]—Billy led off, but was stopped, and caught a return upon his gory nose—smart exchanges—close and struggle at the ropes—Sully ending it by tossing him beautifully over."[102]

The crowd sat, vicariously exhausted by the ordeal that never seemed to end. Bill Poole was happy. His friend was winning—just like he'd told his mates on the ride over. The bell rang and the two squared off. They were visibly fatigued but still acted as professional showmen with an audience of thousands gathered on Hart Island.

They continued to "round 20th [*sic*]—It was not apparent to everyone, as indeed it had been to everyone several rounds before, that Bell could not successfully contend against his experienced adversary. Sully came up smiling, and apparently fresh, while Bell was dreadfully punished, wavering and unsteady."[103]

They fought on to both jeers and unflagging support in the simmering heat of the clearing. To their fans, they were living icons of the warrior ethic of the Five Points.

By the twenty-first round, Bell was groggy and barely able to see but still remained standing. Sullivan threw him to the ground and savagely beat him. Round twenty-two found Sullivan landing a devastating punch square in Bell's battered face, plunging him headlong into the dirt.

Bell's fans began shaking their heads in gross disappointment and stretched out their legs in anticipation of the long march back to the landing site and the trip back across the water.

By the penultimate round, cries of "take him out!" and "he's gone!" echoed from the sheltered wood. The judges had to hold back some of Bell's advancing supporters so they could verify the knockout. After twenty-four knock-down-drag-out rounds, Bell was no longer able to stand. Yankee Sullivan, the pride of the fighting Irish of New York's Five Points, was declared the winner of the fight to the screams and deafening cheers of his acolytes and admirers.

They were going home now.

The Collect Pond

Many of those cheering in the background came from Five Points, where Anthony, Cross, Orange, Little Cross Streets and Paradise Square converged. This was one of New York's poorest and most dangerous areas. The neighborhood produced infamous Irish gangs of the late nineteenth century. Their colorful, even cute, names belied their brutal tendencies and deeds. The Dead Rabbits, Roach Guards, Bowery Boys, Plug Uglies and the Five Points Gang all crossed paths with damaging results and often fatal clashes.

By the late 1820s and early 1830s, Five Points was already considered a slum where poor immigrants and African Americans lived and toiled amid filthy tenements and converted industrial dwellings. Settling near the old Collect Pond, they constituted the poorest, most outcast souls of the country.

The Collect Pond was New York City's main source of freshwater until companies set up shop on its shores and began dumping toxic waste and runoff into the water. By the late eighteenth century, the tanneries,

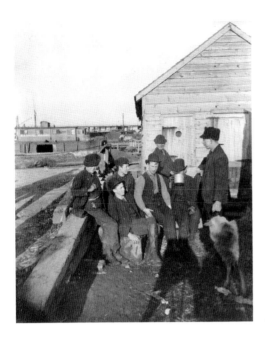

During the early nineteenth century, street gangs in Five Points were primarily of Irish ancestry. This remarkable photograph depicts the Montgomery Guards. *Courtesy of Associated Newspapers Limited.*

breweries, slaughterhouses and machine shops had so polluted the pond that it became a breeding ground for disease. In 1805, the city dug a canal that was meant to drain the water from Collect Pond into the Hudson and East Rivers. This proved to be nothing more than a shallow ditch. It, too, began to emit the same putrid stench as its original body of water.

In 1811, city officials elected to raze bucolic Bunker Hill and use its earth to fill in the troublesome pond and create additional housing. Marketing new ventures requires some ingenuity and creativity, so this new housing option was named Paradise Square.

Unfortunately, Paradise began to sink because the land never fully settled. In short order, the site became a mosquito-infested marsh that continually flooded and began to smell. Any remaining wealthy residents left their houses in the 1820s, leaving only those who could afford what had become low-cost housing, as tenants.

By the 1830s, the surrounding neighborhoods had settled into Five Points, which was populated by an ethnic mixture of English and Scots-Irish following the potato famine. It was also one of the first places passengers fresh off "coffin ships" settled, forming their own gangs like Monk Eastman's infamous Coin Collectors. Five Points's fearful and criminal reputation was known worldwide. One of its old, run-down taverns, the Old Brewery, reported a murder a night at the peak of violent outbreaks in the city.

Charles Dickens visited Five Points in 1842 and came away with very descriptive impressions. He noted:

> So far, nearly every house is a low tavern; and on the barroom walls are colored prints of Washington, and Queen Victoria of England, and the American eagle. Among the pigeon-holes that hold the bottles are pieces of plate glass and colored paper, for there is, in some sort, a taste for decoration even here. And, as seamen frequent these haunts, there are maritime pictures by the dozen: of partings between sailors and their lady loves, portraits of William of the ballad, and his Black-Eyed Susan; of Will Watch, the Bold Smuggler; of Paul Jones the Pirate, and the like: on which the painted eyes of Queen Victoria, and of Washington to boot, rest in as strange companionship as on most of the scenes that are enacted in their wondering presence.[104]

As he got deeper into the neighborhood, Dickens continued:

> What place is this, to which the squalid street conducts us. A kind of square of leprous houses, some of which are attainable only by crazy wooden stairs. What lies beyond this tottering flight of steps that creak beneath our tread? —A miserable room, lighted by one dim candle, and destitute of all comfort, saves that which may be hidden in a wretched bed. Beside it sits a man: his elbows on his knees: his forehead hidden in his hands. "What ails that man?" asks the foremost officer. "Fever," he sullenly replies, without looking up. Conceive the fancies of a fevered brain in such a place as this![105]

COFFIN SHIPS

By 1851, the Potato Famine had been ravaging Ireland for six years, and one million people had died from starvation or disease. By 1855, two million men and women had fled Ireland—some to nearby England and Scotland, others to far-off Australia, many to distant Canada but most to the United States—particularly to New York City.

At Irish ports like Sligo, Cork, Dublin and Limerick, teeming throngs of men, women and children gathered at the docks to board what would soon be called "Coffin Ships" for their harrowing transatlantic voyage.

These ships earned their names because of the terrible living conditions:

Lasting up to six weeks, the Atlantic crossing was a terrible trial for those brave, or desperate, enough to attempt it. Packed cheek by jowl below decks, the steerage passengers barely saw the light of day. Allowed up on deck for no more than one hour a day, in small groups, they would gather around open stoves to cook. When their time was up, it was back down into the dark, dank hold. During the regular storms the hatches were battened down, and the passengers would subsist on hard-tack biscuits. Hygiene was notoriously poor aboard most ships. With nothing more than buckets for toilets, and only sea-water to wash with, disease was rampant. Cholera and Typhus accounted for a great many deaths. Those who died were buried at sea.[106]

Often, one-third of the passengers on board would perish before setting foot on dry land.

When ships finally reached their ports, such as New York, the passengers were penniless and often illiterate. The families that made it to the city faced an even greater challenge than the boats: making ends meet in a nation

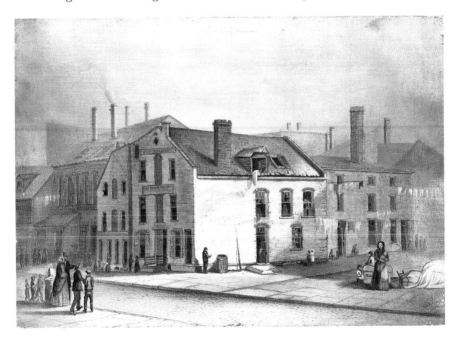

The Coulthard Brewery was built in 1792 in Lower Manhattan. In 1837, it was converted to residential space and was known as the Old Brewery. It soon became a lawless, overcrowded, filthy, disease-ridden building. *Courtesy of New York Public Library.*

that was still largely intolerant of foreigners. This pervasive class distinction forced newcomers to reside in barely livable tenement buildings with appalling, unsanitary conditions and rising crime. As for work, opportunities were either nonexistent or short-lived, which made paying rent extremely difficult. Indeed, it sometimes seemed that life in the Old World may have been the better choice.

Desperate Irishmen stuck together in this socially unwelcoming dynamic. They formed small, but growing, groups that were proud of their heritage. In Manhattan's Five Points there was a constant lifestyle that seemed to survive. Street gangs, petty crime and thuggery beckoned like devils on the shoulders of these men.

THE GANGS OF NEW YORK

Like a mammoth cauldron of thick Irish stew, Five Points would constantly bubble up and boil over with racial and ethnic conflict, contributing to a pitifully low standard of living. Job opportunities were few; drinking and gambling were rampant; and a host of illegal rackets and a plethora of prostitutes painted a seedy portrait of the city in the days leading up to the Civil War.

These early New Yorkers were the stuff of local legend. For nearly one hundred years, they were the ruling gangs of New York—either controlling parts of Manhattan or vying for control of their respective blocks. These entities were authentically immortalized in Martin Scorsese's film *Gangs of New York*.

In one especially pitched fight on July 4, 1857, nearly one thousand members of the native Bowery Boys and the new Irish Dead Rabbits brawled on the streets, ruthlessly beating and stabbing each other, then looting each other's homes in the bloody aftermath. Eight died and more than one hundred were seriously wounded. What began as a turf battle on Independence Day surged into a full-scale gang war that lasted two more days. Terrified by the violence just beyond their thresholds and broken windows, Five Points residents barricaded themselves in their shanties and tenements. Street carts lay overturned, shops were vandalized and pedestrians unfortunate enough to cross paths with the young, mostly drunk, hooligans were likely to get a knock or two on the head for good measure.

Metropolitan and municipal police units were dispatched to quell the riot. After battling their way through the throngs of hoodlums, police found themselves arguing over exactly who to arrest, and they turned on each other. While city officials and police officers sworn to "keep the peace" were beating each other over the head with batons, bystanders concluded that their behavior was not much different than the acts of the gangs they had come to arrest. On that ghastly Fourth of July, Five Points was completely lawless in every sense of the word.

John Morrissey, an Irish American boxer who would later go on to become a U.S. congressman, led the Dead Rabbits. Its members were mostly Irish Catholic refugees, who fled the potato blight that had so devastated their homeland. Like the young thieves of *Oliver Twist*, the often-drunken Irishmen roamed the streets of Five Points looking for trouble by robbing, pick-pocketing and street fighting. Diametrically opposed to the Dead Rabbits were the waspish Bowery Boys, who were considered to be the landed gentry of New York. Most were descended from Englishmen and Scotsmen who had arrived a few generations before. They represented a strong anti-immigrant, anti-Catholic contingent of Five Points.

Established, well-to-do tradesmen, mechanics, smiths and shopkeepers, they were threatened by anyone who seemed to encroach on their traditional values. And they hated the Irish with a passion. They were controlled by Bill "The Butcher" Poole and portrayed themselves as English gentlemen passionately defending what they interpreted as "true American" values. They used their version of rules to back up their non-allegiance to a foreign pope and maintained a racially intolerant ethos that precluded even other white, "non-native" immigrants from joining their gang.

Focused largely on political gerrymandering, voter intimidation and the coercion of local city officials to defend their vision of the United States, this group represented an old guard. Their conservative leanings would be exhibited in kickbacks, favors and the occasional bailout from sympathizers downtown.

One historian observed, "Regaining City Hall through ballot box stuffing and terror seemed entirely possible. Seen in this light, Bill the Butcher was a pioneer in using street fighters to dominate a nominally democratic society. Two generations later, the same idea would occur to Benito Mussolini."[107]

Both sides—regardless of their intended moralizing, professed defense of nativist values, Irish pride or even the Catholic Church—were anchored by men whose criminal leanings, bouts of wanton violence and mayhem, belied their sacred codes and brotherly commitments. In 1855, Morrissey would fatally shoot Poole in Stanwix Hall, a local pub.

The Draft Riots of 1863

The American Civil War erupted in 1860 with one focus in mind: the question of the continuation of slavery. This issue loomed large in places like Five Points and the Bowery, where racial tensions were heightened. In the mid-nineteenth century, many African Americans in Manhattan were the human property of various shopkeepers and farmers, wealthy businessmen and elected city officials. Nearly everyone was aware of the moral stew that bubbled around them and were at odds with both nativists, like the Bowery Boys, and fledgling Irish and German immigrants, many of whom had never seen black folks before.

A historian described the time by saying, "From the time of Lincoln's election in 1860, the Democratic Party had warned New York's Irish and German residents to prepare for the emancipation of slaves and the resultant labor competition when southern blacks would supposedly flee north. To these New Yorkers, the Emancipation Proclamation was confirmation of their worst fears."[108] Enacted in 1862, when final victory for the Union was not at all assured, it proved one of the most divisive pieces of legislation in United States history.

By March 1863, the death toll reached between 618,000 and 750,000, and a historian noted:

Fuel was added to the fire in the form of a stricter federal draft law. All male citizens between twenty and thirty-five and all unmarried men between thirty-five and forty-five years of age were subject to military duty. The federal government entered all eligible men into a lottery. Those who could afford to hire a substitute or pay the government three hundred dollars might avoid enlistment. Blacks, who were not considered citizens, were exempt from the draft.[109]

Tensions reached a boiling point by the summer of 1863, and on a muggy July morning, New York's worst race riot unfolded in a maelstrom of confusion, chaos and bloody violence.

After a federal marshal oversaw the pulling of fifteen hundred randomized draft cards from a rotating steel drum in the middle of a street in Five Points, members of local Irish gangs peeked their heads out of windows, gathered on their doorsteps and loosely formed mobs that descended on the police cordon.

They maintained that life was hard enough without newly emancipated black people competing for their jobs. These myopic, embittered youths

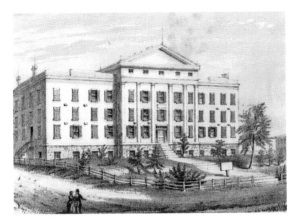

The Colored Orphan Asylum was an orphanage from 1836 to 1946. It was the first institution of its kind in the United States to take in black children. During the Draft Riots of 1863, which became the largest civic and racially charged insurrection in United States history, aside from the Civil War, the orphanage was burned to the ground. Remarkably, no children died. *Courtesy of Bloomingdale Historical Society.*

decided that going off to fight a war against slavery, only to return to the unfulfilling lives they knew before, was the last thing they were going to allow.

A police superintendent was attacked as he tried to stave off destruction of the voting and raffle equipment. Then, telegraph lines were cut. Police fired back on rioters with blanks and flash balls, driving the ruffians back into their filthy holes and dark alleys, like fleeing rats. But they would spring up on side streets and rooftops and fight back from those vantage points.

The *Washington Post* recalled in a retrospective article:

> *In the next few hours, the mob, estimated at 5,000 or more, split into smaller groups, attacking stores and plundering them before setting them on fire. Then they gathered outside the Colored Orphan Asylum at 43rd Street and Fifth Avenue, a residence and school for orphaned black children. The institution was founded by white women about 30 years earlier, and about 200 children were living there. With the mob at the front doors, teachers led the children to safety out the back and took refuge at a local police station. One small girl was left behind and was killed when she was found hiding under her bed. Men and women roamed the place stealing what they could before setting it afire. Outside, men gouged out the bark of large shade trees and ripped out bushes. Others tore down an iron fence. It was as though they were trying to erase any trace of the orphanage.*[110]

Black men were brutally assaulted on the streets, and many were lynched by mobs of angry Irish men and women. Indeed, "accounts of the day say it was Irish women who were the most brutal in these attacks, cutting off fingers and toes as souvenirs or stabbing the men in every part of their bodies. When a man was hanged, they often also set him on fire."[111]

While racial hatred played a dominant role in the Draft Riots of 1863, rich, white natives in their beautiful homes and manicured gardens were not spared. The fury of Five Points was unleashed on everything from wealthy homeowners' expensive chandeliers, pianos and armoires to neighborhood storefronts, police stations, communications lines and Freedmen's Aid Societies.

After four days of hell in Five Points, the riot was quelled by the police and the Seventh Regiment of the New York Militia, which was recalled from Gettysburg to defend its city.

HART ISLAND:
IN THE AFTERMATH OF THE MIGHTY MATCH

Things had quieted down, and uninhabited Hart Island would lie dormant for years after its brief stint in the limelight. The boys from Five Points were back in bed or the drunk tank or nursing hangovers the next morning, desperately trying to ignore familiar cries of hungry children and pleading wives.

In 1864, human activity would resume on Hart Island when it became a training ground for African American soldiers fighting for the Union in the final years of the Civil War. An open-air prison was constructed for 3,413 Confederate soldiers captured on the battlefield. Of these, 235 died from chronic diarrhea and pneumonia—debilitating illnesses that were exacerbated by stark, inhospitable living conditions.

Three years later, New York's Department of Charities and Correction purchased the island from its owners, the Hunt family of New York, and repurposed parts of it as a workhouse for older boys who were transferred from the House of Refuge on Randall's Island. After the camp was established, Hart Island established its infamous legacy as the official, city-designated burial site for its unclaimed and unidentified deceased. Bodies from the new city morgue at Bellevue Hospital trickled in. Prison inmates from Blackwell's Island Penitentiary crossed the channel by ferry with bodies on board. They would perform the task of burying them. These mass burials began in 1875.

One can fathom just how many of those cheering on Billy Bell and Yankee Sullivan lie buried beneath the rough dirt in this sprawling potter's field. Maybe even the suspiciously unnamed author of *The Life and Battles of*

Yankee Sullivan laid beneath the celebrated site of the match. How many of their relatives and friends killed in the violent episodes of Five Points, joined them? The actual number would probably astound us.

With an estimated one million people buried on Hart Island, will we ever know?

BOBBY DRISCOLL

Wendy: Peter, how old are you?
Peter: I don't know, but I am quite young, Wendy. I ran away the
* day I was born.*
Wendy: What!
Peter: It was because I heard Mother and Father talking about what
* I was to be when I became a man. I don't ever want to be a man.*
* I want always to be a little boy and to have fun.*
Wendy: But Peter, just think of all the wonderful things you'll miss:
* having a family, a career, becoming rich and—*
Peter: No, Wendy. Listen. What happens when you are grown up?
* What happens when you are tall? Shadows can no longer be sewn*
* up, and your childhood things are too small.*
I'm sure adult life is a bore. Becoming thirteen is no joy, so instead of
* school and then "studying law" I decided to stay as a boy.*
* —J.M. Barrie,* Peter Pan

Bobby Driscoll—the clean-cut child star with an impish, upturned nose and beguiling expression—was handpicked for an acting career by Walt Disney himself. Of all the roles he played, Peter Pan seemed most like his alter ego. He grew up and worked in Hollywood, but it might as well have been Neverland. His is a story of success in a make-believe world—a world he could never leave behind.

Hollywood would be his downfall.

Bobby Driscoll (March 3, 1937–March 30, 1968) was a child actor who starred in some of Disney Studios' most popular live-action films. Later in life, he became a heroin addict. His body was discovered in an abandoned tenement building. He died from a drug overdose and was buried on Hart Island in an anonymous grave. *Courtesy of True Classic.net.*

So, whatever happened to him? This was, and still may be, a common question among movie buffs, particularly Disney film followers, and definitely those interested in "important" people buried on Hart Island.

Important or not, the common denominator for all interred in New York City's official potter's field on Hart Island is mass anonymity, total detachment and a dark loneliness. When we learn that certain individuals who lived unique, colorful lives are buried on Hart Island, their life stories loom in sharp contrast to their death stories, which seem to attract greater interest and curiosity. Chalk it up to human nature. This perception makes their careers and accomplishments *almost* as interesting as how and why their bodies ended up in one of the bleakest places on earth.

This was Bobby Driscoll's fate. His rise to fame was unbridled. His descent, however, was slow and agonizing.

In 1968, Driscoll's dead body was found by two boys who were exploring the ruins of an abandoned tenement in Greenwich Village. Two empty beer bottles and a variety of religious pamphlets were strewn about the floor and the rickety cot supporting the deceased thirty-one-year-old. He was without money and identification. Like any unknown homeless person or drifter, his body was transported to the Office of Chief Medical Examiner. The cause of death was reported as hardening of the arteries, which is common in heroin users, and/or heart failure due to prolonged drug abuse.

His body was transported for burial to the city's official pauper's gravesite on Hart Island.

> *How a body becomes unwanted*
> *Yet everywhere touched...*
> *Becomes unwanted and works a hoe*
> *With steady pulse it is unwanted*
> *A cargo of bodies crosses*
> *The Long Island Sound*
> *(Stacy Syzmaszek, "Hart Island")*

UNCLE WALT

In 1943, the powerful Walt Disney Company recognized Bobby Driscoll's youthful qualities as pleasantly marketable and quickly cashed in on them. The plight of child stars like Bobby wasn't all sugar and "aw' shucks, Mr. Disney," who was called Uncle Walt by his young actors.

There was a pervading atmosphere of discipline, expectation and pressure on Disney's movie sets. In an interview, Bobby's mother, Isabelle Kretz Driscoll, commented:

> *He was so well supervised by Disney. People weren't even allowed to use swear words in front of him. He had a great deal of love for Walt Disney. And, he always did whatever the director told him to do. He was in this movie with Sonny Tufts* [Miss Susie Slagle's]. *He couldn't have been more than seven and they stood him on a box for some reason. Well, he fell and caught his foot and wound up hanging there, upside down, crying his eyes out without making a sound. Because the director had told him that "noise costs money.*[112]

In fact, when talking about Bobby's talent, Walt Disney was less than complimentary. He said, "Anybody who can make an actor out of Bobby Driscoll has got to be a great director." Richard Fleishcher was that director. "All of us laughed," he noted in his autobiography, *Just Tell Me When to Cry*. Disney hired Fleischer to direct *20,000 Leagues Under the Sea* specifically because of his successful direction of Bobby in *The Happy Time*.

Driscoll's first film was *Lost Angel* with Margaret O'Brien in 1943. Suddenly, everyone wanted the little actor in their movies. He appeared in *The Sullivans*, directed by Lloyd Bacon; *From This Day Forward, So Goes My Love*, with Myrna Loy and Don Ameche; and *O.S.S.* with Alan Ladd, all *before* Disney signed him. Bobby was the very first actor Disney put under contract after the Second World War.

His first Disney film, *Song of the South* (1946), really jump-started his illustrious film career. In this sprawling tale, Driscoll played Johnny, a sensitive boy who reacts to his parents' separation as the Civil War begins. For the next five years, Driscoll was Disney's resident child star. He went on to appear in *Treasure Island* and was the physical model and voice of Peter and a host of others in Disney's *Peter Pan*.

In 1950, he was the recipient of the first Juvenile Academy Award for his performances in two films: Disney's *So Dear to My Heart*, in which he played

a boy who wanted to raise a black sheep for the fair, and RKO studio's *The Window*, for his role as a youngster who witnesses a murder. Bobby was twelve years old at the time.

At one point in his career, Bobby was making $50,000 a year, yet he was only able to collect twenty-five cents a week. He couldn't touch the money he made and was not allowed to read fan mail. These stipulations were most likely parts of a contractual agreement but were limiting and controlling, nonetheless.

These kinds of restrictions were echoed in his devout Baptist background. Bobby's uncle was a Baptist minister and his aunt was a medical missionary in South America, where she was killed by locals. The drama of his religious upbringing was authentic and impactful. It wasn't preparation for a fictitious role. The strict lessons were real and lingering.

COMING OF AGE

I have found that memories are not very useful. I was carried on a silver platter and then dumped in the garbage can.

—*Bobby Driscoll*[113]

Walt Disney had made quite a career for himself as well. He was immersed in the production of cartoon animation film. The medium, however, was becoming more expensive due to the amount of time and labor it took to produce these films. The cost of this business nudged Disney into another popular playing field: the realm of live-action films. In these, he would use his talented child actors in profitable ways.

As Bobby got older, he perceived his diminishing movie roles with Disney as abandonment by one of the most prolific film studios in Hollywood. Some actually believed it was severe teenage acne that limited his winning camera close ups. Like all adolescents, the glow of childhood began to fade, and the markers of maturity appeared.

His last big-screen appearance was in *The Party Crashers* with Frances Farmer in 1958. By the 1960s, his career consisted of bit-parts in films, random television work and guest spots. When work became scarce, he turned to doing odd jobs. During this time, Bobby began experimenting with drugs. The little child star who said, "I'm going to save my money, go to college then become a G-Man,"[114] was a heroin addict by age seventeen.

Bobby Driscoll, shown here with Kathryn Beaumont, shooting reference material for Disney's 1953 animated film, *Peter Pan*. *Courtesy of Tinting History.*

In 1956, he married Marilyn Jean Rush, and they had three children. He had several arrests and drug charges, and in 1965, he served a prison term in California's Chino State Penitentiary. After his release, he tried to establish himself as an avant-garde artist with Andy Warhol's group, the Factory. During this time, he appeared in Warhol's film *Dirt*.

His comments to a reporter at the time seemed to confirm his sense of rejection. He said, "I really feared people. I tried desperately to be one of the gang. When they rejected me, I fought back, became belligerent and cocky and was afraid all the time."[115]

His mother was shocked to hear this. She responded to this interview stating:

> *I can't believe he said that. He never showed any fear of people. Before he went on narcotics he almost never cried. Afterward he was crying all the time. Drugs changed him. That's when he became belligerent. Then he didn't care about his appearance or cleanliness, he didn't bathe, his teeth got loose. He had an extremely high IQ, but the narcotics affected his brain.*

We didn't know what it was. He was 19 before we knew. I felt he was changing but his father said no, it was just a phase he was going through like most boys.[116]

He left the Factory sometime between 1967 and 1968 and then completely dropped out of sight. Who, or what, was he afraid of?

Maybe it was the Bobby he didn't know.

The change wasn't only the absence of substantial movie roles, fewer adoring fans, waning critical praise or the appearance of pimples. It was something about Bobby himself. Something was sorely missing—something that couldn't be replaced—that precipitated his departure and disconnect from stardom, which was the only real lifestyle he had ever known.

Bobby had been groomed at an early age to become the consummate actor—an expert in artifice. He was lost without studio life, the make-believe quality, the adulation and the artistic purpose. He became someone else on film. He knew his characters intimately, but when it came to self-knowledge, Bobby was unschooled, unrehearsed and totally unprepared for real life after Disney. He couldn't fill the void. He didn't know how.

A PRINCE IN A PAUPER'S GRAVE

You know that place between sleep and wake,
The place where you can still remember dreaming?
That's where I'll always love you.
That's where I'll be waiting.

—*J.M. Barrie,* Peter Pan

For years after her son disappeared from her life, Isabelle Driscoll searched relentlessly. Finally, she got the help she needed from the Walt Disney Company and the FBI. In 1969—nineteen months after his death—his identity was confirmed through fingerprints taken by the New York City Police at the time of his death.

In 1972, his death was revealed to the public when *Song of the South* was re-released in movie theaters. Although his name appears on his father's gravestone at Eternal Hills Memorial Park in Oceanside, California, it is a cenotaph (an empty tomb in honor of one whose remains are elsewhere) because Bobby's remains still rest on Hart Island.

But *listen*.
Listen very hard.
Can you hear it?
Yes! There it is!

You wouldn't expect it, but every now and then when the late March sun begins to fade and a rustling of brittle leaves gather at a particular earthy spot, a faint melody might be heard, then the singular giggle of a little boy with an eternal message:

I'll never grow up, never grow up, never grow up
Not me
Not I.

BELLEVUE

Few hospitals in the United States can claim as storied a history as Bellevue Hospital in Manhattan. Founded in 1736, the institution lies tucked away on a verdant plot of land near a slow-flowing tributary where city hall now stands. Its austere main entrance is imposing with its legendary name boldly embossed on the plaque hanging above the rusty wrought iron gate. Its unassuming red brick buildings sit just beyond a tidy courtyard, comprising one of the most preeminent public medical facilities in the country.

Throughout its history, Bellevue has been a pioneering force fighting the city's worst plagues and crises. For nearly three hundred years, it has provided a fascinating window into changing medical ethics and the treatment of low-income and mentally ill patients. Its rich, troubling history also includes harsh criticism for some of its unscrupulous practices.

As one critic noted:

> *Take a stroll, if you dare, through the bowels of Bellevue, New York City's flagship public hospital. You might mingle with prisoners in orange jumpsuits and handcuffs; some may spit or curse at you. Ride the elevator down, and you will look in horror as an agitated drug addict with an infection tries to punch a physician while bolting out of his hospital room with security guards and nurses in pursuit. Next door, a homeless patient lies in bed with heart failure. Next to him is a patient who's visiting New York from Africa with a raging AIDS infection. Peer into another room down the hall, and you can watch patients withdrawing from alcohol or heroin, thrashing about and screaming.*[117]

EARLY HISTORY

While Bellevue is generally recognized as the oldest hospital in America, it technically is not. According to one researcher, "Master Jacob Hendrickszen Varrevanger, surgeon to the Dutch West India Company, is credited with establishing a small hospital to serve the 1,000 inhabitants of New Amsterdam in 1658. It still existed in 1680, but subsequent records of the English Common Council deal more with the need for a poorhouse and workhouse."[118]

The history of what became Bellevue Hospital began in 1735, when begrudging colonists still paid taxes to the King of England in the decades leading up to the American Revolution.

Bellevue's building was initially an almshouse and was christened the "Publick Workhouse and House of Correction." With an annual budget of 80 pounds and fifty gallons of rum, the new quarters included a common room on an upper floor measuring about twenty-five by twenty-three feet. This space served as an infirmary with just six beds to accommodate the alarming number of drifters who walked the streets of New York. The building was ready for occupancy early in 1736.

John Van Beuren, MD, was appointed chief medical doctor and was tasked with procuring all medications and tinctures. Ancillary activities on the grounds of the Publick Workhouse focused on practical skill development. Onsite workers offered classes in sewing, knitting, weaving,

Bellevue Hospital was founded on March 31, 1736, and is the oldest public hospital in the United States. Its morgue became the gateway to Hart Island because all autopsies conducted in New York City during the nineteenth century were performed there. *Courtesy of NYC Health and Hospitals.*

leatherwork and ironwork. Residents were able to get much-needed sunlight and physical exercise by providing manual labor on the farm grounds nearby.

Slowly but surely, additional structures were added to the main facility. Bellevue eventually deemed itself a "pest house," adding the properties of Belle Vue Farms to its domain after a yellow fever outbreak struck the waterfront farms and other residential areas.

In an age when medical knowledge was extremely limited, victims of daunting and deadly diseases were routinely treated at Bellevue. Virulent episodes of smallpox, Asiatic cholera, typhus and puerperal fever (associated with childbirth) were all too common.

The hospital had its own cemetery, where staff continually performed burial duties. Many doctors died from early contact with stricken patients, qualifying Bellevue as a hazardous facility in the mainstream medical community. Yet, it persevered. A reporter noted, "As a public hospital, funded entirely by government money, Bellevue's founding mission was to provide accessible care to every patient who crossed its threshold, whether or not they could pay. This challenge produced an institutional culture that rewarded creative thinking."[119]

Bellevue has left an enduring symbol on the consciousness of America while leading the way—for better or worse—in experimental medical procedures, innovative solutions to public health and, most importantly, as a conduit for the unclaimed dead in the Hart Island saga.

AMBULANCES

The horse-drawn carriage barreled down the cobblestone roads, its driver and attendant banging a small metal gong to ward off collisions with passersby and children playing in the busy waterfront streets. The rickety carriage was hastily covered with a shoddy tarp to protect, or hide, its passengers inside.

Beneath the tarp, men writhed in pain as the ride tossed them around the interior of the coach. They were being transported from pivotal battles of the Civil War. Uniformed corpsmen shared brandy with the wounded men. The alcohol was not plentiful and only partially masked the agony of their shattered limbs. Their brutal bayonet and musket injuries were crude mementos from the carnage at Antietam and Gettysburg.

Horse-drawn carriages became the first ambulances of Bellevue Hospital. *Courtesy of NYC Health and Hospitals.*

The anxious coach driver focused on the dangerously narrow road, keeping up a steady pace until the unmistakable high spires near the dock came into view. The surgeon on board tried to console the Union soldiers with kind words, knowing full well that life as amputees would not be easy. Wooden pegs and inferior prosthetics were the best they could hope for in peacetime.

Finally, the driver slowed the carriage ever so slightly for a safe approach. They had mercifully arrived at Bellevue.

Such was the onset of the nation's first legitimate ambulance service. From 1869 onward, this method of transport from stateside theaters of combat to Manhattan successfully rushed the wounded to the hospital's triage location. Thousands of bloody and poorly bandaged men passed through a medical checkpoint and were swiftly assigned care that would hopefully increase their chances of survival.

Battlefield injuries were exacerbated by gangrene and vile infections from the use of improperly sterilized surgery kits. In many cases death was a certainty. Each carriage could transport eight patients at a time. If one were fortunate enough to be among the eight, a glimmer of hope existed.

This rudimentary method of delivering patients to Bellevue worked so well that the New York City superintendent implanted the system for civilians in 1869. In this system, "A telegraph connected the hospital with local police precincts, and when a car was needed the stations alerted Bellevue by sounding a gong. The program was an unequivocal success."[120]

It wasn't until 1924 that horse-drawn carriages were replaced by motorized ambulances.

The Bellevue Morgue and Hart Island

How, exactly, did bodies end up at Hart Island? Well, their first stop was Bellevue Hospital's morgue. By the nineteenth century, the Bellevue morgue had become the official repository of recently deceased New Yorkers. As one researcher explains, "The hospital always had a morgue—its mortality rate, after all, was quite high in the 1830s—but in 1866, it expanded to become New York City's first city morgue. Bodies had to be buried after a few days, but for identification and forensic purposes, clothing and other personal articles were kept on display for a month then put into storage."[121]

If a homeless person passed away in any of the city's five boroughs, the city's medical examiner would apply to the Board of Health for a burial permit. Identifying the majority of the people in this category, however, was a tedious task that never guaranteed the discovery of helpful information.

Since Bellevue's morgue had become the first official city morgue, any unclaimed bodies—along with a burial permit for the deceased—were transferred to Bellevue Hospital on East Twenty-Ninth Street. The hospital's morgue quickly became the major processing hub for deceased, unknown New Yorkers. Unidentified bodies were fingerprinted and photographed for potential identification in later years, although many of these records have been lost to history.

If a body was not claimed by family or friends within twenty-four hours of notification by mail of the death, the New York City Department of Hospitals was legally authorized to allow burial at Hart Island.

Prior to transport and burial, cadavers in the Bellevue morgue were wrapped in shroud paper and sealed in pine coffins lined with waterproof paper. The morgue was thorough in processing the dead as "inside the coffins and on top of them are placed the duplicate and triplicate, respectively, of the burial certificate, chemically treated so that they are legible even after 25 years."[122]

The coffins were placed in a Department of Hospitals morgue wagon, which operated twice a week. They were delivered to the channel landing and the specific part of the pier operated by the New York City Department of Corrections on City Island in the Bronx. They were then unceremoniously

loaded onto a small, weather-beaten ferry and transported across a stretch of the Long Island Sound to Hart Island.

Inmates from New York's Rikers Island Prison have served as gravediggers since the inception of the potter's field because it is owned and operated by the city's Department of Corrections. This work detail is a much-desired assignment for many men incarcerated at Rikers. These coveted positions are said to go only to the best-behaved prisoners.

By 1969, Hart Island contained more than six hundred thousand unidentified bodies. Sadly, two-thirds of them were infants or stillborn children, according to Department of Corrections statistics.

Every twenty-five years—the approximate time allotted for complete human decomposition—the burial trenches were refilled with fresh bodies from the Bellevue morgue in new pine boxes—some large, some smaller and many no bigger than a shoe box. The perennial ritual began anew.

QUALITY OF CARE AND MEDICAL ADVANCES

Bellevue's history also includes its attraction for pioneering doctors to see patients in a clinical setting as opposed to home visits by local doctors. Medical historian David Ochinsky argues in a recent book on the history of Bellevue, "If you were sick in 1850, if you had any money at all, the doctor came to your house; you didn't go to the hospital. Hospitals were these really down-and-out kinds of places. But what made Bellevue different was that it was a down-and-out kind of place that had amazing physicians working there."[123]

One surprising example of bringing unconventional medical approaches to mainstream treatment occurred in 1870 by Lewis Sayre, MD. A five-year-old boy who could not walk without excruciating, throbbing pain was examined by a team of Bellevue doctors. They put him through a battery of comprehensive tests, which, at first, revealed unremarkable results. The doctors were left scratching their heads.

Upon further examination of the youngster, Dr. Sayre noticed that the boy's penile foreskin was so tight that it could be producing inordinate pressure on his lower torso and causing the debilitating pain. He believed this kind of constriction could trigger dysfunctions in the muscles and nerves in the thighs and legs, thus causing the boy's discomfort and his inability to walk. The doctor concluded that a particular surgical procedure could alleviate the boy's condition: circumcision.

Immediately after the surgery, the doctor's notes were hopeful:

From the very day of the operation, the child began to improve in his general health; slept quietly at night, improved in his appetite, and, although confined to the house all the time, yet at the end of three weeks he had recovered quite a rosy color in his cheeks, and was able to extend his limbs perfectly straight while lying upon his back. From this time he improved most rapidly, and in less than a fortnight was able to walk alone with his limbs quite straight.[124]

Dr. Sayre went on to attribute a number of medical maladies in male patients to the lack of circumcision. A researcher stated,

Sayre became convinced that circumcision, at the time an "obscure religious ritual," was the answer to a number of medical mysteries. Sayre believed that this particular surgery was a remedy to everything from epilepsy, to bladder disease, to lunacy. Although the results of his experiments were inconsistent at best, his evangelism on the subject almost single-handedly transformed views on circumcision in the US, taking it from unconventional to mainstream.[125]

Bellevue: Worth Noting

Despite its many achievements and pitfalls, by the mid-twentieth century Bellevue Hospital had made significant strides. In 1911, the hospital organized a mobile cardiac clinic. In 1917, Bellevue established an entire hospital wing dedicated to treating those with metabolic disorders. The first public school for emotionally disturbed children, PS 106, was opened in the hospital complex itself in 1935. During the early years of the Second World War, Bellevue became headquarters of the world's first medical catastrophe unit because some people believed a stateside attack by Axis forces was possible. In 1962, the city's first intensive care unit was opened; and in 1964, Bellevue was designated as the default hospital for treating visiting presidents, foreign dignitaries, wounded police officers and members of the United Nations.

Poet Sylvia Plath stayed at Bellevue after attempting to overdose on sleeping pills, as did Norman Mailer, who stabbed his wife in a rage.

John Lennon's assassin, Mark David Chapman, was a patient there, and Lennon's body was placed in the Bellevue morgue after his murder. In later years, Aerosmith lead singer Steven Tyler recovered from addiction in a sparsely furnished Bellevue room. David Foster Wallace, author of *Infinite Jest*, spent time in the same rehab surroundings, but later took his own life.

AIDS

Camille Caracappa, a twenty-three-year-old nurse at Bellevue Hospital in the mid-1980s, was unprepared for a strange new outbreak that seemed to affect young men. They generally complained of the same symptoms: vomiting, diarrhea, chronic fatigue, weight loss, cough and shortness of breath, fever, chills and sores or lesions above and below the skin surface.

Caracappa had seen them come in sudden waves, monitored their vital stats and asked her resident doctors which courses of treatment would best help them. They only gave her noncommittal answers, telling her to keep them comfortable and await test results.

In an interview on Bellevue's sixteenth floor she said, "In an instant, all I could feel was a wave of fear." On a wall behind her was a sign that said, "The Only Difference between This Place and the Titanic Is...They Had a Band!"[126]

There was a palpable sense of hopelessness among medical personnel that a horrible medical mystery was brewing. The mystery illness would have a name: acquired immunodeficiency syndrome, also known as AIDS. It is a disease that impairs the immune system by killing white blood cells, leaving the body unable to fight certain kinds of infections and cancers. In most cases, the prognosis was death.

Camille was one of a handful of nurses who had accidentally pricked their skin with needles used on these young men. While she never contracted the disease, she was terrified by her daily proximity to these young patients who were flooding the wards.

By 1985, almost 15,400 cases of AIDS had been reported in the United States—one-third of them in New York. Ronald B. Milch, the director of Bellevue Hospital, complained that the institution "receives $460 a day from the city for each patient, most of who have no hospital insurance. This is because the majority of AIDS patients at Bellevue are drug users who have come 'off the street' or from Rikers Island, or homosexuals who have exhausted what private hospital coverage they had."[127]

The AIDS outbreak cost Bellevue a staggering $900 a day to treat afflicted patients. This unexpected, draining figure posed a serious financial burden on the hospital. Nursing layoffs and financial shortcuts were put in place, but they limited and negatively impacted patient care. A total of at least seven hours of care each day were required by some AIDS patients. But Bellevue remained in the front line of hospital care through the 1980s. As the number of AIDS patients rose at Bellevue, so too did the number of deceased patients—more than at any other in New York.

SC-B1

Over a twenty-year period beginning in 1980, the bodies of more than fifteen hundred victims of AIDS were sent to Hart Island from Bellevue Hospital.

For all the reasons that burial on Hart Island is associated with the saddest kind of anonymity, the only marked gravestone on Hart Island lies deep in a wooded area. It was innocently discovered in the early 1990s by a curious visitor.

Near an insignificant mound of earth is a plain white gravestone. It is the grave of the first child in New York to die of AIDS (1985). The name and sex are unknown. The only identification etched into the stone is the Department of Corrections' code "SC-B1." It means "Special Child—Baby #1."

SHEILA TERRY

Did you ever wonder what kinds of individuals are more apt to commit suicide? If they are movie stars, does it have something to do with too much fame, not enough fame or something else?

What did life—or the absence of it—mean to actress Sheila Terry (1910–1957), who was a true Hollywood starlet of the 1930s before she ended her life by overdosing on sleeping pills? When did her ability or desire to go on cease?

She was found in her New York City apartment, which served as her home and office at the time. Jerry Keating, a neighbor and friend, went to her apartment when he failed to reach her by phone. The door was locked, and no one answered the doorbell. Keating called the police, and they broke into the apartment and found Terry's body on the bedroom floor, her back leaning against the bed. Five medicine capsules with the contents removed were on the floor beside her. Other friends told the police that Terry had returned home from a trip to Mexico a few days earlier and complained of feeling ill.

She had been married and divorced three times (Roy Sedley, 1922–24; Laurence Erastus Clark, 1928–34; and William Adam Magee Jr., 1936–37), yet without family or friends to intervene, she died alone and penniless—so alone that she was buried on Hart Island.

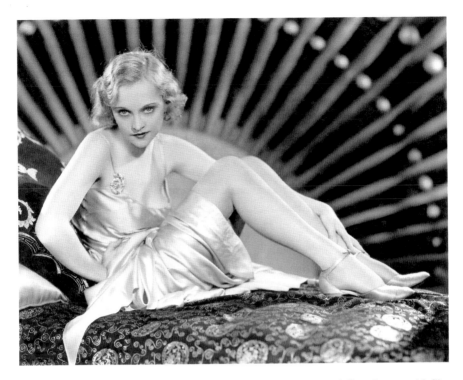

Shelia Terry (March 5, 1910–January 19, 1957) was the silver screen's first glamour girl. She was born Kay Clark in Warren, Minnesota. *Courtesy of Paradise Leased.*

WILL THE REAL SHEILA, SHY-LA OR SHELE PLEASE STAND UP

The actress, described as a "flashy blond," appeared as a lead or second lead in many of the forty-five movies she made within a decade. The most well known were *The Silk Express* (1933), *Bars of Hate* (1935) and *Go-Get-'Em, Haines* (1936). She also co-starred with a young, handsome John Wayne in three major films: *Haunted Gold* (1932), *The Lawless Frontier* (1934) and *'Neath the Arizona Skies* (1934).

Her credits with Warner Bros. included movies with Bette Davis, Louis Calhern and Spencer Tracy in *20,000 Years in Sing Sing* (1932) and with Cary Grant and Sylvia Sidney in *Madame Butterfly* (1932), directed by Marion Gering.

After studying drama at the Dickson-Kenwin Academy in Canada, she worked for a Toronto stock theater company, taking the name Sheila

Terry. In 1927, she secured the lead role in *The Little Racketeer* in New York. Encouraged by this success, Terry auditioned for a big Broadway role but did not get the part. The casting director for Warner Bros., Max Arnow, was sitting in at the audition and approached Terry, offering her a screen test, which would be sent to Hollywood for a decision. This obviously paid off.

However, she was soon summoned home to Minnesota to claim an inheritance from a rich uncle who specified that she would only receive the inheritance if she taught school for two years. Terry said of this time,

> *One of my very earliest desires was to go on the stage. But my folks had me trained to become a school teacher on the insistence of a rich uncle who was that way about education. I certainly do not regret the training, nor the later experience of teaching, for it gave me an understanding and appreciation of many things which I would otherwise have missed. Books and music—especially books—are my chief sources of enjoyment.*[128]

In 1929, when Terry was still teaching, the stock market crashed. Terry took action, "I had really decided to stick to teaching…but the stocks were wiped out and there were no dividends to bring my salary up to anything that a person could live on. I decided to take what I had saved and take another stab at being Sheila Terry."[129]

During this time, Hollywood reacted to something called the Dickstein Bill, which banned the importation of any performer other than exceptional foreign actors. At the same time, demands for more money by established American stars gained momentum, as did their desire to manage the films they would appear in.

Universal Studios capitalized on this development by training the most promising new actors for Hollywood stardom. Just sixty-three new talents were recruited. Sheila Terry was one of them, and she was in good company with a group that included Carole

Shelia Terry appeared in forty-five movies, including three with John Wayne. *Courtesy of moviepostershop.com.*

Lombard, Sylvia Sydney, Frederick March, Randolph Scott, Cary Grant and Spencer Tracy.

Around this time, Terry decided to pronounce her name as Shy-la Terry. Later, upon the advice of a fortune teller, she began calling herself Shele.

KEEPING BODY AND SOUL ALIVE

The stereotypical descriptions of actresses like Sheila Terry as a "flashy," "frowsy" or "vampy" blond, à la Carole Lombard (the highest-paid Hollywood actress in the 1930s), may have kept her employed but did not keep her in high demand.

New York reporter Mel Heimer wrote in his signature column, My New York:

> *When I met her, she was a press agent in New York....She was a nervous, taut woman but I liked her immediately....She never represented anyone worth writing about, really. Most of the time she worked for other press agents....She seldom got anything as surefire, journalistically, as a Marilyn Monroe or Marlon Brando to peddle to the newsmen. I don't know why. Maybe she wasn't pushy enough. Or unethical enough. Honest press agents don't grow on trees....Whatever her past, when I met her she was uncertain and, I guess, a little fearful of where she was going to end up....I could see behind her eyes a deep worry about whether she could keep body and soul alive. In all the years she was in New York, she kept bucking the rough water; the only thing that ever made her bitter was that television was using her old movies and she wasn't getting any money from them. A couple of days ago I picked up a newspaper and saw that Shele Terry had taken too many of the little pink pills and wouldn't awaken ever again. Chalk one up for the cold city.*[130]

MISERY LANE

The lens focused in, narrowing the aperture. The bustling city street went from a wide panorama of movement and commotion to a meticulously acute moment. The photographer waited for just the right moment; the right looks on the faces of the people he was keenly watching on the crowded tenement block. A stout man sporting a heavy mustache and a no-nonsense expression deftly pressed the shutter and took his snapshot without realizing he was making history. Meanwhile, the masses looked on nonchalantly, more concerned with how they were going to eat that night or if they had enough money to keep the lights on. Their stomping ground—a stretch of block on East Twenty-Sixth Street between First Avenue and the East River—was aptly named Misery Lane. It was a place where no one wanted to end up. The area was filled with wobbly push carts, odorous beggars, homeless people, skinny stray dogs and all the tumult of a largely immigrant community. Late-nineteenth-century New York City seemed more like a shabby bazaar than the sophisticated bastion of international culture, exorbitant real estate prices and singular prominence it would later acquire.

JACOB RIIS: IN THE BLINK OF AN EYE

Jacob Riis (1849–1914) was a Danish-born immigrant from a working-class family who moved to New York in 1870 at the age of twenty-one. Like many Europeans who sought better lives in these bustling industrial times following

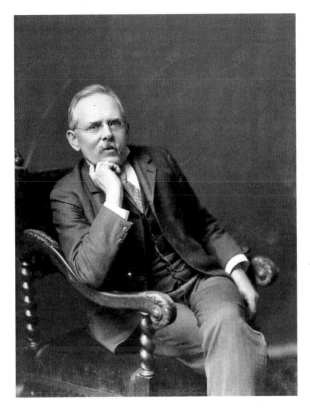

Jacob Riis (May 3, 1849–May 26, 1914) was a Danish American social reformer and photojournalist whose book, *How the Other Half Lives*, was instrumental in revealing the living conditions of the poor in nineteenth-century New York City. *Courtesy of Library of Congress.*

the Civil War, Riis was hopeful that a cosmopolitan city like New York would provide upward social mobility. Much of Europe was still restricted by rigid class structures that prevented enterprising individuals from exploring creative ways to make a living. But America loomed across the Atlantic—its promising shores drew millions in these dynamic years.

The harsh reality of the streets quickly dimmed Riis's hopes. His optimistic vision of the New World rapidly turned into a longing to return to Europe. He had been in America for a few days and had already spent his last five dollars from his transatlantic voyage. He was at rock bottom, and he had just begun.

He took some odd jobs—first as a carpenter then as a miner—and continued to struggle with the reality confronting him: so many had so little despite the towering high rises, the ostensible affluence and the incredible technological advances of the age. Telegraphic communication was possible, the internal combustion engine was being tested and steam power was ushering in a whole new approach to travel. For average people, though, life went on.

This was the time of towering personalities whose critiques of material progress would later transform the ways people thought of capitalist societies. Karl Marx, for one, was shocked at how rapidly society was changing. Of course, Marx never had a real job or starved, but like Riis, he struck a nerve despite his flawed vision of a worldwide working-class revolt.

In many ways, it was these unsung working poor who, decades later, took action by forming some of the strongest unions and driving city and federal officials to reduce barbarous working conditions and create a minimum wage. Riis was not only from their circles, but he became one of their supreme champions. He couldn't have foreseen his effect in these early dark days of his arrival. He was a harsh critic of the U.S. economic system, particularly as it operated in major industrial areas like New York City. As he stressed,

> *The trouble with New York, the trouble with practically all of the cities of our land, of which it is the type, is that all, alas, we who live there have thought of them in terms of money, never of men. And as we sowed, so have we reaped. Great markets, great money centers, our cities have become little else. Even the amusements that are there are just a way of making money, or of spending it. Naturally, their politics have fallen under the same head.* [131]

A PERSONAL INVESTIGATION FROM THE INSIDE OUT

After getting expelled from a number of local shelters and finally begging a Catholic priest for food, a young Jacob tried and failed to enlist in the French army at the consulate. Prussia had just declared war against France, and he anticipated his native Denmark would soon be swept up in the struggle. He was rejected and thrown out. After coming back from the depths of despair and thoughts of suicide, Jacob finally caught a break when he was hired as a low-level police reporter and assigned to the Lower East Side. It was here, using the newly invented flashbulb photographic camera, which commercially debuted in 1887, that Riis would begin his own independent investigation into the conditions of New York's indigent tenement denizens— the underbelly of the sleek veneer of capitalism in full swing.

He and three photographer friends started to photograph the slums of New York City, and three years later he published *How the Other*

Half Lives: Studies Among the Tenements of New York. It contained more than a hundred photographs. He would also become the editor of the *New York Tribune*, a position that solidified his searing critiques of the class warfare of his age and helped him perfect his technique. A reporter stated, "His earliest photographs were posed to approximate reality or starkly caught their subjects by surprise in the flash of magnesium powder and potassium chlorate. Later, he coaxed people to appear more natural as he interviewed them."[132]

Moved by the situation confronting him on the streets of his adopted nation while reporting for his crime bureau, his iconic photographs captured the imaginations of people the world over who had not known about the abject poverty plaguing New York City in the early stages of industrialization. In the 1880s and 1890s, wealth in the United States was concentrated in the upper strata of society, creating the infamous Gilded Age, which would later be harshly criticized by people like author Mark Twain, who coined the high-flying phrase. Spanning roughly from 1880 until just after the turn of the century, it set the backdrop against which the teeming masses of impoverished citizens fought and sometimes died for some sense of equality.

In late 1892, Riis visited eleven of the city's sixteen public waste disposal centers—five of which were reproduced as engravings in the *Evening Sun*. After taking his bearings and speaking to a few huddled and freezing family members, Riis wrote in his notebook, "I found boys who ought to have been at school, picking bones and sorting rags. They said that they slept there, and as the men did, why should they not? It was their home. They were children of the dump, literally."[133]

The neighborhoods Riis captured—Hell's Kitchen, Five Points, Murderer's Row, Baxter Street and Mulberry Bend, to name a few—had served as homes to the city's booming immigrant population. Lady Liberty beckons, "Give me your tired, your poor, your huddled masses yearning to breathe free," and from every shore of Europe and the Far East, they came in droves. Arriving with everything they owned and still suffering with seasickness from the long ocean voyages, they were determined. They were brave. What could the New World offer them?

They debarked on Ellis Island, which had opened as a processing center in 1892. They often changed their foreign last names to better fit in with the Anglo-American community. They brought unique skills, trades, crafts, recipes and Old-World know-how. Adding their colorful heritage to the established culture while they attempted to assimilate, an estimated ten

Baxter Street Alley near Mulberry Street taken by Jacob Riis circa 1887. *Courtesy of Smithonsian.com.*

thousand people were processed each day. In 1907, at the peak of Ellis Island's operation, the center managed to book twenty-one thousand people in a single day.

From soldiers of foreign wars to tradesmen to intellectuals escaping persecution abroad, these late-nineteenth-century immigrants would become the backbone of the working class in New York City. With bags and families in tow, they entered the bustling, looming city just beyond the docks, hopeful that their voyage was not in vain.

The magnitude of these migrations cannot be understated, as they resulted in some staggering socioeconomic and residential repercussions. As historian Robert Hughes noted, "The Tenth Ward of lower Manhattan—the Lower East Side, around Orchard Street—had, by the 1890s, the highest concentration of people in the world: 344,000 people packed into one square mile, or nine square yards each, including street and pavement space. There were, it was thought, 11,000 sweatshops turning out clothing, cigars, furniture and tinware."[134] Commodities and quality wares were in high demand by affluent members of society. High-quality handmade leather gloves, felt hats, women's clothing and finely built upright pianos were among the dozens of goods made and sold in New York during this transformative period.

Places like Five Points figured prominently in the duality between established Anglo-Americans and the burgeoning immigrant community. These neighborhoods also underscored the darker side of a culture that's industrial engine also consisted of exploited laborers, malnourished children and overworked mothers.

Five Points was controlled by five major criminal gangs that became an iconic part of Manhattan's late-nineteenth-century social history. Jacob Riis captured the neighborhood beautifully in a number of famous photographs—one entitled *Bandit's Roost* depicts a dark, narrow alley flanked by high tenement walls. Ten gang members in top hats and overcoats peek out at him from rickety windows. One man glares menacingly with one leg perched on a metal trashcan. A carpet of garbage litters the alley floor. One can only imagine how relieved Riis was to break down his gear and move on.

As one author observed:

> *Physically, the Five Points was mostly what we now know as Little Italy, Chinatown and the blocks of monolithic courthouses that seem to anchor Manhattan. Metaphysically, it constituted hallowed ground in the American story, occupied by successive waves of freed slaves and Irish, Italian and Chinese immigrants. With the exception of its more celebrated neighbor, the Lower East Side, no part of the country has been a place of the poor, the immigrant and the aspiring for as long as the Five Points.*[135]

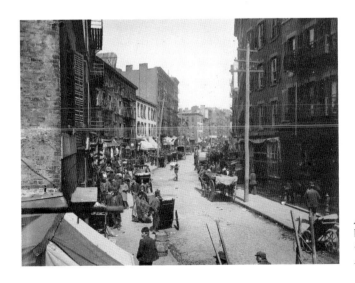

Mulberry Bend taken by Jacob Riis. *Courtesy of New York Encyclopedia.*

This melting pot of ethnicities not only produced new cultural nuances and value systems in the neighborhood but also introduced elements of diversity that would forever define New York. Unfortunately, some of these cultural additions led to many of the city's most bitter rivalries and conflicts.

In 1882, the United States ratified the Chinese Exclusionary Act, which banned Chinese women and children from entering the country and restricted Chinese male immigrants with the exception of diplomats, students and businessmen. Slavery had been ended only decades before, and the newly freed people struggled desperately to escape the still-hostile South, fending for menial work and dodging lynch mobs. Italians and Eastern European Jews were strengthened by family bonds amid their new nation's predominately white Protestant hierarchy. These groups preferred to speak their native languages and continued their traditions and habits despite their new surroundings. Consequently, they were forced into ghettos.

About 2.3 million people from the Russian Empire migrated to the United States between 1871 and 1910. Among them were Lithuanians, Poles, Latvians, Finns and Ukrainians. They were fleeing repressive laws imposed by the antisemitic tsar, Alexander III, who forbade Jews from owning land and incited many pogroms against them in the form of brutal, racist street riots. From Italy, a migration boom occurred around 1871—ten years after northern and southern Italy were politically unified.

Indeed, the dynamic was called a melting pot. But even the most watched pot will boil just when we walk away, and we're left with the fear that we should have stayed to lower the temperature for safety's sake. Immigrant families only wanted to live peacefully, profitably and happily but couldn't dodge the violence and criminal behavior that kept kicking up the heat—often dangerously beyond its boiling point.

Homelessness plagued the city, averaging between twenty thousand and thirty thousand people living on the streets in the late 1870s. This meant that roughly 12 percent of school-age children were also homeless.[136] This is a staggering figure that played out in acute generational poverty and delinquency. For the most part, immigrant parents adjusted as best as they could to new lifestyles, but their hopes for rich, educated lives for their children hit a brick wall. The resulting issues of this kind of deprivation cast a long shadow beyond the turn of the century and extended to the close of the Gilded Age, the stock market crash of 1929 and the subsequent decade of the Great Depression.

One of Riis's contemporaries noted:

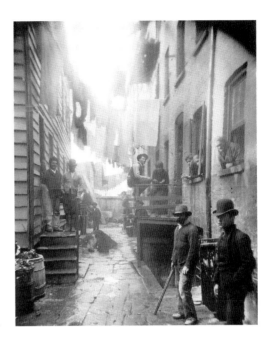

Bandit's Roost taken by Jacob Riis circa 1888. *Courtesy of Alexander St. Foundation.*

There is...undoubtedly a multitude, powerfully large, of little orphans or half-orphans, or children cast out from their homes or who have been dropped here by the tide of emigration or have drifted in from the whole country round about, or who have run away, or are the offspring of drunken parents, and who live a vagabond life, preying on the community themselves by half-idle employment in the streets and docks. From these come the pickpockets, petty thieves, small burglars, "cotton baggers," copper stealers, young prostitutes, peddlers, street sweepers, and boot-blacks that swarm in various parts of the City. Some are honest and industrious, others live by their wits, and all are exposed to incessant and overwhelming temptation.[137]

Riis was different after he found his place. He still had the same serious expression and the same thick mustache, but his clothes were a little more respectable. He had a desk with stationary, and his name was on the office door. He had some cash to spend on goods other than food and shelter. He even had a few friends in high places. It had been a hard road, but his instincts had paid off: the public had a taste for the bitter truth, and he had found his tiny place in the vast swirling cosmology of turn-of-the-century Manhattan.

As a muckraking photojournalist, Riis's work ultimately led to legislative reforms that helped alleviate some of the suffering of New York's tenement

dwellers. As he recalled, "'Are you not looking too much to the material condition of these people,' said a good minister to me after a lecture in a Harlem church last winter, 'and forgetting the inner man?' I told him, 'No! For you cannot expect to find an inner man to appeal to in the worst tenement house surroundings. You must first put the man where he can respect himself.'"[138] Riis was acutely aware that decency and progress required basic human input, which was sorely absent in the dense urban environments he studied. Without a safe and secure place to come home to, how could citizens be expected to survive, let alone realize the American Dream? It was an issue he spent the rest of his life addressing.

Theodore Roosevelt, a dear friend of Riis and New York City's police commissioner at the time, created the Tenement House Commission, which led to the 1901 formation of the Tenement House Department. It was chaired by another close friend of Riis, Robert de Forest of the Charity Organization Society. These public advocacy groups raised awareness and directed much-needed help to impoverished communities that had previously been ignored. Roosevelt even accompanied Riis on many of his beats, poking his head into a shack here and shining a lantern on an unassuming couple going about their menial tasks there. The two made quite an odd, effective duo and bore a striking resemblance to each other down to the styling of their thick mustaches and choice of eyeglasses rims.

Roosevelt was moved by the experience and personally thanked Riis for not only showing him "how the other side lived," but for suggesting and even drafting legislation to improve the situation. The Tenement House Commission, for example, insisted on redesigning existing housing units to prevent crowding and to improve fire safety, admit more natural light, enhance air quality and reduce proximity to human and commercial waste, among other basic sanitation protocols to establish a dignified and healthy baseline for low-income residents. The Society for the Improvement of the Condition of the Poor argued, "Crazy old buildings, crowded rear tenements in filthy yards, dark, damp basements, leaking garrets, shops, outhouses, and stables converted into dwellings, though scarcely fit to shelter brutes, are habitations of thousands of our fellow-beings in this wealthy, Christian city."[139]

The project lasted almost forty years and saw the creation of public parks in and around tenement housing, the removal and retrofitting of almost forty thousand old and damaged windows and the realization, at least partially, of the vision Riis had advocated for so strongly. Yet capitalism, while adapting to these progressive clarion calls, still stood fundamentally

opposed to them from a philosophical perspective, underscoring the need, as Riis argued time and time again, to reconsider what we considered sacred in our nation.

He asked the following of his readers in an article published in the *Harvard Crimson* in 1907:

> *We hear much of the slum. The slum is just a question of the per cent [sic] you will take. If it's 5 per cent. There is no slum problem; if 25, it looms large. It pays to build bad tenements that wreck the home. That is the reason of the fight. As I said, it is just a question of greed and of the cold indifference that asks, "Am I my brother's keeper?" In that war the generation that is coming has to take sides. Which side are you on?*[140]

An Iconic Image

A gaunt inmate in a mud-spattered uniform stands bent over a rough patch of upturned dirt. One foot balanced precariously on the shifting soil at the lip of the trench and a gloved hand extended to the man at the bottom, it is as if he is saying, "How many more?" Beside him, two simple pine boxes rest side by side. Another half-dozen lay neatly in the square, freshly dug grave under an overcast sky. A supervisor in a double-breasted suit, bow tie and top hat clutches a cane and stands guard, watching the team work. A distant ship sails past still in the deep channel waters but close enough for its crew to see something going on through a spyglass.

The man at the bottom of the hole looks preoccupied. He is staring up at the busy man with the photographic apparatus who is seriously framing his shot. This would be among the first images of the scene taking place on this deadly, quiet, backwater island in the middle of Long Island Sound.[141]

Riis sardonically remarked in the fourteenth chapter of *How the Other Half Lives*:

> *One free excursion awaits young and old whom bitter poverty has denied the poor privilege of the choice of the home in death they were denied in life, the ride up the Sound to the Potter's Field, charitably styled the City Cemetery. But even there they do not escape their fate. In the common trench of the Poor Burying Ground they lay packed three stories deep, shoulder to shoulder, crowded in death as they were in life, to "save space;" for even*

on that desert island the ground is not for the exclusive possession of those who cannot afford to pay for it. There is an odd coincidence in this, that year by year the lives that are begun in the gutter, the little nameless waifs whom the police pick up and the city adopts as its wards, are balanced by the even more forlorn lives that are ended in the river. I do not know how or why it happens, or that it is more than a mere coincidence. But there it is.[142]

For Riis, the anonymity of dumping the unknown and—he would argue—the unwanted was a logical extension of a pitiless city-wide socioeconomic and industrial plan.

At that time, the island housed a trade school for delinquent boys as well as the potter's field. Riis viewed Hart Island as a sinister part of what he considered a city-wide circle of exploitation, which instead of reforming citizens from the tenement districts, only embittered them. Fate would inevitably bear the boys' bodies back to the mass trench years later, as many did not have living relatives or friends to identify them after their passing.

While Hart Island is now reentering the public's consciousness due to local activism and a revival in the grim plot of the land's past, the issues Jacob Riis exposed more than a century ago remain. Manhattan has become one of the most expensive areas to live in the United States. While gentrification has removed some of the troubling criminal aspects of places like Five Points and The Bowery, there remains a large homeless

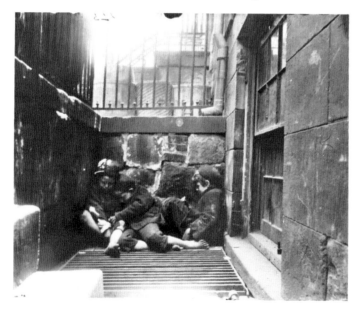

Kids Sleeping on Mulberry Street taken by Riis circa 1890. *Courtesy of New York Encyclopedia.*

population with thousands, whose faces appear eerily similar to those of Riis's, living in tenements and subsidized housing projects.

A survey stated that, as of June 2018, there were 61,421 homeless people—including 14,934 homeless families and 22,266 homeless children—sleeping in the New York City municipal shelter system each night. The same study traced the root causes of homelessness to familiar themes in the city's history: "lack of affordable housing, doubled-up or severely overcrowded housing, domestic violence, job loss, and hazardous housing conditions,"[143] a grim echo of centuries past. In human panoply of comparison, one thing is certain: history does repeat itself.

As a *New York Times* journalist reminds readers:

> *Today, the poor often die pretty much the same way as he [Riis] depicted: thousands of forgotten New Yorkers are buried annually in the same unmarked trenches on Hart Island off the Bronx that Riis photographed. Who was buried and who survived? Look into the eyes in his captivating photographs: Whatever happened to the three children of the English dockworker and his family living in a one-room flat on West 28th Street near what is now the High Line? Or the barefoot boys, whom Riis called Street Arabs, who posed huddled above a grate on Mulberry Street in Little Italy.*[144]

LEONARD MELFI

Leonard Melfi, one of the most prolific playwrights in New York's 1960s experimental theater scene, said, "I write about people meeting each other and reaching out to each other. I love that."[145]

Most theater professionals of the day would agree that Melfi was largely responsible for relighting the fire of interest and creativity in New York's Off Broadway and off-off-Broadway resurgence.

In taped interviews, Leonard Melfi (1932–2001) is personable, centered, likeable, funny, engaging, untouched by affect or fame and, above all else, sure of his connection to the human condition. The characters he created were compelling, admittedly quirky, eccentric and nontraditional but just as deserving of words, situations and solutions as any character ever written—maybe even more.

Born and raised in Binghamton, New York, Melfi moved to New York City in search of an acting career and studied with Uta Hagen, among others. Between lessons, he'd write thoughts and situations suitable for dramatic scene work and turned to playwriting more readily than acting. He recalled, "I found that it really turned me on watching other actors do the plays I wrote."[146]

Melfi was revered by his peers as one of the most respected and creative playwrights of his generation. He was best known for his work with the offbeat La MaMa Experimental Theatre Club on East Fourth Street in New York's East Village, which produced twenty-two of his plays. Melfi claimed, "A playwright needs a place to write for," and he

felt lucky that he and La MaMa were artistically compatible. He wrote more than seventy plays, and twenty-two of them were written for and performed at the La MaMa Theatre.

His artistic collaborations involved other well-known pioneers in the new, experimental theatre movement, including Tom O'Horgan, who produced Melfi's best known play, *Birdbath,* in 1965, and Kevin O'Connor, who directed Melfi's *Niagara Falls* in 1967. Other successful vehicles included *Having Fun in the Bathroom, The Raven Rock, Horse Opera, Porno Stars at Home, Fantasies at the Frick, Ferryboat, Encounters, Later Encounters, Lunchtime, Rusty & Rico, The Shirt, Club Hellfire* and *Halloween.* The major characters in his plays were mostly social outcasts with mysterious secrets that were revealed in moments of great anxiety and emotion. He was also a contributing writer to the 1969 Off-Broadway musical *Oh, Calcutta!* and authored Hollywood screenplays and appeared in the film *Rent Control* in 1984.

Leonard Melfi wrote many screenplays for movies, including *Lady Liberty,* starring Sophia Loren. *Courtesy of Film Affinity.*

"I WAS SORT OF DOOMED."

The Melfi family of Binghamton, New York, was lively and seemed to thrive on drama and booze. In an interview on the radio station WBAI in 1966, Melfi said of his family, "We always talked, and we always cooked together, and while cooking we drank. My father's father was a bootlegger and my mother's father made wine in the cellar…I was sort of doomed." He joked that he had developed his taste for alcohol by "working in the family business."[147]

An Offbeat Final Act

By October 2001, Melfi had been struggling with alcoholism for some time and was renting a single room at the Narragansett Hotel at Broadway and Ninety-Third Street in New York. His niece had tried several times to see him, but his door was locked, and he didn't answer. Well-meaning friends also tried to contact him. At times, he told them through the closed door that he was "okay" and not to worry. His niece became concerned enough to call paramedics to the hotel. They entered Melfi's room and found him in cardiac distress on October 28, 2001.

He was taken by ambulance to Mount Sinai Hospital, the closest medical facility. He died of congestive heart failure four hours later in the emergency room. It was eventually reported that his body was "misplaced" by hospital staff and ended up being buried on Hart Island in March 2002.

Melfi's brother, John, finally tracked his brother's remains, had them exhumed from Hart Island, sent to the Frank E. Campbell Funeral Chapel on Eighty-First Street and Madison Avenue in New York for official identification and finally transferred them to the DeMarco Funeral Home in Binghamton. After a complete funeral mass, Leonard Melfi was buried in the family plot in April 2002.

On May 2, 2002, a public memorial for Melfi was conducted at the La MaMa Theatre Annex in New York. Playwright Edward Albee sent the following note, which was read aloud to those present at the memorial: "Years ago, there were many serious and daring individuals in Greenwich Village under 30 as well as young playwrights, myself included. It was a wild and vital time, and no one was more vital than Leonard."[148]

THE TRIANGLE SHIRTWAIST FACTORY FIRE

The girls had been at their stations for almost nine hours, which was usual in a fifty-two-hour work week that earned them about ten dollars. They had come from neighboring boroughs and blocks—some Jewish transplants and many Italian immigrants—to the eighth, ninth, and tenth floors of the Asch Building on the northwest corner of Greene Street and Washington Place in Greenwich Village.

It was an entirely routine day in early spring as the sun began its slow descent. The droning mechanical whir of the company's 240 sewing machines filled the long, cramped room where workers sat almost shoulder-to-shoulder, back-to-back. Despite the usual gossip among staff and the clipped comments from shift supervisors for not keeping up the grueling pace, the job paid the bills, and another long shift was almost over.

Young immigrant women made up most of the roughly six hundred employees of the Triangle Shirtwaist Company, which was owned by Max Blanck and Isaac Harris. The employees spent their time bent over long sewing tables, hemming and fashioning by hand the company's line of blouses known as shirtwaists. These workers were forced to toil another seven hours on Saturdays, leaving them scant time with families and even less for any semblance of leisure. As one young worker, Clara Lemlich, recalled, "The bosses in the shops are hardly what you would call educated men, and the girls to them are part of the machines they are running. They yell at the

girls and they 'call them down' even worse than I imagine the Negro slaves were in the South."[149] They were not permitted to leave the space for fresh air or smoke breaks, but a few were known to sneak a puff of a cigarette under their blouses—their small pleasure and act of defiance during their long hours of drudgery. Most of them were between fourteen and twenty-three years old.

It all started with a match or a still-lit cigarette. Some say it was a sinister act of insurance fraud and arson in a garment industry that was failing. No one really knows, but at 4:40 p.m. on that fateful March afternoon in 1911, from a smoldering ember tossed in a scrap bin under one of the cutter's tables on the eighth floor, a small flame fanned, reaching the top of the bin within seconds. Two hundred pounds of dry cloth from two months of fabrication, along with nearby garments hanging on a steel rack, quickly caught fire. Someone walking on Washington Place noticed smoke wafting out of a high window and called out, "Fire," a few minutes later. It was 4:45 p.m. before anyone knew something was wrong.

The first fire alarm was tripped at a local station following the pedestrian's tip. A Triangle Shirtwaist Company bookkeeper in an eighth-floor office, Dinah Lifschitz, smelled something burning and rang the tenth floor by telephone, urging them to evacuate. Since her own floor and the ninth did not possess audible fire alarms, and the ninth floor was not reachable by phone, work went on as usual, with only those in the immediate vicinity curiously craning their heads as the smell of burnt garments made its way across the work floor. A nearby floor manager tried to douse the flames with a fire hose, but its water valve had rusted shut from disuse. The hose itself had rotted and was filled with small holes. He quickly stepped out of the room. Lifschitz followed him.

Meanwhile, the girls were exhausted and at the end of a nine-hour shift. Whatever was going on across the room or above or below them, they could take care of tomorrow. Someone was probably taking care of it already. But within minutes, just before the staff packed up for their train rides and walks home, everything changed. One survivor, Rose Freedman, recalled the following almost fifty years later:

> *On the day of the fire I was working on the 9th floor, I had gotten my pay and we were all ready to leave and all dressed. The fire must have been burning on the 8th floor for some time when we went to the freight elevator exit to go home. We had to leave that way because that is the way the watchman was able to look in our bags and where he stayed. There was*

a narrow vestibule leading to the freight elevator. I was waiting in that vestibule when all of a sudden the smoke, and then the fire, began to come up the elevator shaft. I turned to run back to the other end of the shop where the freight elevator was. I took one look into the shop as I ran and I saw the flames coming in from all sides. [150]

There were other ways out but no exit. The ninth floor, besides its two smoke-filled freight elevator shafts, had a fire escape and connecting stairways leading to Greene Street and Washington Place below. But flames were licking the steel guardrails of the Greene Street gangway, and owners Blanck and Harris had seen fit to permanently lock the ninth floor's only fire escape to keep the girls from stealing clothes and slipping out the back door. A general panic quickly ensued.

Sarah Dworetz described the scene: "I had to fight and push my way across the shop. There was screaming and shoving and many girls tried to climb over the machine tables." [151] The heat was uncomfortably real as the girls sweated and ran hopelessly in circles, looking for something, anything. The smoke billowed into the cutting room floor, seemingly from everywhere, as they cried out for their suddenly absent male overseers—most of whom had fled minutes before with vital keys to rear exits still clutched in their hands. Some of the girls managed to brave the scorching rails of the single Greene Street staircase and got to the roof of the Asch Building a few floors up. Their faces and hair were blackened by soot, and they jumped the gap to the neighboring high rise. Elevator operators, Joe Zito and Gaspar Mortillalo, made three terrifying trips back from the ground level to cram as many surviving women into one of the building's still-functioning carriages. Its bent and warped frame had already exceeded temperature thresholds and was finally rendered inoperable

The Triangle Shirtwaist Factory Fire on March 25, 1911, was the deadliest industrial disaster in the history of New York City. The fire caused the deaths of 146 garment workers. *Courtesy of Jewish Women's Archives.*

as they descended to the final floor the third time. The crashing bodies of those who had attempted in vain to slide down the cable shaft to the top of the car finished the job, as most slipped off its scalding tensioners and metal wires, further denting the elevator car and jarring it off its moorings before its attendants were able to pry its doors open.

THE HORROR

By the time the New York City Fire Department arrived with their water trucks, crowds had gathered at the base of the building to watch in horror as the chaos unfolded. An account stated, "For those left on the 9th floor, forced to choose between an advancing inferno and jumping to the sidewalks below, many would jump. Others, according to survivor Ethel Monick, became 'frozen with fear' and 'never moved.'"[152]

William Shepard, one of the first reporters on site, remembered in painful detail what he saw as he rounded the corner and the smoldering top floors of the Asch Building came into view, "I learned a new sound that day, a sound more horrible than description can picture—the thud of a speeding living body on a stone sidewalk."[153] As standard fire ladders in 1911 only reached to a vertical height of seven floors at maximum extension, authorities were utterly helpless and could only stand idly by as the pleas and choked, desperate calls from these young women rang out from the windows. Many had already passed out from asphyxiation, as noxious, super-heated fumes from burning fabrics bellowed out of the eighth and ninth floors, and "assistant cashier Joseph Flecher looked down from the tenth-floor roof to see 'my girls, my pretty ones, going down through the air. They hit the sidewalk spread out and still.'"[154]

By the time firefighters had extinguished the flames and the crowd had dispersed in shocked disbelief, 146 people were dead, including the incidental death of a young Jewish man whose fiancé worked at the Triangle Shirtwaist Company. Lying ill in a hospital bed upon hearing the tragic news from a friend that evening, he jumped out of bed and died shortly thereafter of a sudden heart attack. As one researcher has correctly noted, "There were many indirect victims of the fire. Mothers who lost their daughters—girls full of life and hope, brides-to-be, innocent—could not contain their grief, and many of them passed away before their time."[155] Sixty-two bodies lie in tangled heaps at the base of the charred Asch building—a macabre scene

The makeshift morgue that was established at Charities Pier off East Twenty-Sixth Street. It is nicknamed Misery Lane. *Courtesy of Ephemeral New York.*

that emblazoned itself in the memories of those unfortunate enough to have witnessed it. Another eighty-five would later be pulled out of the Triangle Waist Factory's eighth and ninth floors, and many would be burned beyond recognition. Seventy-one more were seriously injured.

THE SOCIETY OF THE BROTHERHOOD OF TRUE CHARITY

While many of the young ladies who perished in the fire could be identified, many could not. Those who refused to jump were badly burned as the firefighters stepped through the charred and twisted wreckage of the once tidy factory floor. There they found totally unrecognizable lumps of ash splayed out in whatever final desperate pose they struck before expiring. As unclaimed or unidentified deaths, according to New York City policy, bodies were traditionally shipped to the City Morgue at Bellevue and later passed on to the potter's field at Hart Island. It was fairly certain where these women would be laid to rest. Yet in the weeks before their transfer and interment, a curious philanthropic twist provided much-needed aid and lent a sense of dignity to an otherwise anonymous removal of the victims.

Chebra Agudas Achim Chesed Shel Emeth, the Society of the Brotherhood of True Charity, was founded in 1888 by Barnett Freedman, a Jewish clothier, in response to the squalid poverty of many of his fellow immigrants in New York City. An organization that served the Jewish residents of the Lower East Side of Manhattan before incorporating as an official nonprofit in 1889, it would later branch out to provide burial services for the impoverished deceased in the greater metropolitan area of New York City.

Renamed the Hebrew Free Burial Association in 1965, most early cases involved the deaths of small children, some of whom had been abandoned or stillborn. An internal memorandum from the committee noted,

> In death poor Jews—everyone from the devout to the impious—ran the risk of losing their connection to Jewish communal life. By 1910, many of the Jews who resided in Manhattan's 2,500 six-story slum walk-ups could not afford the cost of a funeral or grave. Thousands each year ran the risk of burial on Hart Island, a potter's field in the easternmost part of the Bronx, where, the tenants received neither graveside ceremony nor marker, buried in mass graves.[156]

Hart Island

In total, the Society of the Brotherhood of True Charity buried twenty-two victims from the Triangle Shirtwaist Factory Fire, laying their bodies, enshrouded in simple white cloth, to rest in pine boxes at the Mount Richmond Cemetery on Staten Island. Simple and austere gravestones marked the graves, providing a small, but tangible, distinction from the utter anonymity of Hart Island's common trench. Other victims were buried at Calvary Cemetery, Mount Zion Cemetery and fourteen other cemeteries. It is not known if friends or loved ones were able to identify them, but hundreds of thousands of New Yorkers gathered in the rain in the wake of the fire to march in solidarity for these tragic victims of corporate negligence.

There were two major outcomes of the fire. On the one hand, the deceased women's relatives and loved ones demanded to know how such a horrific accident was possible. In probing the business ethics of the company, citizens and officials exposed much bigger problems focusing

on a lack of women's rights, shocking working conditions and industrial shortcuts abused by profit-seeking business owners. Indeed, within days of the fire, an advocacy group rallied at Cooper Union and stretched a banner across a platform. It read, "Locked doors, overcrowding, inadequate fire escapes...We demand for all women the right to protect themselves." Still a full decade before women were legally permitted to vote in the United States, the tragedy served as a valuable window into a burgeoning capitalist machine that's bottom end often resulted in exploitative labor and, in the case of the Triangle Shirtwaist Fire, the preventable deaths of hundreds of young women and girls. New York City fire chief Edward Croker was forced to issue a statement urging "girls employed in lofts and factories to refuse to work when they find [potential escape] doors locked."[157]

Two weeks after the fire, a grand jury indicted Triangle Shirtwaist owners Max Blanck and Isaac Harris on charges of manslaughter. On a cold December morning nine months later, the civil trial commenced. The defense produced 103 witnesses, including a number of young Triangle Shirtwaist Factory workers dressed in their finest gowns and overcoats. As one researcher of the trial explained:

> *Through his witnesses (assistant district attorney) Bostwick tried to establish that the fire quickly cut off escape through the Greene Street door, causing the panicked workers to turn to the Washington Place door—a door the prosecution contended was locked. More than a dozen prosecution witnesses testified that they tried the door and were unable to open it. Katie Weiner told jurors, "I pushed it toward myself and I couldn't open it and then I pushed it outward and it wouldn't go. I was crying, 'Girls, help me!'" Other witnesses testified that Blanck and Harris kept the door locked to prevent employees from pilfering shirtwaists. (On the stand, Harris admitted to an almost obsessive concern with employee theft even though he conceded that the total value of goods taken over the years was under $25).*

After the fifty-second witness had finished testifying, the jury rested and returned to chambers to mull over the testimony they heard over the past three weeks

The clincher was an obscure clause from the city's building codes. According to Article 6, Section 80, of New York's Labor Law, "All doors leading in or to any such factory shall be so constructed as to open outwardly where practicable, and shall not be locked, bolted, or fastened during working

hours." Judge Crain notified the jury that in order to reach a guilty verdict, they would have to establish that the door in question was locked during the fire and that the defendants knew this and did not address it. The judge also told the jury that they must find beyond a reasonable doubt that the locked door caused the death of employee Margaret Schwartz.

THE VERDICT

After deliberating for just less than two hours, the jury returned with a verdict of not guilty. Blanck and Harris were acquitted, and both dropped heavily back into their seats as their wives began sobbing behind them. After the verdict, juror Victor Steinman stated, "I believed that the door was locked at the time of the fire, but we couldn't find them guilty unless we believed they knew the door was locked."[158] Five police officers escorted Blanck and Harris to a nearby subway station with an angry mob shouting disparaging remarks and insults at them. It would be a full three years after the fire—March 11, 1914—before twenty-three individual civil suits against the owners of the Asch Building were finally settled. The average recovery payout was a mere seventy-five dollars per life lost.

The horrific saga of the fire led to the creation of some landmark legislation that ensured steps would be taken to prevent another catastrophe. New York City created the Factory Investigating Commission, which scrutinized businesses like the Triangle Shirtwaist Company. It observed workers' conditions and safety precautions and notified owners of unethical practices that must be changed.

In fact, two years after the incident, Clara Lemlich, who survived the fire, helped found Local 25, an advocacy group of a few hundred shirtwaist makers and dressmakers, most of whom were women. She had championed women's rights and workplace justice. She suffered multiple broken ribs from thugs hired by anti-union figures like Blanck and Harris. The meeting rallied the group:

When the meeting's star attraction, the American Federation of Labor President, Samuel Gompers, spoke, the crowd went wild. After he finished, Clara expected a strike vote. Instead, yet another speaker went to the podium. Tired of hearing speakers for more than two hours, Clara made her way to the stage, shouting, "I want to say a few words!" in Yiddish. Once she got

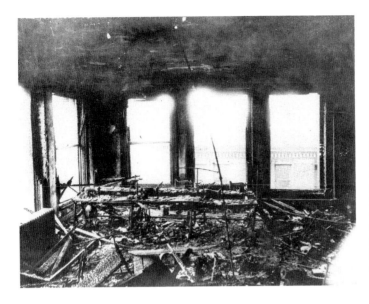

Photograph from 1911 of the charred remains of the tenth floor of the factory. Only the walls and floor were intact. *Courtesy of Bettmann/ CORBIS.*

to the podium, she continued, "I have no further patience for talk as I am one of those who feels and suffers from the things pictured. I move that we go on a general strike…now!" The audience rose to their feet and cheered, then voted for a strike. [159]

The next morning, more than fifteen thousand shirtwaist workers refused to work, demanding a 20 percent pay increase, a fifty-two-hour workweek and overtime compensation. The following day, amid picket lines and looming strikebreakers paid under the table to intimidate the mostly female contingent, twenty thousand more workers from five hundred local factories walked out. Soon after, more than seventy smaller factories accepted the union's demands.

From 1911 to 1914, thirty-six new laws reforming the state labor code were put in place. Frances Perkins, a member of the nine-person state labor code committee and later secretary of labor in the Roosevelt administration, proclaimed,

> *Out of that terrible episode came a self-examination of stricken conscience in which the people of this state saw for the first time the individual worth and value of each of those 146 people who fell or were burned in that great fire. We all felt that we had been wrong, that something was wrong with that building which we had accepted or the tragedy never would have happened. Moved by this sense of stricken guilt, we banded ourselves together to find a*

Gravestone of one of the twenty-two victims of the Triangle Shirtwaist Factory Fire. They were destined for a mass burial on Hart Island before the Hebrew Free Burial Association interceded to pay for their interment at a cemetery on Staten Island. *Courtesy of Jewish Women's Archives.*

way by law to prevent this kind of disaster. It was the beginning of a new and important drive to bring the humanities to the life of the brothers and sisters we all had in the working groups of these United States.[160]

The sacrifice of those trapped and exploited young men and women who perished in the Asch Building would ultimately pave the way for many of the policies that Franklin Delano Roosevelt passed during the New Deal and for reforms we continue to enjoy today. Still, this tragic episode serves as a painful reminder of Jacob Riis's famously observed and written testimony as to how the other half lives.

LEO BIRINSKI

With little known about his life—no legitimate records to prove his place of birth (maybe Lysianka, Ukraine, or at least eight other possibilities) or even a solid date of birth, Leo Birinski, or Leo Gottesmann (June 8, 1884–October 23, 1951?) became a known playwright, screenwriter and director. In 1920, it was said that he created a false report of his own suicide. Was this fodder for his creativity or for another play he would write one day, or was it simply characteristic of Birinski's perception of his own life and times? We'll never know.

It is believed that Birinski grew up in Ukraine and Czernowitz, the capital of the Austro-Hungarian province of Bukovina. In the early 1900s, he moved to Vienna and worked at a bookshop translating material and writing his own stories and plays. During this time, he authored three plays: *Der Moloch* (*The Molach*), about a god associated with child sacrifice; *Raskolnikoff*, which was adapted from Dostoevsky's *Crime and Punishment*; and *Narrentanz* (*Dance of Fools*), a tragicomedy that was the most successful of the three.

In April 1921, perhaps prompted by renewed public interest in the suicide rumor, Birinski moved from Vienna to Berlin. The story was supposedly explained as a case of mistaken identity. The individual in question was Leon Gottesmann, not Birinski. This information was supposed to quell the unflattering rumor, though the event was subsequently recorded in contemporary research venues.[161]

Because Birinski's life data was so elusive, nobody could attest to any part of it. His most productive working years as a director in Europe spanned less than a decade—approximately from 1910 to 1917, then he was virtually forgotten or, perhaps, deliberately unavailable or willingly hidden.

Nonetheless, he surfaced to write screenplays for thirteen movies, including *Tragedy of Love* with Marlene Dietrich and *Varieté* by German film director Ewald Andre Dupont, as well as films by Gennaro Righelli, Italian director, screenwriter and actor. At this time, Berinski also wrote the stage play *Der heilige Teufel: Rasputin und die Frauen.*

The affecting silent horror film *Waxworks*, which released in Germany in 1924 and 1929 in the United States, was directed by Birinski and Paul Leni, a popular director in the German Expressionist movement. It stars veteran actors Emil Jannings, Conrad Veidt, Werner Krause and William Deterle. The plot follows the proprietor of a wax museum who hires a poet to write fictional stories for his wax models, each of whom were depraved, notorious criminals. As the poet writes, he envisions himself as the victim of these criminals.

The German horror film genre, or the German Expressionist genre, flourished in the era of the Weimar Republic, producing such films as *The Student of Prague* (1913), *The Golem Trilogy* (1915–20), *The Cabinet of Dr. Caligari* (1920), *Warning Shadows* (1923) and the first film to incorporate the Bram Stoker Dracula legend, *Nosferatu* (1922).

In September 1927, Birinski arrived in the United States, and his wife followed two years later. Both traveled with and presented Nicaraguan passports. His passport listed the city of Bluefields, Nicaragua, as his birthplace. Was it a false identity? A fantasy? Was it the stuff screenplays are made of? Perhaps it was just another beat in the Birinski biography—real or not.

> *The only way to resign from our profession is to die.*
> —*Leo Birinski et al.*, Mata Hari

He continued writing in the United States. He wrote screenplays for *Mata Hari, Song of Songs, The Gay Desperado* and *The Lady Has Plans,* which was the last he wrote. The first film he directed in the United States was the German version of *A Ship Comes In* (*Das große Glück*) in 1928.

Between the mid-1930s and the mid-1950s, the successful radio show *Lux Radio Theatre* produced what was described as a "classic radio anthology

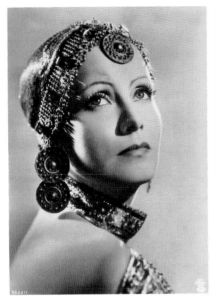 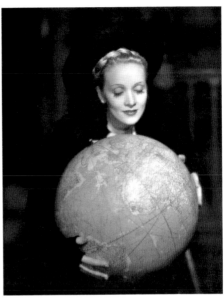

Left: Leo Birinski (June 8, 1884–October 23, 1951) was a playwright, screenwriter and director from Russia. In the late 1920s, he relocated to the United States, where his first major American screenplay was turned into the 1931 movie *Mata Hari*, staring Greta Garbo, who is photographed here. There were many legends and rumors concerning Birinski—some of them even spread by himself—including the false report of his suicide in 1920. *Courtesy of biography.com.*

Right: Birinski's second major film achievement was his screenplay staring Marlene Dietrick in the 1933 movie *Song of Song. Courtesy of eyeforfilm.com.*

series" of Broadway shows adapted for hour-long radio broadcasts. Birinski was responsible for writing many of the adaptations. After a successful twenty-year run, the series expanded into televised shows under the name *Lux Video Theatre*. The primary show sponsor was Unilever, one of the world's largest consumer goods companies, which originally sold household cleaning products and personal items, such as Lux brand soap—hence the name of the shows.

In 1935, Birinski's stage play, *Nowhere Bound* was presented on Broadway at the Imperial Theater. In 1944, another of his plays, *The Day Will Come*, ran at the National Theater, which is now the Nederlander Theater.

Plot 45, Section 2, No. 14

Between 1944 and 1951, Birinski again fell off the map. Information about the last seven years of his life are curiously sketchy. According to his death certificate—which contains no personal identification—Leo Birinski died on October 23, 1951, at Lincoln Hospital in The South Bronx, New York.[162]

It appears he died alone in poverty. He was buried in Hart Island's mass gravesite with just the recognition: "Plot 45, Section 2, No. 14."

THE BOWERY

J acob Riis died in May 1914, only a month before the outbreak of World War I. He had seen the human wreckage of his adopted city play out in places like Mulberry Bend and the Five Points but was spared the age of wholesale slaughter that beset the Old World. In late 1914, as Europeans vied for control of the continent in this unprecedented and brutal new display of industrial warfare, Americans looked across the Atlantic. Sheltered from foreign invasion by the vast ocean, the country was eased out of a looming recession by selling ammunition and materials to the warring nations abroad.

Finally lured into the conflagration in 1917, purportedly by the sinking of the passenger liner/ammunition transport ship *Lusitania*, Americans got a taste of the cordite and mustard gas and felt the trembling shock and rattle of heavy artillery and machine guns that killed almost twenty-one million and wounded another twenty million. "The war to end all wars" concluded with an uneasy peace, sowing seeds of discontent that would fuel the fury of the Second World War.

PROHIBITION AND WOMEN'S SUFFRAGE

In the interwar period, Americans who had returned from their brief service in the closing year of World War I were beset by a changing home front.

In 1920, the United States passed the Volstead Act, which forbade the sale and importation of alcohol. The United States' current marijuana law bans its possession at the federal level but permits states to decide on recreational and or medicinal use. The Volstead Act permitted alcohol to be consumed and used in religious ceremonies, though state law prevented its purchase and enjoyment. The fun had ended, so it seemed. As the *Manchester Guardian* dramatized in a feature on January 17, 1920, "One minute after midnight to-night [*sic*], America will become an entirely arid desert as far as alcoholics are concerned, any drinkable containing more than half of 1 percent alcohol being forbidden. Excessive fines and dungeons keeps yawn for transgressors of this Federal law."[163]

Many women from the Temperance League were instrumental in abolishing the sale and consumption of liquor because many had been victimized by the drunken abuses of their spouses, and they had enough. In the same year, a voice was given to that half of the nation's population: women could now vote. The Nineteenth Amendment was one more step toward equality. As Susan B. Anthony proclaimed almost fifty years before this groundbreaking suffrage legislation passed, "It was we, the people; not we, the white male citizens; nor yet we, the male citizens; but we, the whole people, who formed the Union. And we formed it, not to give the blessings of liberty, but to secure them; not to the half of ourselves and the half of our posterity, but to the whole people—women as well as men."[164] Times were changing, indeed.

Against this canvas of changing laws and legalities, gangsters and bootleggers etched another chapter in history. The criminal underworld flourished from Al Capone in Chicago to Florida and even to Cuba during Prohibition. The colorful, almost stereotypical characters of New York's Mafia—especially those under the leadership of the Genovese family—thrived during this period. These were national concerns, yet everything happening in Manhattan seemed bigger and more exciting.

Indeed, as Mark Twain, the ubiquitous critic with his ear to the ground, claimed, "Prohibition only drives drunkenness behind doors and into dark places, and does not cure it or even diminish it."[165] Without access to legal spirits, many low-income alcoholics chose to make their own or buy homemade street liquor called "smoke" from corner boys and miscreants in alleyways and subway stations. A combination of water and fuel alcohol, a pint sold for 15 cents in most of the smoke joints that were tucked away in the back rooms of local paint shops, groceries and other small businesses.

The government quickly caught on to the racket and took drastic measures to prohibit its consumption. One study notes the dangers of drinking this alcohol:

> *According to a Dec. 26, 1922 edition of the* New York Times, *"five people were killed in the city on Christmas Day from drinking 'poisoned rum.'" That was only the beginning. By 1926...750 New Yorkers perished from such poisoning and hundreds of thousands more suffered irreversible injuries including blindness and paralysis. On New Year's Day 1927, forty-one people died at New York's Bellevue Hospital from alcohol-related poisonings. Oftentimes, they were drinking industrial methanol, otherwise known as wood alcohol, which was a legal but extremely dangerous poison. One government report said that of 480,000 gallons of liquor confiscated in New York in 1927, nearly all contained poison.*[166]

THE BOWERY

Geographically, The Bowery stretches roughly from Chatham Square to Cooper Square at Fourth Street. The East Village and Lower East Side lie to the east, while Little Italy and NoHo are to the west and Chinatown borders it to the south.

The Bowery is one of the oldest-settled stretches of land in Manhattan, and the street from which the neighborhood takes its name was once a footpath used by members of the Lenape tribe to traverse the island from north to south. In the mid-1600s, this area contained large farms, which were tended by slaves imported by the Dutch West India Company. The land was referred to as *bouwerij*, meaning "farm" in Dutch. By the early 1800s, most of the farms had been torn down and replaced by residential and industrial buildings.

Once the home of the most affluent members of New York social circles and a showcase for the city's performing arts, by the late 1860s, The Bowery had fallen from grace and assumed a reputation as a place of ill repute. Its streets were occupied by lowbrow concert halls, German beer gardens, dime museums, gambling parlors and brothels. Businesses were replaced with pawnshops and flophouses. The first YMCA opened in The Bowery in 1873, and The Bowery Mission was founded in 1880.

The Bowery is a neighborhood in Lower Manhattan. This view is looking north from Grand Street circa 1910. *Courtesy of Library of Congress.*

Prostitution became more prominent in the area through the 1890s, and by the early 1920s, the neighborhood would be known as infamous Skid Row—a catchall term for the rough and tumble areas in The Bowery, whose itinerants and alcohol-fueled patrons would leave their mark on New York history. The nickname was derived from a nineteenth-century logging district in Seattle where skids served as foundations for the rolling of timber.

Skid Row harkened back to the hopeful agenda of Jacob Riis: would we allow the less fortunate to languish in squalor and substance abuse or would we live up to our great national character, lift them out of the gutter and give them the same opportunities afforded the affluent?

The Bowery has always been a sort of amplified community *in extremis*, underscoring not only the stark class divide that has come to be an intrinsic part of Manhattan but also the wild tapestry of every type of character who comes to New York seeking fame, fortune, a career, a place to drink, a place to belong, a place to escape.

One writer observed, "Not only is the Bowery New York's oldest street, it is perhaps the one that best embodies these contradictions. It has been poor, rich, violent, cultured, upscale, and downtrodden—all at the same time. It has also served as a buffer between neighborhoods, while never truly being part of those neighborhoods. It has born witness to every facet of New York's history."[167] Writer O. Henry found himself here, drunk on cheap liquor, honing his craft until his liver gave out, and Hungarian composer Béla Bartók lived in a tiny apartment on Great Jones Street. Many liked the landscape for its places to hide, and especially to buy, sell and use heroin.

The neighborhood had been controversial from its inception. Former president Teddy Roosevelt noted in 1913, "The Bowery is one of the great highways of humanity, a highway of seething life, of varied interest, of fun, of work, of sordid and terrible tragedy; and it is haunted by demons as evil as any that stalk through the pages of the 'Inferno.'"[168] As the Second World War ended, rising incomes and greater financial stability led to the emergence of the middle class. Through initiatives like the GI Bill, and because of higher taxation on the upper sphere of society, the average American enjoyed disposable income and luxuries for the first time in decades. Those at the bottom, though, remained untouched by social change as life dragged on in the gutter.

Sammy's Follies

Music from a viola accompanied by a small rhythm section thumped as patrons clapped along to the beat and swilled their chasers as fast as Sammy could pour them. A man of average height and above average character, Samuel Fuchs, the proprietor of the infamous Sammy's Bowery Follies, could be found behind his bar's assorted taps almost every night of the week, slinging drinks and lighting patrons' dangling cigarettes. In his top hat, felt vest and suspenders, he wouldn't seem out of place in the ring of a turn-of-the century circus, which, in essence, is what his bar had turned into. In the words of one patron, "From eight in the morning to four the next morning, Sammy's is an alcoholic haven for the derelicts whose presence has made the Bowery a universal symbol of poverty and futility. It is also a popular stopping point for prosperous people from uptown who like to see how the other half staggers."[169]

His establishment at 27 Bowery opened in 1934—just a year after Prohibition ended and five years into the Great Depression. The notorious dive hosted an impressive display of notable people from all rungs of society. Running a full thirty-five years until the untimely stabbing of its proprietor during a 1969 robbery, Sammy's was a watering hole for the denizens of The Bowery and adjacent neighborhoods. Fuchs often boasted that his bar was the Stork Club for the ne'er-do-wells of the city. Adorned with crooked picture frames of vaudeville stars, strange ads from the 1920s and '30s, goofy props and a tip jar next to the rickety stage that read, "Don't forget the kitty!" it felt more like something out of a Barnum and Bailey act than a functioning establishment. Mark Barnett, also known as Barney Marks, served as the official "Master of Ceremonies," and wore absurd circus master attire. His two daughters, Sharon and Marcelle, who were eight and ten when they first walked into Sammy's in the late 1950s, spent every Saturday night until last call sitting at a corner table with their mother and sometimes performed themselves.

Denizens of Sammy's Night Club in The Bowery. *Courtesy of Vintage News Daily.*

Each night, patrons crammed into the bar's cozy booths, drinking all variety of cheap spirits and ever-flowing beer—often to the point of delirium. The stench of burnt tobacco and spilled beer hung heavy, but no one cared. The place had character and the crowd was tight. With a kind of end-of-the-world theme, patrons were on a first-name basis to counter the anonymity of the streets. If society offered no salvation for these folks, Sammy's offered a sense of purpose—a sheltered harbor in the storm of street life.

Many of those who donned their one good coat and polished their one nice pair of shoes for their big night of intoxicated release and escape at places like Sammy's returned to their makeshift rooms in one of the neighborhood's municipal shelters, which afforded some protection from the elements and a few hot meals to people who otherwise would have starved in the cold. Others with a little more cash who wanted private rooms could stay in the dozens of single-room occupancy roach motels or flophouses that littered The Bowery. These ramshackle abodes stood as testaments to continuing impoverishment in a city esteemed for its lure of affluence and opportunity. Many still stand today, like the White House Hotel, a ninety-two-year-old building just off Bond Street. The average room contained a small cubicle with just enough room for a simple bed—often a wooden shelf and a cheap foam mattress, a tiny wooden storage cabinet, some hooks on the wall and a fluorescent light fixture. The White House's sinks, showers, toilets and urinals were all shared and located at the ends of its corridors.

A traveler visited the building in 2009 and remarked:

> [The lobby had] *the feel of a sanitarium, minus the institutional obsession with cleanliness. Residents sit hunched over cans of soda or cups of coffee, eyes closed or staring, lost in silence. A man in a wheelchair whose left leg ends in a stump below the knee can often be found there, listening to music on earphones. After a time, he laboriously wheels himself across the lobby, through another door and down the hall toward his room. One formerly homeless man refuses to leave the building, according to fellow residents. He looks out the window, but as far as anyone knows, he has never ventured out on the street.*[170]

It was even worse in mid-century. Unlike its current status as a curious part of an affluent and gentrified neighborhood, the White House Hotel was a routine lodging place for the majority of impoverished Bowery residents.

Many of the destitute who landed on Skid Row played into the hands of exploitative medical experiments as well. Dr. Perry Hudson, the head of

urology at New York's Francis Delafield Hospital, began soliciting indigent men in The Bowery in 1951 for a series of invasive studies focused on exploring the preemption of prostate cancer. As a recent expose revealed, "Dr. Hudson was trying to prove that prostate cancer could be caught early and cured. But he did not warn the men he was recruiting that the biopsies to search for cancer could cause impotence and rectal tears. Or that the treatment—should cancer be found—surgery to remove their prostates and, often, their testicles—had not been proven to prolong life."[171]

Recollecting on speeches given at local flophouses before bedtime, Hudson claimed, "I had a lot of old vegetables thrown at me. I was talking about making a small incision in a very interesting part of their anatomy."[172] About twelve hundred men from The Bowery participated. Nearly one hundred were found to have cancer or precancerous growths and were operated on. They were often pumped with estrogen—a procedure that frequently led to chemical castration and a host of dangerous long-term side effects.

There were no control groups in the study, which invalidated its statistical and medical conclusions, and there were few, if any, of the follow-ups customary in longitudinal studies because of the itinerant nature of the "volunteers." There were numerous reports of city officials withholding Dr. Hudson's homeless test subjects' food vouchers for no-shows once they signed up. Many died of complications and likely found their way to the potter's field on Hart Island. Others survived, pocketed their cash and only years later understood what horrors they had subjected themselves to when their bodily functions began to deteriorate. Medical historian Dr. Robert Aronowitz concluded, "Hudson used Bowery men because only desperate, poor, and unknowing men would participate. It was unimaginable that the average American man would volunteer."[173]

Common Trenches

The familiar faces—their hard looks set against the bracing chill. There was a group of five or six black people and a few white people—one smoking a cigarette and holding a long shovel as he looked down at the crew. Their blue shirts and cheap government-issued caps identified them in case any tried to make a break for it. But no one did as they loaded the pine boxes from the lip of the trench to the cold, barren bottom for burial in the anonymous mass graves. In a picture taken in the 1930s, a group of Hart Island's convicts is

burying a series of bodies straight from The Bowery. The people had died from drinking wood alcohol, or "smoke" in some out-of-the-way place. [174] And, how many were buried in Hart Island at this point?

While they're not drinking "smoke" today, maybe it's cheap brandy from 7-Eleven, or a can of Steel Reserve. Homelessness and substance abuse are still as present as they ever were in New York. In 2015, the Bowery Mission's internal statistics reported 1 in 128 New Yorkers was homeless. In a city of 8.5 million people, nearly 63,000 spend the night in city shelters. In addition, 4,000 more sleep in subway cars, under overpasses or on the street.

Mayor Bill DeBlasio started an initiative for homeless residents in which those who have been registered in the city's database for three months who hold some sort of job or can prove disability income are eligible for a one-year sponsored relocation to subsidized housing outside of city limits. Very few landlords in the five boroughs have expressed interest in housing low-rent clients because the program's budget cannot afford to pay market prices for apartments. After the first year, participants are expected to be back on their feet. The program is an extension of former mayor Michael Bloomberg's Project Reconnect, which helped buy sixty-four hundred homeless New Yorkers one-way tickets out of the city.

THE BOWERY AND SKID ROW NOW

A 2011 *New York Times* real estate feature on the neighborhood observed:

> *Where flophouses and derelict buildings once stood, luxury condominiums with prices of more than $2,000 per square foot are popping up. Empty lots, gas stations and family businesses have been swept away. Fancy hotels now charge upward of $400 a night for the privilege of crashing on the same Bowery where $4.50 bought a bed for the down and out. A luxury rental apartment—where one-bedrooms start around $4,000 a month—have replaced John McGurk's long closed but not forgotten watering hole.....Hamid Rashidzada bought a studio at 199 Bowery five years ago for $390,000, when prices had not yet begun to soar. Now, he needs something larger and is selling the apartment for $549,000, confident that at that price he will find a buyer, because it is tough to find an apartment anywhere on the Bowery for under $1 million. Seven years later, as of last week, 199 Bowery #4 is currently appraised at $1.4 million.* [175]

LEOLA DICKERSON

She lay on the floor for three days. A slip and fall had rendered her helpless—at the mercy of fate as neighbors came and went just feet away from her door. The mailman finally became concerned that she had not been picking up her mail and called 911. One is left to wonder if, during those three days, she drew comfort from the many family portraits hanging in her Pleasantville, New Jersey home.

Surrounded by a patchwork of smiling faces, Leola Dickerson was far from alone in life. Her husband, Mango, had died in Alabama with relatives, but Leola remained firm in her resolve that she had left the South and wouldn't be going back. After all, she was loved in New Jersey. As a lifelong housekeeper and caregiver for the Katz family, she had three generations of doting relationships; she had raised her husband's nephew, Joseph Dixon, as her own son (though the lack of a formal adoption would prove to be a vital oversight); and her husband's granddaughter, Constance Dickerson Williams, called and wrote to no avail after Leola's fall. None of these loved ones, though, would have a say in Leola's care at the end of her life. Rather, it would be Jay Stuart Dankberg, her court-appointed guardian, who would be steering the ship. His smiling face was not among those hanging on Leola's walls.

At eighty-six, Leola had one blood relative left—a younger brother named Johnny, who arranged for her transfer to a nursing home after her stay at a New Jersey hospital for treatment after the fall. A diabetic who would require a double amputation after Leola's death, Johnny was not in a

Leola Dickerson (1919–January 22, 2008) was a housekeeper for the Milton and Katz families. A court appointed a guardian before her death, and although she had enough assets for a traditional burial, no steps were taken to provide her with such. As a result, she was buried on Hart Island. *Courtesy of Dan Scott, Find a Grave.*

medical or financial position to be of much assistance, and when the nursing home diagnosed her with dementia and recommended a guardian, he didn't object. Leola's affairs and assets would now be managed by a stranger—a stranger whose pockets would be filled from those very assets. Leola's $88,200 home and $783 monthly Social Security check were not lucrative by any means, and mounting bills from the nursing home promised to diminish her value on paper even further. Four court-appointed lawyers would come and go as Leola's guardians, each either declining the appointment or failing at the job—unable to muster the wherewithal to file the basic paperwork for their entrusted ward.

A year into the guardianship process, the oldest son of the Katz family, Dr. Michael Katz, appealed the process only to be granted Dankberg's alleged expertise. Katz knew that protecting Leola's remaining assets had to be a primary focus, so he stepped in to safeguard her home from predatory lenders and paid for nearly $50,000 in repairs. Leola had cared for his mother until the end, after all, and now it was her hour of need. A lethal heart condition would quell his fight, and Katz passed away before he could right the wrongs a broken system had done to Leola. Her beloved home would provide a roof over the heads of squatters and looters.

While her loved ones fought for her final days to be spent in comfort, Leola slowly withered at the nursing home. After Joseph's initial hospital visit after the fall, he returned the following morning to find no trace of Leola in the room. Hospital staff would not divulge her location, and the lack of paperwork documenting his and Leola's emotional bond supported this refusal. Joseph continued searching for the only mother he had ever known.

Joseph had periodically visited Leola's home during the two years she spent at the nursing home he would never find. On one of these visits he saw

the open garage door. This had been the home of Leola's baby—a beautiful blue Thunderbird, which was her most prized possession. The garage door revealed empty space. The car was gone, and Joseph knew so was Leola.

At the time of her death, Leola's financial assets added up to $342.24, which went to outstanding legal and medical bills that had added up to more than $100,000. None of these debts would include a proper burial. Leola's body would once again lie alone—this time in the city morgue, for three months and twenty-one days. It is unknown whether she was one of eighty unclaimed bodies leant to medical schools during that time.

After an extended wait, Leola's body was finally granted a grave. She would share Trench 331 with 162 lost, forgotten or discarded dead. [176]

DORIS MCCREA

Doris McCrea (1912–July 10, 2012) was employed by Continental Grain Company as a bookkeeper. Despite having more than sufficient means, her court-appointed guardian failed to provide a proper burial for her. *Courtesy of Earl Abbe, Find a Grave.*

When Doris McCrea awoke from a fairly routine colon surgery, the thought of an unmarked grave on an island of death was not part of the plan. But Doris soon fell through a series of cracks in a broken system that would send her on a one-way ferry trip to Hart Island. [177]

She knew she was sick, but not *that* sick. Colon surgery was one of the many nuisances that came with age, but Doris wasn't planning on the operation suddenly revoking her ability to control her own life. Doris was organized, after all, and had retired from a decades-long career at the Park Avenue headquarters of Continental Grain, eventually leading its central files department. She had planned ahead for the challenges seniority would bring, minding her pennies and splitting time between a small space at Ten Eych-Troughton Residence, a low-cost living community run by the Salvation Army for women, and her home in Turner Falls, Massachusetts, where her beloved husband had been buried years before. She was planning to return to this living arrangement after surgery, but now there seemed to be a problem, and no small one at that.

The hospital had diagnosed Doris with dementia and was insistent that, in the absence of living relatives, she would need a court-appointed guardian. Doris vehemently objected, but the $4,618 in legal fees spent by the hospital while filing the guardianship petition would eventually be withdrawn from her savings. Martha Bomba, Doris's guardian, would arrange for her care at Queens Boulevard Extended Care Center, racking up well over $60,000 in bills to be paid out of the sale of her antique-filled home.

Two of those bills, noted as "luxury fund" and "burial fund," were charged to set aside money for Doris to be laid to rest alongside her husband in their home's Massachusetts backyard. Bomba had written checks from Doris's estate to cover these costs, but four months after her death in July 2012, Doris was buried on Hart Island, alongside 148 other bodies. Her case wasn't reviewed until exhaustive research and reporting by Nina Bernstein of the *New York Times* made its way into the ears of the funeral home where Doris's estate checks for burial had been assigned. It turned out that Doris's funeral funds had been left in escrow, and her final wishes had been lost in the shuffle from hospital to nursing home to hospice. When Bernstein's *Times* article ran six months after Doris's death, Doris was swiftly exhumed and reburied next to her husband, awaiting her proper headstone.

FAILURE OF GUARDIANSHIP

Both Leola and Doris became wards of the state and were provided with court-appointed guardians who were bound by law to "exercise the utmost care and diligence when acting on behalf of the incapacitated person," including creating an "irrevocable burial trust fund." Both women had the means for a dignified resting place, but neither was granted one. To examine their stories is to uncover a positive feedback loop of relationships between courts, guardians, nursing homes and medical institutions.

The guardianship system can fail, and it can fail miserably. Loopholes and lost opportunities for oversight leave space for predatory figures to seep into the framework of what should be the most entrusted network of professional relationships. The journey almost always begins at a hospital, which turns to the court system, which turns to a nursing home, which can sometimes turn to a machine-like guardian system that processes wards by the thousands. Surely this cannot be true of the majority of guardianship cases, but it is

doubtful that this would bring much solace to Leola, Doris or any of the other victims of court-appointed guardian failure.

"Adding insult to injury" is a kind phrase to apply to the practice of morgues turning over unclaimed bodies to medical institutions without first being sure of final wishes. It is true that our society produces a mass of homeless and otherwise devalued peoples, and there are many cases in which a body has no final resting place. In these situations, it is debatable how to maintain the dignity of the dead, and that division is not one easily summarized.

Misfortune can befall even the most vigilant, but there are means of self-protection. Formally naming a person one trusts to act as a guardian is perhaps the most vital, as well as documenting final wishes clearly in writing. As Leola Dickerson's loved ones discovered most horribly, it can be impossible to intervene in a court-appointed guardianship without sufficient evidence to support the objection.[178]

It was last reported that Doris McCrea's grave, while in its proper place, lies unnamed. As long as that remains the case, she still has much in common with the hundreds of thousands piled in trenches on Hart Island.[179]

15

AIDS

On a hot midsummer night in June 1969, a group of police officers stormed into Greenwich Village's tiny Stonewall Inn. Owned and operated by the notorious Genovese crime family, the bar had recently been transformed into a club for the neighborhood's emerging gay and lesbian community. The bar provided a relatively safe environment for customers to be themselves and had a don't ask, don't tell policy. When the police appeared, they dragged a handful of intoxicated people into the street for immediate arrest under the city's statutes, which allowed police to charge gay men with a misdemeanor for "solicitation of homosexual relations" and the vague but legally binding accusation of "inappropriate dress." Those involved revolted.

A melee ensued—customers fought back, ran out of the front and back doors and screamed at the injustice. I was recalled that "at one point, an officer hit a lesbian over the head as he forced her into the paddy wagon—she shouted to onlookers to act, inciting the crowd to begin throwing pennies, bottles, cobble stones, and other objects at the police." After arresting more than a dozen people and erecting a slipshod barricade, the police were confronted by hundreds of more protesters who joined from neighboring blocks. The crowd set fire to the bar, requiring a full squad of emergency firefighters to douse the flames and rescue many still trapped inside, including a writer for the *Village Voice*.[180]

For many New Yorkers, this confrontation was a long time coming, as Greenwich Village had traditionally been a welcome respite for gay and

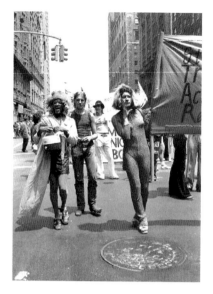

Sylvia Rivera (*holding the banner*) and Marsha P. Johnson (*with cooler*) at the Christopher Street Gay Liberation Day Parade. Both Rivera and Johnson are considered pivotal in starting the Gay Liberation Movement by igniting the Stonewall Inn Riots that took place in the early morning hours of June 28, 1969. *Courtesy of National History of the Lesbian, Gay, Bisexual and Transgender Community Center.*

lesbian people. The Stonewall Riots, as they came to be called, were a turning point for the gay liberation movement, whose tensions had reached boiling points in other parts of the United States, but whose actions had reached a fever pitch that fateful June night in Greenwich Village.

Its aftermath was impactful not only locally but nationwide, and in the wake of the Stonewall Riots, the United States saw the formation of the Gay Liberation Front, Parents, Families and Friends of Lesbians and Gays (PFLAG) and the Gay and Lesbian Alliance against Defamation, among other support groups and foundations. In 2016, President Obama declared the streets and neighborhood in the immediate vicinity of the Stonewall Inn a historic site.

PANDEMIC

AIDS, the acronym for acquired immunodeficiency syndrome, was a relatively unknown condition that, in the United States in the 1980s, largely affected the gay community. First reported in the United States in 1981, it quickly spread in a matter of months. HIV, or human immunodeficiency virus, the precursor to AIDS, was not listed on U.S. death certificates until 1987, though we can now say with relative certainty that HIV had already infected a large minority of the population long before it was identified

by medical professionals and infectious disease agencies. As a 2016 report states, "A new genetic study confirms theories that the global epidemic of HIV and AIDS started in New York around 1970, and it also clears the name of a gay flight attendant long vilified as being 'Patient Zero.'"[181]

It has been deduced from genetic evidence that the trail of the disease, from its origins in Kinshasa, Congo, wove a winding path from the Caribbean in the 1960s, to New York, to San Francisco, and later to Europe, Asia and Australia. The study explains, "Researchers got hold of frozen samples of blood taken from patient's years before the human immunodeficiency virus (HIV) that causes AIDS was ever recognized and teased out genetic material from the virus from that blood."[182]

While its origins remain somewhat of a mystery, its outbreak was both rapid and aggressive, with thousands dying from the vicious contagion in its earliest manifestations. Recently, researchers have theorized that AIDS may have originated as early as the 1920s in Kinshasa, Congo. From the sweltering colonial interior of the Central African basin, a perfect storm of population growth, sex and railways allowed HIV to spread. The report says a roaring sex trade, rapid population growth and unsterilized needles used in health clinics probably spread the virus. Meanwhile, Belgium-backed railways had one million people flowing through the area each year, taking the virus to neighboring regions."[183]

Part of the reason for the AIDS outbreak in New York City was the fact that many gay men from small towns and communities flocked to Greenwich Village, believing they could live there without recriminations. This concentrated nexus of gay men created an ideal environment for the disease, which eventually spread to tens of thousands of people. At a time when only a handful of social gathering places in the United States permitted the free expression of counter-culture sexual orientations, the urban center of New York, with bars like the Stonewall Inn and Mineshaft, was extremely appealing. Much like in its purported genesis in Kinshasa, a highly sexualized community, a lively drug culture with unsterilized needles and a modernized transportation link replicated in New York what had once been confined to a remote part of colonized Africa.

As Michael Worobey, an expert on the subject from the University of Arizona, argues, "New York City acts as a hub from which the virus moves to the west coast."[184] By 1976, AIDS had hit San Francisco, another scene amenable to counter-culture communities, where a bustling nightlife and drug scene only accelerated the contagion.[185]

ST. VINCENT'S HOSPITAL

Guitar runs soared, drums beat wildly and the bass thumped as the colorful lights played across the arena. In a flashy, glam-rock outfit, he pranced across the stage with his signature strut, belting out the verse to one of his band's iconic tracks, "Don't Stop Me Now":

> *Yeah, I'm a rocket ship on my way to Mars*
> *On a collision course*
> *I am a satellite, I'm out of control*
> *I am a sex machine ready to reload*
> *Like an atom bomb about to*
> *Oh, oh, oh, oh, oh, explode.*

Adored by millions the world over and highly regarded by fellow musicians, Freddie Mercury, the legendary front man of Queen, spoke highly of New York's gay club scene and can be seen in an iconic photo proudly wearing a Mineshaft tank top and a police officer's cap.

This bar, in particular, was notorious for its open sexual policies and its BDSM-friendly staff, which encouraged and facilitated these activities in its various dark rooms and recessed nooks. The same staff carefully screened patrons who seemed too uptight or squeamish, or who might be undercover cops. It was eventually shut down in 1985, technically for a liquor license violation, but in reality, the mayor of New York at the time felt the Mineshaft was radically accelerating the AIDS epidemic in the city. Though he never publicly admitted he was gay, it was likely from this very environment that Mercury contracted and later died from AIDS.

As biographer Mark Langthorne noted:

> *I would like to think that by now Freddie would have come out of the closet.*
> *The world has changed so much. He was a recording artist in the '70s*
> *and '80s, two decades when the level of homophobia is difficult for anyone*
> *born after 1980 to fully comprehend. In particular, Britain and the USA*
> *were scary places for gay people, and the onset of AIDS gave license to the*
> *religious fulminators and right-wing zealots.*[186]

Limited, successful treatments exist for those suffering from the virus today, but in the mid-1980s, if doctors were slowly beginning to comprehend the nuances of the disease, they were still blind as to how

to lessen or end its powerful punch and its potential to spread through normal human proximity.

A *New York Times* feature lamented in 1987, "As their days dwindle, these are things AIDS patients say they want most: cool sheets; a hand to hold; a promise that they will not have to bear too great a suffering, and that they will not have to die alone."[187]

Unfortunately, many primary care providers and mortuaries avoided and denied physical contact with living or dead AIDS patients, and few hospitals would admit verified cases of people stricken with AIDS for fear of contaminating their wards. Embalmers wouldn't touch their corpses. In many cases, those dying were essentially abandoned and left to fend for themselves, spending their last agonizing months in offbeat clinics, at home in sick beds or in one of the handful of hospitals that would provide care, like New York's St. Vincent's Hospital.

St. Vincent's opened in 1984 and featured the first AIDS ward on the East Coast. By 1986, a third of its hospital beds were occupied by AIDS patients. It was at rare places like this hospital that small expressions of hope, however futile, were seen in the form of a visit, or in simply being treated with human dignity. Many parents were ashamed of their sons' lifestyles and viewed AIDS as an unfortunate but inevitable end to what they viewed as deviant behavior, and many refused to see their sick children or acknowledge their conditions.

Robert Ruggiero, a funeral home owner in The Bronx, was among the first to accept and embalm AIDS victims. He recalled, "The parents would say, 'It's not our problem—just do what you have to do.' These families were so disheartened by the lifestyle their son was [*sic*] living. Some said, 'Just cremate him and mail us the ashes.'"[188]

Andrew Boynton, a visitor at St. Vincent's, recalled:

If Arthur was asleep, I'd sit and wait till he opened his eyes, just watching him breathe, holding the food or juice I'd brought him. Often, only a few minutes would go by before he woke, and he'd ask me about what had gone on in rehearsal that day (we danced in the same company). Sometimes we'd talk about what was happening to him—why he was there, what his treatment was, when he could leave.[189]

Despite cultural fears and aversion to discussing the issue—Ronald Reagan didn't even use the word *AIDS* until 1987—people, like Boynton, chose to step up and address it. In a colorful instance, New Yorker Eric Sawyer created

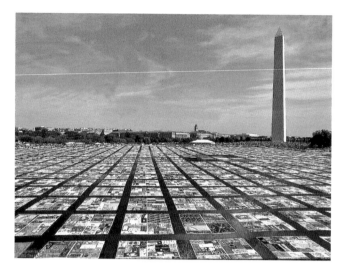

The AIDS Memorial Quilt celebrates the lives of people who have died from AIDS-related causes. Weighing an estimated fifty-four tons, it is the largest piece of community folk art in the world. *Courtesy of NAMES Project Foundation.*

an alter ego, Harmony Moore, a roller-skating fairy godmother, and would skate around the city, paying those stricken by AIDS a visit. As Sawyer noted in a recent interview, "It made us happy to be able to show these wonderful people that someone cared for them, that they weren't pariahs and that we loved them even if their families did not."[190]

For most, if not all of these early AIDS victims, death was all but assured. There were no reliable or effective preventative treatments to hamper HIV from turning into AIDS, and treatments would not become available until many years later. However, it was not just lack of access to quality, end-of-life care that victims were forced to endure—it wasn't until they passed away that their untold stories surfaced. Only miles away, a desolate rocky shore awaited—its untold dead mutely beckoning their new companions to join them in solemn repose.[191]

ABANDONED

After expiring due to complications resulting from AIDS—respiratory infections, organ failures and other immune system breakdowns—instead of a traditional departure from the hospital to a waiting mortuary and a potential family viewing, those who passed from the disease were quickly cordoned off by hospital security. Still fearing postmortem transmission, staff was instructed not to handle bodies and to await special AIDS-related

disposal teams from the city. Skipping the formality of a normal wake, their burials remained something of a unique and tragic twist in this bizarre episode of New York's history.

Hart Island, the little, mile-long patch of overgrown scrub in the intersection of the East River and Long Island Sound, had for over a century remained New York City's location of choice for interment of unclaimed and unknown persons. Officially controlled by the city's Department of Corrections, the island had been closed off to the public since 1976. Since the mid-nineteenth century, it has been the final resting place of the city's anonymous dead. From stillborn children, to homeless men and women who succumbed to unforgiving winters; to those whose families could simply not be located and who possessed no valid identification, the barren 101 acres of this potter's field provided their final resting place. "The term 'potter's field' is biblical, referring to a clay-heavy piece of land near Jerusalem bought with the thirty pieces of silver returned by a remorseful Judas to the chief priests. Worthless for farming, the land would be used to bury strangers."[192]

When unclaimed individuals die, they become state property and can be given away to a medical school as cadavers for dissection or to a mortuary training institution for student embalming practice. If no one was interested, they were shipped to Hart Island. Normally, the deceased would be loaded onto a ferry at nearby City Island in simple pine boxes, spirited across the channel, and carted by teams of convicts on prison work shifts into the designated "common trench" mass grave. A somber and rare photograph from 1922 captures three black inmates in blue state-issued coveralls paying their respects to the departed at the bottom of a recently dug trench. Here, on top of the bodies of the million buried over the ages, most of whom had already decomposed, they were unceremoniously committed to the dirt. Approximately one thousand more bodies are added each year, and on average, forty of those are eventually identified and returned to family members.

Many of these AIDS victims ended up on Hart Island, and crews dug deeper graves for them—fourteen feet deep—to ensure that any remaining pathogens could not reach the surface and spread from the grave. These graves were segregated from the general population of unclaimed bodies and restricted to the southernmost tip of the island. While this may seem overdone or outright disrespectful, we must remember just how unknown the transmission mechanisms of AIDS were when these burials were taking place. Regarding the first case of AIDS bodies reaching their final destination, a recent *New York Times* piece notes, "When these seventeen

bodies arrived in 1985, the island's hardened crews, used to burying dozens of indigent people per week, recoiled. These were different. They had died from a widely feared nascent disease."[193]

Only years later, when it was clear that the condition was not contagious by proximity, the bodies of AIDS victims arriving on Hart Island were consigned to the common mass grave. In fact, the seventeen aforementioned bodies are the only numbered graves in a burial site containing more than a million poor souls. Their muddy tombs contain small cracked stone markers with numerical designators rather than names.[194]

It was already hard enough to find a missing relative or friend on Hart Island, since if a name was even ascribed to a grave, only handwritten ledgers were kept, and these remained largely inaccessible to the general public. Compounding the issue were the legal realities of Hart Island. As a city-owned private island run by the Department of Corrections and closed to the public, the Island of the Dead wasn't exactly a welcoming place for relatives to visit. If family members were located, they were still unable to pay their final respects in any traditional sense. To this day, "mourners are restricted to an 8-foot by 10-foot gazebo near the dock, which offers no view of any of their loved ones' graves. No photographs are permitted, and they are under guard at all times."[195]

It's hard to pinpoint the exact number of AIDS patients who lie buried at the edge of the pine forests of Hart Island. We know that since 1980 at least 68,113 people have been buried in the potter's field. We also know the following:

> From 1980 through 2000, there were about 1,500 bodies buried on Hart Island from Bellevue Hospital Center, which had the city's largest AIDS treatment center. Another roughly 1,750 bodies came from St. Luke's-Roosevelt Hospital and nearly 1,500 from Harlem Hospital Center, both of which also had large AIDS wards. During the same period, nearly 1,000 bodies arrived from St. Vincent's Hospital, whose AIDS ward gained recognition as the epicenter of the medical fight against AIDS. Another 455 came from St. Clare's Hospital in Manhattan, another major AIDS treatment center.[196]

That's nearly five thousand additions to Hart Island.

Many other hospitals and clinics likely sent their deceased to Hart Island as well. If we consider that from 1987 to 2015, according to the Centers for Disease Control, 507,351 people have died from HIV, and we narrow

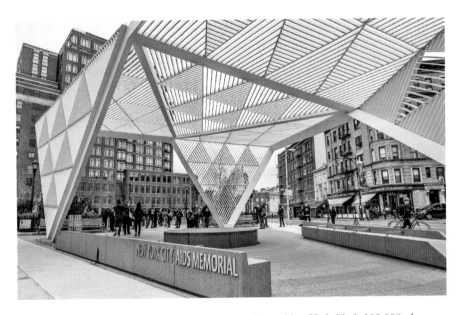

The New York City AIDS Memorial was built "to honor New York City's 100,000-plus men and women and children who died from AIDS." It is estimated that thousands of gay men were buried in anonymous graves on Hart Island. *Courtesy of NYC: The Official Guide.*

that number down to the state of New York, we are left with approximately 100,000 reported AIDS or HIV-related deaths. Conservatively, nearly one in ten of the people buried on Hart Island since 1980 were AIDS victims.

While the epidemic has abated and medical knowledge has expanded in the wake of the outbreak, AIDS remains deadly, and New York is still one of the highest per-capita cities for those afflicted. As of 2018, there were about 129,000 people living in New York with HIV. One in five of them do not know they are infected. In New York City alone, nearly 1,500 people die of AIDS annually.[197]

16

CADAVER RESEARCH

The biblical Ecclesiastes famously proclaimed that all men and women "share a common destiny."[198] He was, of course, musing about the nature of death as the great equalizer—the one certainty in life. While we often cannot choose when or how we die, we usually have control over what happens to our bodies afterward. Religions and cultures have different practices from traditional burial to cremation to mummification, but the common theme is the expectation that our wishes and beliefs will be respected once we pass away.

Unfortunately, this is not always the case.

In 2016, after an extensive investigation by the *New York Times*, New York University School of Medicine was forced to apologize for "Allowing bodies donated for use as cadavers by medical students to wind up in mass graves for paupers."[199] The *Times* reported that NYU had been collecting donated corpses—sometimes from wealthy patrons or those who donated large sums of money to the university—for either medical research or for medical students to practice. Before donating their bodies, the patrons had signed forms expressing their wishes for their bodies to be cremated and their ashes either returned to family or disposed of "in an appropriate and dignified manner."[200]

For some time, NYU made a point of publicly respecting and honoring those who had donated their bodies for medical research by holding regular ceremonies in which "medical students honor their 'first patients and true teachers.'"[201] With this in mind, it was no surprise that patrons who donated

their bodies to NYU's School of Medicine expected that their bodies would be looked after after they died. Instead, on more than one occasion, these bodies ended up buried on Hart Island.

Of the million people buried on Hart Island, it is unknown how many bodies made their way across the water after being used as medical cadavers for the New York University School of Medicine.

Ruth Proskauer Smith and Marie Muscarnera were two such New Yorkers. The reasons for their removal to Hart Island are unclear. Allowing the City of New York to bury a body on Hart Island saved NYU around $155 per body, but the university insists that financial gain was not the reason for sending bodies to Hart Island. The spokesperson was unable to shed light on why this practice that lasted until 2013 had taken place, though.[202] Spokesperson Lisa Greiner also said that the institution was not aware of how many donated cadavers were buried on Hart Island because records were lost during Hurricane Sandy and because the medical program's former director, Dr. Bruce Bogart, retired in 2013 and suffers from dementia

Ruth Proskauer Smith

Ruth Proskauer Smith passed away in her Manhattan home on January 22, 2010. Born on August 14, 1907, she spent her life tirelessly and proudly fighting for women's reproductive rights in America.[203] She was born into a distinguished family—her father, Joseph, was a judge on the New York state supreme court and her mother, Alice, helped found the Euthanasia Society of America.[204]

After graduating from Radcliffe College with a Master of Fine Arts in Medieval art, Ruth met and married Theodore Smith in 1932, opting to take his last name. Although the marriage didn't last, Ruth and Theodore had two children: a son, Anthony, and a daughter, Gael. By the time of Ruth's passing, she had six grandchildren and seven great-grandchildren.

Smith soon became a fieldworker for the Planned Parenthood League of Massachusetts in the 1940s and was eventually promoted to executive secretary.[205] During this time, she helped lead the movement to legalize contraceptives in Massachusetts. Ruth returned to New York in 1953, and with an interest in abortion rights, she directed family planning services at a local hospital. This would prove to be an eye-opening experience, as

Ruth saw the direct ways that a person's societal status impacted access to abortion procedures.

In the late 1960s, Smith helped found the National Association for the Repeal of Abortion Laws (NARAL). Four years later, the Supreme Court handed down the decision in the *Roe v. Wade* case, which legalized abortion throughout the United States. This was due, in no small part, to the tireless work of groups like NARAL and Planned Parenthood. In an oral history released for NARAL, Ruth recalls the historic Supreme Court case, stating, "There was much jumping up and down, and we all felt that we had won a very strong point." NARAL's work would continue after this, although the *R* was changed to stand for "Rights" to reflect the Supreme Court victory.[206]

Along with being a tireless fighter for women's rights, Smith's wit and tenacity was also well documented. In late 1999, she received a personal invitation to join the Republican Senatorial Inner Circle with an admission fee of $1,000. This was likely an error, as she was often at odds with Republicans. Smith happily crafted a reply to the senators who had invited her, delighting in the fact that she was on "President Nixon's enemy list," and that she would "contribute the $1,000 you are seeking from me, to Democratic pro-choice candidates."[207]

For her lifetime of service ensuring that U.S. citizens had increased contraception and abortion services, as well as the right to die with dignity, Ruth Proskauer Smith received a personalized birthday greeting from President Barack Obama and First Lady Michelle Obama for her 101st birthday. She spent her final years in New York assisting with pro-euthanasia campaigns. Even after she was one hundred years old, she spent time teaching other senior citizens about the Supreme Court. Ruth was 102 years old when she passed away in her Manhattan home. As her son Anthony said, "She died where she wanted to, when she wanted to, and as she wanted to."

MARIE MUSCARNERA

Marie Muscarnera was born into severe poverty in Brooklyn. Her family was quite large—an Italian immigrant family with ten children, they depended on her labor as a teenager to stay afloat.[208] Muscarnera's "fierce drive, dressmaking talent and shrewd investments" allowed her to accrue a sum of more than $1.3 million by the time she passed away at age ninety-one in 2005.[209] She left all of her earnings to charity, including $691,700 to the

New York University Medical Center at night. Due to an oversight, Ruth P. Smith's remains were sent to Hart Island for interment rather than being disposed of as her family wished. *Courtesy of New York University.*

New York University School of Medicine. She also donated her own body to be used by the school with the expectation that it would be cremated and buried or spread in a dignified and respectful manner.

Instead, after Muscarnera's body was used as a cadaver, the anatomy program paid $225 to a funeral home to transport the body to a city morgue. Her body ended up buried in a mass grave on Hart Island, unbeknownst to her family and friends for quite some time.

AFTERMATH

These actions garnered quite a bit of outrage, especially from friends and family who, upon learning that their loved ones' final wishes were ignored,

demanded answers. In a letter to the *New York Times*, Ruth Proskauer Smith's son, Anthony, wrote that she would have been outraged that her remains ended up in a pauper's grave after being used by the NYU School of Medicine, "not because she would have cared where she was disposed of, but because this hugely wealthy institution used this device to cheat the city by having taxpayers pay for burial."

Lisa Greiner, NYU's spokesperson, reassured the *New York Times* that donated medical school cadavers were no longer being sent to Hart Island for burial and when they were, it was not because of the cost. She told reporters, "As an institution, we weren't aware that this was happening. I promise you it's not happening now."[210] Several theories have emerged about why, if not for monetary reasons, the NYU School of Medicine would send bodies to be buried on Hart Island. One theory links this practice to confusing notification letters sent to surviving relatives. These notification letters changed wording several times, although none of the letters mentioned burial in the mass graves on Hart Island as an option. For several years, one official form incorrectly stated that unclaimed bodies used as cadavers would be cremated and then buried by the City of New York.[211] Not only does the City of New York not bury ashes, but it is also illegal for the city to cremate unclaimed bodies.

There are at least sixteen medical schools in New York State that receive at least eight hundred donated bodies every year.[212] The concern is that the lack of oversight and regulation means that Ruth Proskauer Smith and Marie Muscarnera may not have been the only medical cadavers who ended up on Hart Island. There could be hundreds more in similar situations.

In late August 2016, after the *New York Times* published its piece about Hart Island and the New York University School of Medicine, New York governor Andrew Cuomo signed a law banning the "use of unclaimed bodies as cadavers" unless there was explicit written consent from the deceased's spouse or next of kin, or unless the deceased explicitly registered as a body donor.[213] This ended the previous law, which was in effect for more than 162 years and required city officials to take custody of unclaimed bodies.

New York state senator Simcha Felder sponsored this new law, and he reiterated the wide range of evidence of lack of oversight and regulations when he said, "After numerous cases of unclaimed bodies being delivered to medical schools for uses that may have been in stark contrast with the religious or personal wishes of next of kin, this law now makes it illegal to show such disrespect to the deceased."

In an email, Governor Cuomo stated that "The death of a loved one is a time of unimaginable grief. It is vital that we take every possible step to respect and follow the wishes of the deceased and their family members regarding the disposal of their loved ones' remains."[214] The bill had actually been drafted in 2015 but was stalled and met with opposition until the *Times* piece highlighted the frequency of city-claimed bodies being buried on Hart Island. The old law only gave families forty-eight hours to claim a deceased relative's body before the City of New York was allowed to hand it over to facilities such as the New York University School of Medicine.

Even without unique factors, such as Hurricane Sandy destroying vital records and the onset of Dr. Bruce Bogart's dementia, it would still be impossible to tell how many bodies have gone from being medical cadavers to being buried in Hart Island's mass graves. The City of New York declines to publicly identify bodies in the morgue and those that it grants to medical schools.[215] This makes it very difficult to determine even a rough number of bodies that could have ended up on Hart Island, although it is possible that this number could be several hundred.

After the report by the *New York Times*, New York University's senior associate dean for medical education, Mel Rosenfeld, once again reiterated the university's sorrow, stating they "sincerely regret any actions on our part that did not reflect the wishes of those altruistic donors and their families who willingly donated their remains for medical education….In 2013, we instituted major changes to our disposition practices for donor remains that will ensure that we honor the donors' wishes with regards to their remains."[216]

It is unlikely that many of these bodies will be identified because, unlike Ruth Proskauer Smith and Marie Muscarnera, most bodies are not identified before the City of New York buries them. For those who do decide to donate their bodies, it seems that NYU has vowed to replace its practices with more regulated ones, ensuring that the wishes of the deceased are not disregarded in the future.

17

THE CHILDREN

Sixty or so prisoners overseen by an officer at the top of the trench carried on as they'd done the previous weeks of their burial detail rotation. Many had been ferried across the chilly waters of Long Island Sound from nearby Rikers Island and landed unceremoniously at the small dock. They were then hastily shuffled, under armed guard, to a barren patch of land just past the waterline. Dotting its bleak windswept landscape were nineteenth-century ruins, a grove of sparse and windblown trees and various signs warning curious people to "get off" and declaring the place the sole domain of the Department of Corrections. Only a few curious birds in the branches noticed anything out of place as their sheltered quietude was disturbed by this recurring motif. Once at the designated site, the convicts were handed shovels and put to work. As trucks loaded with cargo ground to a halt, their tailgates lowered with a heavy thud, and the convicts gathered themselves for another morbid day on their curious beat.

Digging a trench almost ten feet deep and sixty feet long, their shovels and picks clinking against buried rocks and roots, they signaled their guard to begin the familiar process. A *Los Angeles Times* reporter noted:

> *The tiny pine boxes were neatly stacked, five deep and five across, in Hart Island's sand and clay. The long mass grave, which ultimately will hold 1,000 such coffins, bore no names or monument. No funeral was held, no mourners could visit. The only memorial was a dog-eared, handwritten ledger of the latest arrivals: 'Baby Girl Saturn—3 hours,' 'Boy Samuel—1 day,' 'Anonymous.'* [217]

Rare photograph of a Rikers Island Prison inmate burying a child on Hart Island. *Courtesy of Claire Yaffa, Children with AIDS Collection.*

This is what it was like in 1986, when that reporter visited the potter's field at Hart Island to witness the burial *en masse* of children who were never given a chance at life. Of the island's one million buried people, it is estimated that one-third are children like these—the victims of still births, disease or any number of untold contingencies that take the lives of infants of primarily disadvantaged backgrounds. Ranked as the tenth worst in terms of infant and child mortality among the twenty-two largest cities that were surveyed in the mid-1980s, New York City provided a seemingly endless supply of unfortunate children to fill Hart Island's common trench.

Often lacking education on responsible contraception or the wherewithal to properly prepare for pregnancy, these impoverished women in New York were frequently faced with a doubly harsh twist of fate. Their children were more likely to be born with both congenital diseases and a deck stacked against them in terms of their ability to survive the first few weeks out of the womb.

When impoverished mothers give birth to infants who do not survive, and they are unable to cover the costs of a burial in a marked grave, city officials will usually inform them that that deceased child is slated for the city cemetery. Mothers are led to believe this is a typical grave they can visit, and many are truly astounded to discover that the city was referring to its mass grave off Long Island Sound. A tucked-away destination exclusively maintained and run by New York's Department of Corrections, Hart Island, beyond its physical distance, placed an even greater strain on loved ones and friends of the deceased through its strict no visitation policies. A few exceptions had been made, but overall, once anonymously laid to rest, the

dead were lost under the mud of ages and left to slowly decompose in their neatly stacked rows until the next mass interment of bodies replaced them. While modern medicine had cured polio, rid the world of smallpox and led to life-extending breakthroughs, the old curse of poverty—that seemingly constant thread in New York's history—still plunged many into despair and took a staggering toll on young children and newborns alike.

Squalor, Violence and Disease

We forget just how hard life was a few generations ago. While in 2018, New York City still contained the largest population of homeless people in a major U.S. city, generally speaking, human welfare has improved considerably. Consider water, food and sanitation standards as well as basic survival rates for the lowest rungs of society. In the mid-nineteenth century, when an influx of Irish immigrants flooded the shores of Ellis Island and settled in places like The Bowery and Five Points, one of the main issues they faced was basic sanitation. As the *Irish Times* reported in a recent retrospective, in parts of Manhattan in the 1860s,

> *Almost 300,000 people lived within one square mile. Rear structures were appended and floors were added, stacked precariously one on top of another. Rooms were divided and subdivided. It was not uncommon for five families—about 20 people—to share one room that measured 12 ft by 12 ft and had two beds and no table or chairs. There was no ventilation or sanitation inside, and human and animal waste piled up in the courtyards outside. Swine roamed freely, and dead horses posed a major problem on the streets.*[218]

Water contaminated with cholera, E. coli and dysentery, among others, were often lethal poisons for unknowing residents in poor districts. Mortality rates only dropped when city public health officials established regulated municipal water treatment facilities that infused chlorine and used activated charcoal, sand and other materials to kill off a host of deadly pathogens. In many cases, infant mortality rates were directly tied to drinking water that was contaminated through runoff and leaching from septic pits.

Refrigeration was also a major obstacle to overcome in the early days of electricity because it often did not reach lower-income neighborhoods. In

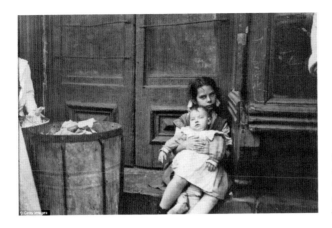

Girl holding Baby on Door Step taken by Jacob Riis circa 1890. *Courtesy of Museum of the City of New York.*

the winter, those living in New York City could chip blocks of ice for their in-house iceboxes, extending the length of food and warding off spoiling and bacterial breeding grounds. However, during summer months, this was impossible. Similarly, keeping diseases-carrying mosquitoes out of the household was a dilemma plaguing these early immigrants. While netting and mesh screens were useful, many still crept in through cracks and gaps in door frames. As typhoid, yellow fever, cholera and a whole panoply of epidemics raged in mid-nineteenth-century Manhattan, these young immigrants were beset by a wide array of challenges and threats to their offspring before they even counted their meager weekly earnings at the dinner table.

Spoiled Milk

Maternity was often one of the largest hurdles facing poor women in the slums of New York. Mothers frequently died during labor and suffered a whole host of complications from malnourishment and back-to-back pregnancies, as many of these young ladies were Irish Catholics who did not practice contraception. Reliable birth control would not be available for almost a century in any case.

Should a baby be born healthy—with a hearty complexion and a strong cry—he or she was still at risk from the ingestion of spoiled milk or a food-borne illness. As industrial agriculture was in its infancy and animal husbandry and milk processing were still largely local affairs, certain batches often carried disease.

Some milk was even contaminated by a dirty trick of the dairy industry. By feeding cows byproducts of distilled liquor, processers posed a grave threat to those unfortunate enough to buy a batch of this bizarre and poisonous milk. Many who purchased this "swill milk" were middle-class folk. It was an especially lucrative era to be producing cow milk because Americans considered it to be a highly nutritious substitute for breast milk. At the time, economic and societal pressures pushed women to wean their babies sooner.[219] As one researcher noted,

> *The cows in these stables ate the leftover grains from the fermentation process in the brewery or distillery. Unfortunately, the milk produced from these stables was very low quality and often full of bacteria. Even milk brought to the city from the country was often adulterated with water and carrying bacteria. With the rise of pasteurization, officials began touting milk as a healthy part of a child's diet. There were [sic] still a lot of bad or "loose" milk for sale at corner groceries though.*[220]

Hocked as "Pure Country Milk" by duplicitous dairy farmers trying to make a quick buck, this milk resulted in the deaths of more than eight thousand babies a year. Historian Richard Menkel notes that by the late 1830s, swill made up "between 50 and 80 percent of all milk consumed in America's large northeastern cities."[221] This scandal went unexplained until 1858 when a young journalist named Frank Leslie traced the source to swill milk. It was but one of the vast arrays of sanitary issues that beset those who lived in this age before federal and local health boards carefully monitored consumables.

Orphan Train Movement

In an age when abortion was taboo, difficult to obtain and often deadly, many children were simply abandoned by parents who could not care for them, leading local organizations and concerned citizens to take up the burden of a problem for which New York City was largely unprepared. The Orphan Train Movement was just such a charitable initiative established in 1853 to transport orphaned and homeless children from crowded inner-city slums on the East Coast to rural shelters in the Midwest. These orphan trains ran successfully from 1854 until 1929

and helped relocate nearly two hundred thousand abandoned and homeless children.

Three institutions—Children's Village, The Children's Aid Society and the New York Foundling Hospital—were behind the Orphan Train Movement's creation and operation. Supported by donations from wealthy donors and staffed by teams of volunteers and a handful of paid professional medical workers, it is estimated that nearly thirty thousand children from New York City were placed in foster homes throughout the country during the 1850s. The program only ceased when federal laws established nationwide foster programs for the needy and abandoned in the late 1920s.

There was more than a bit of moralizing going around in this, the height of the Victorian era, with its severe views toward sexuality and children born under less-than-wholesome conditions. While it is easy to dismiss these dispositions as arcane relics of an early-modern time, one must bear in mind just how difficult it was to enjoy sexual relations under the constant threat of unwanted pregnancies. While there was little a mother could hope for in terms of federal aid or foster care, some of the earliest children's hospitals admitted poor and abandoned children and

> *many people during this era believed that immorality and poor character caused poverty. Since sickness and poverty often appeared together, providing spiritual guidance and moral uplift to the ill, in addition to offering food, clothing, and whatever other material provisions were needed, was supposed to help the poor rise above their condition and facilitate better health. Stratifying the needy into "deserving" versus "undeserving" categories helped charitable organizations and hospitals decide which individuals to aid. Because indigent children were considered the innocent victims of their parents' bad choices or unsuitable lifestyles, they were, by definition, always deserving of assistance, and aiding them engendered little controversy.* [222]

These orphans were exposed to wealthy patrons who served as role models—at least in theory. Given few therapeutic treatments and little medical attention, they were expected to adsorb useful values and a strong work ethic and sense of purpose from their time under the aegis of their adopted caretakers. A historian notes, "Staff and trustees often discouraged or made it difficult for parents to visit their children, hoping that prolonged contact with staff would facilitate Americanization in immigrant children, and inculcate middle class behaviors and health practices among the native-born." [223]

The Mothers

More than a century later, this lonely saga would continue with mothers searching desperately for closure only to discover an unmarked grave, a number or nothing at all. MJ Adams, from Rapid City, South Dakota, who is now middle aged, discovered much too late that her stillborn child lies under the potter's field. Her husband, Walter Albasi, said, "MJ and I were reading the paper one Sunday morning last year, as we do, and I looked over and saw she was crying…. She handed me the story [about Hart Island] and said, 'Is this where my baby is?'"[224] It was a full fifteen years after a hospital in Manhattan had sent her stillborn baby to Hart Island.

Adams, who now owns the Corn Exchange restaurant in Rapid City, was living in New York City in 1995 with her then-husband, Carlos Gabard. Medical officials, after an ultrasound and follow-up exams, quietly told her the terrible news: her full-term child had died in utero. Lacking the cash to afford a proper burial, Adams and Gabard signed a release form that consigned her stillborn child to what hospital workers referred to as the "city cemetery."

She recalled, "We were so poor. We had a crib and the baby clothes that I'd gotten at a baby shower, but we didn't have money for a funeral or a mortuary."[225] When she returned to the hospital a month and a half later to follow up with doctors who had promised her a comprehensive autopsy of the child, she discovered that it had not be performed. Alarmed, she asked frantically where her child was taken, but no one could provide an answer.

That same year, Rosario Lucero, a Mexican immigrant living in New York City, gave birth to a stillborn baby girl at Elmhurst Hospital in Queens after a doctor botched an attempt to reposition the child in her womb. After the ordeal and subsequent postpartum trauma, she was told by an orderly that the child would be taken to "an island." Her other daughter Marie remembers, "My mom never got any information about where she was taken. My mother doesn't speak English well and the city wouldn't give us any other information."[226]

As Hart Island has come into the spotlight, it is clear that these cases were not uncommon. But still the phantom pain of the lost child lingers, casting its long shadow over whatever sense of progress mothers feel they might have made since that day was forever burned into memory.

Dr. Laurie Grant, an obstetrician and gynecologist from Valhalla, New York, waited nearly eighteen years to discover that her own stillborn baby was buried in a common trench run by prison inmates. It was reported that

"Grant's daughter was born via Cesarean section on July 13, 1993, at Lenox Hill Hospital in Manhattan following a difficult pregnancy that almost cost her own life. It was later discovered that Grant has a rare autoimmune disorder, mixed connective tissue disease that may have resulted in her illness during pregnancy."[227] During her convalescence, a scene eerily similar to Rosario Lucero's unfolded. A nurse informed Dr. Grant that her child would be properly buried and that relevant information regarding her whereabouts would eventually be passed along. In a recent interview "Grant emphasized that she did not give legal consent for her baby's burial in a mass grave. 'I almost died,' Grant said. 'I was so sick, and also, now in grief, I wasn't thinking of the baby being buried.'"[228]

In 2015, however, despair gave way to hope. Through civilian pushback and a federal class action lawsuit, the City of New York settled with the New York Civil Liberties Union to grant access to parts of Hart Island for visitation of the common trench. The city agreed to ferry family members

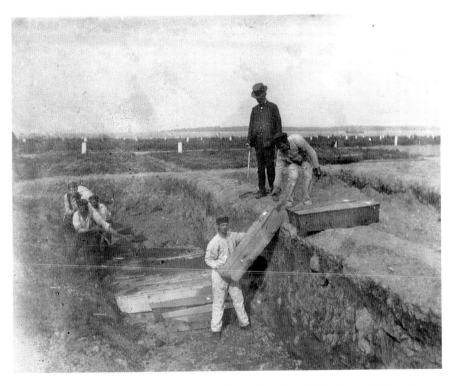

The Potter's Field—The Common Trench taken by Jacob Riis circa 1890. *Courtesy of Howard Greenberg Gallery.*

and friends to the island and permitted them to leave mementos on grave sites. It did not restrict the number of return visits or limit the number of people who were allowed to come in individual groups. A *New York Times* reporter noted, "Until the settlement, the only public access that the Correction Department had ever conceded, under jail-like restrictions, was to a rough-hewed gazebo close to the dock—not even in sight of the burial places of daughters and sons, sisters and brothers, mothers and fathers, grandparents and grandchildren."[229]

A breakthrough victory for mourners who sought closure, it also painfully reopened emotional wounds that had lain dormant for, in some cases, decades. Rosario Lucero's daughter lamented, upon receiving word that they'd soon be allowed to visit Hart Island, "For twenty years my mother and I have waited to visit the grave of my baby sister. It will be very difficult, but finally being able to visit her grave will allow us to mourn the sister and daughter we never got to know."[230] Nine days later, on a warm July day, after the somber and stoic ride across the placid waters of Long Island Sound, a reporter observing them at the grave site solemnly noted, "They only held each other and wept, saying their own prayers, and speaking softly to the quiet earth."[231]

LLOYD "BUFORD" THRELKELD

LESSON ONE

The idea is simple. Everyone, from the time we're children, has blown into an empty soda or milk bottle. The sound, while not terribly easy on the ear, is unique; it gets attention and can be easily repeated and perfected.

All one has to do is hold the opening of the bottle to the mouth and buzz the lips about an inch from the rim. The sound may resemble many things depending on the person: a distant fog horn, a bat snoring in a humid cave, a sexy chord on a bass guitar, a plump note on a tuba and on and on.

This is the basis of jug band music.

You've probably heard or listened to jug band music at some point in time. This particular, homegrown American genre made clever use of something that would normally be discarded or refilled—usually with whiskey—the lowly, glass or ceramic jug.

Remarkable variations are possible by altering the lip tension to create a higher or lower pitch or altering the amount of breath blown to produce a shorter or longer note. An accomplished jug player could produce sounds with a traditional two-octave range.

Jug bands were first seen in early African American vaudeville and medicine shows that peddled sketchy miracle cures during band breaks. The jug band genre was prolific in Louisville, Kentucky, and Memphis, Tennessee, in the heyday of urban southern blues, jazz and ragtime. Later, it would also be incorporated into good ole rock and roll.[232]

Lloyd Buford "Whistler" Threlkeld (April 18, 1893–September 1, 1935) was a pioneering jug band musician. His jug band was among the very first to be recorded. *Courtesy of Nose-Flute Blogspot.*

LESSON TWO

Have you ever heard of the nose flute? (Don't laugh until you've heard one.) This sound is more difficult to make with random stuff hanging around the house.

Yes, flutes as reed instruments are almost always played by delicately blowing into a series of tiny holes in a long, pipe-shaped instrument. This produces languorous, serene notes (think yoga) or quick, spirited ones (think a Fourth of July parade). But the art of fluting does not stop there.

The first nose flute was invented and patented as the "Nasalette" by Irishman William Carter (1846–1919). His family came to the United States when he was five years old and settled in Lockport, New York. He worked as a tinsmith all his life and died in Rochester.[233]

The nose flute, which can be made of wood, plastic or metal, can produce the same kinds of whistling or lyrical sounds as its traditional relative. The only difference is that the nose flute is, of course, played by exhaling air from the nose into a small kind of contraption that, for lack of a better image, might resemble the facial part of a Halloween costume if one decides to dress as Porky Pig.

DOUBLY BLESSED: "THE WHISTLER"

Now, combine the idea of jug band music with the nose flute, and enter the world of one of America's foremost jug band leaders, Lloyd "Buford"

Threlkeld (1893–1935). Known as the Whistler for his ability to make sweet, melodious sounds emerge from his practiced nose flute, he also played guitar and sang. Band member Willie Black was a staple in his group, playing homemade banjos and banjo-mandolins. Whistler and His Jug Band was one of the most famous jug bands of its time.

Buford Threlkeld was born in a tiny town called Eminence, Kentucky, and moved to Louisville around 1910. He formed a string band, adding a lively jug player as the genre grew in popularity. While the band was mostly based in Louisville, the group toured as far north as New York City and Washington, D.C.

In 1932, he moved to New York and lived right in the center of Harlem. He continued performing but stopped recording. In May 1935, he was admitted to Bellevue Hospital with tuberculosis. He died in September of that year.[234]

Threlkeld was a known entity. He had a successful public career and following. His music had been recorded and performed by jug bands around the world. But he died without recognition and without company. He was buried along with so many others of similar status in the vapid earth of Hart Island.

In 2013, Buford Threlkeld was posthumously inducted into the Jug Band Hall of Fame.[235]

"It'll Start With a Smile"

John Sebastian, formerly of the pop group The Lovin' Spoonful, was so taken with jug band sounds that he reproduced them for many of the group's songs. He described the sound as "poinky, slapping emanations… basic to the roots of rural, social black music…acoustic blues and ragtime. It's the kind of 'Saturday night' music that rustled up lively 'hokum tunes' and 'dirty ditties.'"[236]

"Foldin' Bed," recorded in 1931 by Whistler and His Jug Band with RCA Victor, was one such suggestive number that urged a woman to get a folding bed and keep it folded so no other man could join her in it when her husband was away.[237]

19

THE HART ISLAND PROJECT

For almost a century and a half, the nearly one million people who rest under the potter's field on Hart Island have had no voices. Their surnames, interests, past experiences, friends, families and places of origin have largely been lost to history, consigned as they are to a common trench. As city officials and public health figures found a convenient spot to dump the unknown and the Department of Correction's officers patrolled their desolate patch of channel dirt, the rest of the world moved on, unaware that the largest mass grave in the United States was but a stone's throw from New York City's glow. This changed in the early 1990s when one of Hart Island's most notable figures entered the picture, drawing not only much needed attention to this forgotten chapter of American history but also much needed relief and closure to families whose relatives and friends were committed to the shallow trench. These are stories that are not told, that the public hasn't had access to. As F. Scott Fitzgerald said, "What people are ashamed of makes for very good stories."[238]

MELINDA HUNT

Such were the sentiments of Melinda Hunt, a pioneer and self-described historical steward of Hart Island. Her personal collections of original correspondences, archives of burial logs, city records and on-the-ground

detective work have exposed major problems in the way the impoverished and unidentified have been handled over the 150-plus years of Hart Island's existence. A Yale-educated sculptor, visual artist, local historian and public activist, Hunt began her journey as the preeminent authority on Hart Island in 1991 when she visited the potter's field with photographer Joel Sternfeld, only months after becoming a naturalized American citizen. A retrospective from the *New York Times* noted on Hunt and Sternfeld, "Their work led to several exhibitions and public art projects in New York and Europe, a dance and theater production at Lincoln Center and a book of photographs, *Hart Island*, published in 1998. It was the last year any private individual was allowed to photograph the island. Ten years later, she directed *Hart Island: An American Cemetery*, a documentary film that follows relatives in search of loved ones buried on the island."[239]

Hunt was born in Canada and came to the United States in 1977, moving from Manhattan to Peekskill, New York, in 2010. Her outsider's perspective has been a strength for her—she has approached the subject not out of indignation but with a curious interest in unveiling the mysteries of this strange place. She had no friend or loved one buried there, but found the story was waiting to be told despite the shroud of secrecy that hung like a channel fog over the few acres of the island's rocky coast.

Her efforts reached the public with the creation of the Hart Island Project, a now digitized collection of information pertaining to burials at the potter's field. Started after her visit in 1991, it first consisted of collecting data from old city records and collating files and correspondences to paint a loose picture of the scope of Hart Island's history. From her home office, she would receive letters and calls from concerned relatives and friends and even arranged a memorable visit, which she and Sternfeld photographed, involving a mother seeking closure of a buried child. Hunt recalled in an interview,

> *The Hart Island Project…was the subject of censorship by the city in 1993. This led me to produce a public artwork at Madison Square Park in 1994, celebrating that park's history as a potter's field and the artwork, Circle of Hope, which led to the revitalization of Madison Square as well as the current, seasonal public art program at that location. The Hart Island Project was the inaugural exhibit at the Lower East Side Tenement Museum in 1997–98.*[240]

For the past quarter century, Hunt has independently aided families in obtaining copies of public burial records. Over the course of 2008 and 2009, Hunt received two Canada Council inter-arts grants, which enabled her to build her online community database and focus on her Hart Island art installations. Hunt also acquired fifty-eight thousand burial records through Freedom of Information Act requests and legal petitioning. For the next three years, information garnered from these once-secret records were logged in an online database by volunteers all over the world.

By 2011, she felt satisfied that she had finished compiling material and information pertaining to death records, which date back to 1980, and went live at www.hartisland.net. With search fields that include information such as burial locations, possible plot numbers and other curiosities that might have come her way over the years, the Hart Island Project's rich digital history may be the most valuable tool for those seeking answers of long-dead relatives and friends. Hunt's efforts have not been solely historical: The Hart Island Project has led to limited access to Hart Island after a class action lawsuit with plaintiffs who rallied behind Hunt. It has also resulted in legislation that requires the Department of Corrections to upload burial records on a public online forum, which was never considered before Hunt's clarion call was heard.

TRAVELING CLOUD MUSEUM

The Hart Island Project's website contains a beautiful and interactive digitally mapped grave and trench marker, complete with GPS coordinates if locations are known. Created in 2014, this Traveling Cloud Museum houses publicly submitted stories of people who are listed in interment logs but are otherwise unknown. This feature of an already impressive and visually rich site allows individuals to share songs, videos, old pictures and anecdotes about deceased members who have been laid to rest in the potter's field, breathing new life into the common trench and finally giving the millions buried there some semblance of dignity and respect. Hunt notes,

> *The website has grown because we are continually adding burial data and now GPS information. We now have mapping tools combined with burial information and user-added stories. I was lucky enough to get a new media*

grant from NYSCA in 2011 and found willing collaborators in graphic designers Studio AIRPORT, front-end developers Red Dot, and back-end developers Inspire Innovation, all based in Utrecht, Netherlands, to build the Traveling Cloud Museum.[241]

She has also included a clever series of timers on the Traveling Cloud Museum tab that count down the years, days, minutes and seconds from the time an anonymous person was buried on Hart Island to the time someone identifies them—a grim and pressing reminder that hundreds of thousands remain to be claimed.

Hunt is also an award-winning visual artist who has showcased her talents and her cause in a variety of notable outlets. She claimed, "My intention… is to make the invisible visible." Hunt continued, "The various processes of my work are an attempt to understand things well enough to be able to tell a story that hasn't yet been told." [242]

An art exhibition featuring people located through the Hart Island Project was held at Westchester Community College in 2012. Entitled *Shades of New York*, the exhibition presents a series of ink drawings of people who were buried on Hart Island between 1980 and 2010. Set against large black-and-white photographs of Hart Island landscapes, some of which were shot by Jacob Riis, sketches of what the people might have looked like starkly juxtapose the desolation of the potter's field. Based on snapshots sent by family members for whom she helped locate deceased relatives, these twenty-six-by-forty-inch portraits set on thick landscape paper and drawn with Japanese sumi ink bring a human element to a subject the city has purposefully kept under wraps.

Hunt noted, "These sketches are the first time I'm actually seeing the people who are buried."[243] She spoke of a particularly tragic episode captured on the canvas which details the death and burial of Sidney Grimes, a New York City employee: "He came up out of the subway on September 11, and a body fell from the sky on top of him. He survived but developed post-traumatic stress disorder, and one day he wandered off."[244] Grimes later died at Bellevue Hospital in 2004 and was buried on Hart Island. In his portrait, Hunt portrayed his torso being pierced by a gnarled tree whose twisted roots have been torn from the ground. His left arm reaches skyward from behind a barbed wire fence, grasping for something, anything.

She plaintively concluded a recent interview with the *New York Times* stating,

The drawings mark the end of a long journey that begins when someone goes looking for someone else, and they care enough to tell me the story and give me a photo. People can now search the records without contacting me, so my drawing is really collaboration with someone I may never know, to tell a story about someone whose identity has been lost. For me, even though many of the stories are dark, the process is hopeful because the person has been reclaimed.[245]

CONCLUSION

Perhaps best known as being engraved at the base of the Statue of Liberty, the final lines of "The New Colossus," a sonnet by American Emma Lazarus, read, "Give me your tired, your poor, your huddled masses yearning to breathe free, the wretched refuse of your teeming shore. Send these, the homeless, tempest-lost to me; I lift my lamp beside the golden door." [246] This engraving promises hope and freedom to all who visit New York City and, by extension, the United States. But what happens to these tired, poor and homeless? What happens to those who die in New York City but cannot—or will not—pay for a funeral? After all, the dead have to go somewhere, don't they?

The answer lies closer than most think. On another island, twenty or so miles northeast of Liberty Island, a place known as Hart Island exists. This island does not see many visitors, and unlike Liberty Island, many New Yorkers know nothing about it. Perhaps it is easier that way. Hart Island is a mass grave. It is a place where the poor, the indigent and the unknown are buried by the city. No funerals are held. No funerals are needed.

The island is maintained by the Department of Corrections, and inmates from nearby Rikers Island carry out most of the burials. [247] Since 1869, it is believed, more than one million corpses—including almost three hundred thousand infants—have been buried on this tiny island. [248] Those buried here do not receive the luxury of an individual grave, as luxury is not a concept familiar on Hart Island. Practicality serves as the main theme on the island. The dead are placed in wooden coffins and buried in giant trenches about

ten feet deep. The coffins are stacked like building blocks in rows three high and six wide. It is more practical this way.[249]

But Hart Island hasn't always been a mass grave. In the past it functioned as a Union Civil War prison camp, a tuberculosis sanatorium, a boy's reformatory and even a missile base.[250] Although many New Yorkers are blissfully unaware of Hart Island, a rare few may know it by another name. Hart Island is more commonly known as a potter's field, which is a biblical term referring to the "burying place for strangers" that was bought with the thirty pieces of silver Judas received for betraying Jesus. Indeed, the island may have an almost biblical feel to it, as the mass grave reminds you of an ancient necropolis or the great Pyramids of Giza. Similar to these sacred places, no one visits Hart Island without an appointment.

When first learning about Hart Island, the obvious questions present themselves. There are questions about the dignity of mass graves and the unfairness of restricting access to the island. And the most pressing issue: eventually, and it seems sooner rather than later, Hart Island will run out of space. With about a million people buried on the small island, it is only a matter of time before there is no more space for corpses.

THE BURIAL CRISIS OF 2042

This leads to an ever more pressing question: What happens when the world runs out of space for the dead? Hart Island was originally purchased by the city of New York in 1868 when it became clear that the existing cemetery space was unfeasible.[251] If New York realized that it would need extra space to bury its dead, then what about more densely populated cities? What about Shanghai, Beijing or Tokyo?[252]

When we think about issues affecting the world like overpopulation, the amount of plastic we use or the lack of space for the dead, it is very easy to dismiss this issue as being far away. It is easy to say that this issue will only present itself in the far future, and there's nothing we can do about it right now. Sadly, this could not be further from the truth. This lack of space for new corpses is not new. It is known as the burial crisis, and it is truly staggering to see just how imminent it is.

As it stands, it is expected that seventy-six million Americans will die before 2042. If we were to bury all of them, it would require land roughly the size of Las Vegas.[253] But it isn't just America facing this crisis. The world is seeing

a shortage in space for burying the dead. Of the thirty-two boroughs in greater London, eight are completely full and have ceased providing space for burial services, and it is believed that another ten will run out of space within a decade.[254] Officials have reported that if there is no change to the number of corpses buried and cremated, Sydney will run out of space for the dead by about 2051 and there will be "widespread unavailability of graves" by as soon as 2036.[255] The situation seems dire, with countries around the globe expecting to run out of space within the next few decades. But for the citizens of Hong Kong, the crisis is already here. Thousands of families are forced to store their loved one's ashes in crude sacks in funeral homes, waiting up to five years for space in local cemeteries.[256]

Sydney, Hong Kong, London and New York, as well as many others around the globe, aren't sitting idly by and waiting for the burial crisis to reach boiling point. Rather, they are acting and attempting to alleviate the crisis through several solutions.

One common solution is grave recycling. This process involves removing remains from older graves and burying them deeper in the same grave so the old space on top can house another body.[257] This process is known as "Lift and Deepen" and is already being used in some parts of Australia and Europe. Theoretically, this process could be repeated indefinitely or at least until digging deeper became unfeasible. By that time, cemeteries would operate similarly to Hart Island and would essentially transform into mass graves. Other ideas that have been used involve tearing up paths, flowerbeds and other decorative aspects of a cemetery to create space for new graves.[258]

It may seem shocking or even disgusting to hear about graves being recycled. It is natural to want our loved ones' remains to be respected. Many South Australian residents were reasonably shocked when more than

If all Baby Boomers alive in 2019 were to opt for a traditional funeral, the space required would be the equivalent of Las Vegas. *Courtesy of Travel Vegas.*

four hundred headstones were bulldozed in 2014 as part of Dudley Park Cemetery's ongoing effort to recycle graves.[259] But the reuse of headstones, and entire graves, isn't a new occurrence. In fact, it has been happening for thousands of years.

According to the Population Reference Bureau, more than 108 billion humans have been born in the history of humanity, and 97 percent of them have already lived and died.[260] Because cemeteries were so overcrowded that bodies were literally "stacked on top of one another," people in eighteenth-century France had to create the underground catacombs beneath Paris.[261] Similarly, Europe saw such an overwhelming amount of people die during the Black Death that normal burial procedures were suspended because the population was more concerned with disposing of the bodies as quickly as possible.[262] Like Hart Island, mass graves were used.

But these temporary fixes are just that: temporary. While they do alleviate the pressure facing cemeteries, they still result in burying full corpses and, as such, can't offer much more than a band-aid fix. So, where do we go from here? Perhaps we need a solution that reduces the size of corpses buried so they take up far less space than they currently do.

There are at least two options in this regard. The first option, and probably the most well known, is cremation. Cremation is the combustion and vaporization of corpses into smaller compounds, such as ash. It is clearly a popular method, with about 30 percent of people choosing this option.[263] Resomation, while less well known, is also a worthwhile consideration. Also known as "green cremation," resomation involves a chemical process that reduces the body to water and bone, which are then turned into a fine white

Rendering of an underground cemetery under construction in Jerusalem. *Courtesy of* Times of Israel.

powder like the ash created through cremation albeit with a less damaging impact on the environment.[264]

While cremation might seem like the answer on paper, unfortunately the reality is not as simple. Religious and cultural factors come into play and severely limit the degree to which we can cut down on having to bury full bodies. Southern Italian families, for example, generally wish to be buried above ground, and Islam dictates that cremation is prohibited, and Muslims must be buried in their own individual areas.[265] Similarly, there is a passage in Genesis in which God says, "For dust you are—and to dust you shall return."[266] Because of this, Jewish law states that all bodies must be buried separately in (or at least connected to) the ground. Chinese culture places a stricter emphasis on full burials—a proper burial is seen as "the most important thing you can do for your parents."[267] In fact, when parts of Northern China declared cremation as the only option for the deceased, there was an increase of elderly people committing suicide, as they would rather die earlier and be guaranteed a proper burial than die at an uncertain time in the future and risk having their body cremated.[268]

Burying bodies in the traditional way will always be in demand, so other methods of fighting the burial crisis are needed. Often the simplest method is the most effective. Hart Island has shown us that mass graves work, at least in some capacity. As we already know, more than a million people are already buried there, and the island still has room for more—what other cemeteries can boast the same? If we want to survive this burial crisis, it appears we need to devote large amounts of space—islands even—to producing mass graves. It sounds grim, and it will take some getting used to, but the alternative is having nowhere at all to bury our dead.

Hart Island isn't the only place experimenting with mass grave burials. In downtown Tokyo, a futuristic cemetery known as Ruriden replaces graves and tombstones with small Buddha statues. Each statue represents a deceased person, and visiting relatives simply have to swipe a smart card for the corresponding statue to light up, allowing the family to see where their loved one is resting.[269] In a densely populated country such as Japan, space-saving technology is necessary, especially when it comes to the dead. By using technology, Ruriden hopes to act as a form of mass grave where cremated remains take up less space than before.

Similarly, in Mumbai, India, officials have begun constructing a tower with the belief that "if you can't go down, there is nowhere to go but up."[270] The Moksha Tower will be split into four sections for the four main religions practiced in Mumbai. The idea is fairly straightforward: rather

A new burial solution could involve a floating cemetery, as seen in this Hong Kong proposal. *Courtesy of CNN.com.*

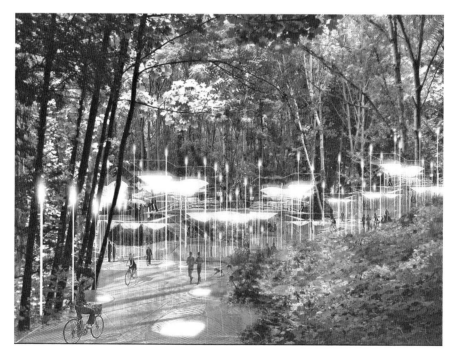

A prototype of the Sylvan Constellation—a futuristic design for cemeteries that proposes a network of memorial vessels that transform biomass into elegant and perpetual renewable constellations of light. *Courtesy of Columbia University Graduate School of Architecture.*

than burying bodies in the ground, why don't we bury them in the sky in a series of skyscrapers?

Lastly, Israel has attempted to get the best of both worlds. Because cremation is uncommon in Israel, the country requires a lot of space for its dead. In response, subterranean catacombs are being made under Jerusalem[271] and seventy-foot-high skyscraper cemeteries are being built in Tel Aviv.[272]

So, where does this leave Hart Island? It is easy to see that Hart Island presents a solution to overcrowding. It is currently a potter's field—a place used to bury New York City's poor and destitute, but it could be used to house all of the city's deceased. It isn't outrageous to suggest that Hart Island could have been managed better. The Parks Department may have had more success running the island than the Department of Corrections, and public access absolutely must be allowed, especially for relatives of the deceased. The island's faults aside, it makes a strong case for mass cemeteries. Central, easily accessible locations, such as Hart Island and the facilities in Japan, Mumbai and Israel, present far better solutions to the crisis than individual cemeteries ever could. If we continue to do nothing, we will eventually run out of space for the dead, and we will look to Hart Island and wish we'd done something sooner. As many learned from Superstorm Sandy, sometimes it takes a great tragedy to reveal a deeper truth.

APPENDIX

ISLANDS OF DEATH

The island was named for Abraham Riker (originally Rycken), a Dutch immigrant who purchased the 413-acre plot of land in 1664. His family owned it until 1884, when it was sold to the City of New York. However, during the late 1800s, a family descendant named Richard Riker served as a New York City criminal court judge and was notoriously recognized for abusing the Fugitive Slave Act by sending (or selling) free African Americans living in New York to slave owners in the South. Many of these Americans were labeled as "fugitive runaway slaves" without the benefit of due process to prove they were, indeed, free.[273]

Rikers Island

Rikers Island is New York City's most infamous jail and rated one of the ten worst facilities in the country.[274] It has sustained a reputation for inmate violence, staff brutality, rape, adolescent abuse and mistreatment of the mentally ill. It also has one of the country's highest rates of solitary confinement. Unsurprisingly, inmate assaults on uniformed and civilian staff are also common, making Rikers Island one of the most dangerous places to work.[275]

The jail complex is actually composed of ten separate jails situated in Manhattan's East River between Queens and the mainland of The Bronx. It is adjacent to the runways of LaGuardia Airport.

In 2012, the Legal Aid Society brought a lawsuit against New York City claiming "a deeply entrenched pattern of violence by the guards," who doled out "unlawful, excessive force with impunity" These events often sent prisoners to the hospital with serious injuries, incurring millions of dollars in treatment and legal settlements for the city. But the New York City Department of Corrections continued to build more than one thousand additional solitary cells as well as special units with undefined purposes, for adolescents and the mentally ill.[276]

In its early development, Rikers housed one of the world's largest correctional and mental institutions. Its broad expansion was accomplished by inmates hauling ash and compacted trash bales delivered by barge from Manhattan to be used as landfill. Just seven years after the prison opened, a Bronx court condemned living and operating conditions inside the prison, noting its filth, overcrowding and the growing presence of contraband. [277]

The strange thing about Rikers Island is that at least 85 percent of its inmates have not been convicted of a crime. Rather, these individuals are detained on a pre-trial basis, held on bail or remanded to custody. The rest of the population has been convicted but serve relatively short sentences.

Randall and Wards Islands

Randall Island and Wards Island were originally two distinct islands narrowly separated by a small channel of water once known as Little Hell Gate. In the mid-1960s, construction rubble from Manhattan was used to fill the gap between the islands. Inmates provided the labor and the islands were renamed as one entity: Randall and Wards Islands.

The islands are separated from Manhattan by the Harlem River; from Queens by the East River and Hell Gate; and from The Bronx by the Bronx Kill—a strait defining the southernmost area of The Bronx.[278]

In 1637, the idyllic islands were purchased primarily for farming from its native inhabitants by Dutch governor Wouter Van Twiller. Wards Island was known as "Great Barn Island" and Randall Island as "Little Barn."

In 1772, British military captain John Montresor bought Little Barn as an outpost during the American Revolution to survey possible invasion

sites. He established an officers' hospital on the island, while British troops launched amphibious invasions. Great Barn served as an army base.

In 1776, George Washington established Little Barn's first unsavory purpose: to quarantine those infected with smallpox.

After New York City purchased the islands (Randall in 1835 and Wards in 1851), a compilation of other "undesirables" including orphans, juvenile delinquents and the criminally insane were deposited on Wards Island, which is less than a square mile in size. In the 1840s, one hundred thousand surfacing cadavers from the Madison Square Park and notorious Bryant Park potter's fields were moved to a seventy-five-acre plot on the southern tip of Wards Island. It is not known if these remains are still interred there.

During the nineteenth century, the island housed an orphanage, an almshouse, a potter's field, an Idiot Asylum (its exact name) and a children's hospital.

The most troublesome of Wards Island's occupants was the House of Refuge (1854), run by the Society for the Reformation of Juvenile Delinquents. Street criminals and young, homeless children—mostly adolescent boys of Irish descent—were haphazardly schooled there and used as labor to make caned chairs and shoes. Those who misbehaved were hung by their thumbs.

In 1850, Ward's Island was also the site of the biggest hospital complex in the world for sick and destitute immigrants: The State Emigrant Refuge.

Other buildings included an immigration station, a homeopathic hospital, a rest home for Civil War veterans, the Inebriate Asylum and the New York City Asylum for the Insane, which has evolved into the Manhattan Psychiatric Center and the Kirby Forensic Psychiatric Center—both operated by the New York State Office of Mental Health. The Kirby Center houses the criminally insane, monitored by the New York State Office of Mental Health Police.[279]

Blackwell's Island

The insane asylum on Blackwell's Island is a human rat trap. It is easy to get in, but once there it is impossible to get out.
—*Nellie Bly*

This island has been known by a myriad of names depending on who inhabited it or owned it, and when. The latest lifestyle version—contemporary

neighborhood and community—of what has been called Roosevelt Island (for Franklin D. Roosevelt) since 1973, is an upscale, livable apartment complex. It is clearly more upbeat and promising in contrast to its dark history.

Today, the island's primary transportation to Midtown Manhattan, the Roosevelt Island Tramway, is visually unmistakable as the fire-engine red tram cars sail along hefty cables in good weather and bad. The tramway also provided one of the film locations for the Sylvester Stallone movie *Nighthawks*.[280]

Like Rikers, Randall and Wards and Hart Island, this skinny, two-mile strip of land in New York's East River housed—or confined—its own brand of prisoners: the mentally and criminally insane, petty violators, the city's poor and those afflicted with smallpox and other fatal diseases of the day.

The original native inhabitants of the island were members of the Canarsie tribe. The Dutch called it Hog Island and Manning's Island in the 1660s when it was purchased by British captain John Manning. When Manning's son-in-law, Robert Blackwell, became manager of the business of the island, it was named Blackwell's Island. The city bought the island in 1828, planning to create "a city of asylums."

Among the various dwellings on Blackwell's Island for the criminal and mentally ill, two buildings in particular—the penitentiary and lunatic asylum—were widely known for scandalous reports of inmate overcrowding, drug dealing, riots, escape attempts, favoritism and blatant corruption. Other buildings included a smallpox hospital, the Strecker Memorial Laboratory (1892) for the study of infectious diseases, a specimen examination room, an autopsy room and a mortuary among others.

Among the well-known celebrities who spent time on Blackwell's Island were writer and political activist Emma Goldman and lusty film star Mae West for "obscenity and the corruption of morals" in the wake of the play she'd written, entitled *Sex*. It is said that she regularly dined with the warden and his wife and her "punishment" was dusting the books in the prison's library.[281]

The asylum's most famous patient, however, was writer and reporter Nelly Bly, who feigned insanity as a Cuban immigrant to be deliberately committed in 1887. This brave and harrowing act allowed her to spend ten days and ten nights in nightmarish confinement in Blackwell's Island's lunatic asylum. She gathered more than her share of information for the content for her famous book, *Ten Days in a Madhouse*.[282]

From 1912 to 1973, the island was known as Welfare Island and was mainly used as hospital space.

North Brother Island

A smaller pair of islands—North and South Brother—is located in New York City's East River between Riker's Island and The Bronx. South Brother had been privately owned and was purchased by the city in 2007.

North Brother Island was uninhabited until 1885, when Riverside Hospital moved there from Blackwell's Island. The hospital was founded in the 1850s to house smallpox victims and others with "quarantinable" diseases, such as typhus, tuberculosis and yellow fever.[283]

North Brother Island's most notable patient was Mary Mallon, better known as "Typhoid Mary," the first documented person in the United States to be an asymptomatic carrier of the bacteria that causes typhoid fever.

Mallon was initially quarantined at Riverside Hospital in 1907 after medical authorities confirmed that seven of the eight families she had worked for as a cook became sick with typhoid fever. More testing showed that Mallon did carry the bacteria but appeared to be in perfect health.[284]

In 1910, she was released from the hospital with strict medical orders to discontinue working as a cook. Mallon believed there was nothing wrong with her and proceeded to find work as a cook. After a series of positions, and after she contaminated twenty-five people at Sloan Hospital for Women in 1915, she was forcibly returned to Riverside Hospital. She died from pneumonia in 1938, still believing she had been unfairly held against her will. Mary Mallon was associated with causing forty-seven cases of typhoid fever and three deaths.

After World War II, war veterans and their families lived on North Brother Island during a nationwide housing shortage. The island was abandoned until the 1950s, when it opened a center for drug treatment, but closed in 1963. Today, it is a bird sanctuary for Black-Crowned Night Herons and is off limits to the public.[285]

A NEW BEGINNING

And all of a sudden there was a big commotion and they see the lady with her hand up. And everybody ran upstairs, screaming, crying and kissing each other.
—Estelle Schwartz Belford, arrived on Ellis Island in 1905

Twelve million people would pass through Ellis Island between 1892 and 1954. Despite the long and wearying ocean trip, these immigrants were fueled by the fervent dream of starting better lives in America.

I can't tell you the feeling. We were so happy that we started singing. I'll translate: "In America life is golden, in America the flowers are more beautiful, in America the world is much better and that's what I'm longing to be, my dear."
—Renee Berkoff, arrived On Ellis Island in 1922

They were brave explorers sure about nothing at the end of their quest except that it promised more than they already had. They remained dogged in their mission to start anew—to celebrate a rebirth of life and hope by coming to a place called America.

It wasn't about looking back; it was about looking forward. National Park Service ranger Douglas Treem said, "Steam ships would dock right out there in the Verrazzano Narrows. Our ferries would go out there and load immigrants onto them and that would be their trip to Ellis Island....Their first sight in America would be the Statue of Liberty; that's what they were waiting to see."

Sometimes something as simple as a cough could detain new arrivals to Ellis Island, where they would be diagnosed and, if necessary, treated somewhere on the island's medical complex, a twenty-two-story building, before being released. As disappointing as this surely was, New York already had its share of epidemics, quarantinable diseases and deaths. Detaining newcomers for medical observation was a preventative measure.

The boat was stuck in the harbor and we could see Ellis Island and it looked so beautiful, like a castle. All kinds of people were on the sidewalks in line before going into the clinic for examination. And the noise and the languages were absolutely incomprehensible...but not scared anymore.
—Stephen Peters, arrived on Ellis Island in 1920

The clear difference between life on Ellis Island and life and death as it existed on other New York City islands, especially Hart Island, is that an overwhelming majority of newcomers to America did, in fact, pave new lives, new mindsets, new skills, all pointing to new prosperity in New York City.

Most importantly, they accomplished this in freedom and they weren't "scared anymore."

NOTES

Introduction

1. Todd Gunter, "Hurricane Sandy Grows to Largest Atlantic Hurricane on Record," *CBS Boston*, October 28, 2012, Local, https://boston.cbslocal.com.
2. National Hurricane Center, *Hurricane Sandy*, National Oceanic and Atmospheric Administration, October 29, 2012, https://www.nhc.noaa.gov.
3. "Atlantic City International Airport, NJ," History, Weather Underground, October 28, 2012, https://www.wunderground.com.
4. National Oceanic and Atmospheric Association, "Costliest U.S. Tropical Cyclones Tables Updated," January 26, 2018, https://www.nhc.noaa.gov.
5. Michael Shwirtz, "Report Cities Large Release of Sewage from Hurricane Sandy," *New York Times*, April 30, 2013, https://www.nytimes.com.
6. United States Census Bureau, *Quick Facts*, U.S. Department of Commerce, accessed July 10, 2018, https://www.census.gov.
7. Melinda Hunt and Joel Sternfeld, *Hart Island* (Scalo, Zürich, December 1, 1998).

Chapter 1

8. New World Encyclopedia, s.v. "Henry Hudson," last modified December 16, 2017, 16:59, http://www.newworldencyclopedia.org.
9. "New York City," History, A&E Television Networks, last modified March 15, 2019, www.history.com.
10. Ibid.
11. "The Hudson Estuary: A River That Flows Two Ways," Department of Environmental Conservation, New York State, www.dec.ny.gov.
12. "Richard Nicoll," Legal History by Era, Historical Society of the New York Courts, http://nycourts.gov.
13. Ibid.

Chapter 2

14. Benjamin Rush, *Destroying Angel: Yellow Fever and the Birth of Modern Medicine* (self-pub.,1999), e-book, http://bobarnebeck.com.

15. "New York City Yellow Fever Epidemic—1795 to 1804," Disasters, Weismann Center for International Business, Baruch College/CUNY, accessed August 27, 2018, http://www.baruch.cuny.edu.

16. "Cholera," Virtual New York, Graduate Center CUNY, accessed August 26, 2018, https://virtualny.ashp.cuny.edu.

17. Thomas Selin, "Roosevelt Island's Smallpox Hospital," *Paris Review*, October 30, 2017.

18. Lady Mary Wortley Montagu to Mrs. S.C., "LET. XXXI," April 1, 1717.

19. Joel Tarr, "Urban Pollution, Many Long Years Ago." *American Heritage Magazine*, October 1971.

20. "Renwick Ruin," Roosevelt Island Historical Society, accessed August 28, 2018, http://www.rihs.us.

21. Anika Burgess, "See the Abandoned and Inaccessible Island Where Typhoid Mary Died," *Vanity Fair*, June 6, 2015.

22. Bourdain, *Typhoid Mary*, 15.

23. Veronique Greenwood, "The Frightening Legacy of Typhoid Mary," *Smithsonian*, March 2015.

24. Bourdain, *Typhoid Mary*, 15.

25. Firo Marineli, et al. "Mary Mallon (1869–1938) and the History of Typhoid Fever," Annals of Gastroenterology, U.S. National Library of Medicine, 2013, 132–134.

Chapter 3

26. Ken Warpole, *Last Landscapes: The Architecture of the Cemetery in the West* (London: Reaction Books, 2003), 94.

27. "African Burial Ground," Preservation History Database, New York Preservation Archive Project, accessed August 2, 2018, http://www.nypap.org.

28. Ibid.

29. Francis W. Maerschalck and G. Duyckinck, cartographers, *A Plan of the City of New York from an Actual Survey, Anno Domini, MDCC, LV*, 1755?, 47 x 86 cm, Library of Congress, https://www.loc.gov.

30. Reed Tucker, "The Hidden Cemeteries of NYC," *New York Post*, October 25, 2014.

31. Ibid.

32. "African Burial Ground," Preservation History Database.

33. Ibid.

34. Kaufman, *Cultural Politics of Preservation*, 296–308.

35. "History and Culture," African Burial Ground, National Park Service, accessed August 2, 2018, https://www.nps.gov.

36. "Reinternment," African Burial Ground, National Park Service, accessed August 2, 2018, https://www.nps.gov.

37. "Community Activism," African Burial Ground, National Park Service, accessed August 2, 2018, https://www.nps.gov.

38. "A Sacred Space in Manhattan," African Burial Ground, National Park Service, accessed August 2, 2018, https://www.nps.gov.

39. Keri Blakinger, "From the Graveyard at Madison to Nightclubs at Herald: A Look at the Mysterious Histories of NYC's Squares," *New York Daily News*, March 10, 2016.

40. "Take a Look at Washington Square's Black History," Archive, Washington Square Park Conservancy, February 10, 2017, http://washingtonsquareparkconservancy.org.

41. Carmen Nigro, "Beware of Zombies: A Grim History of Washington Square Park," *NYC Neighborhoods* (blog), *New York Public Library*, March 10, 2011, https://www.nypl.org.

42. Ibid.

43. Emily Kies Folpe, "A Short History of Washington Square Park," Washington Square Park Conservancy, https://washingtonsquareparkconservancy.org.

44. Carol Inskeep, *The Graveyard Shift: A Family Historian's Guide to New York City Cemeteries* (Orem, UT, Ancestry Publishing, 1998), 4, 209–210.

45. Folpe, "A Short History of Washington Square Park."

46. Ibid.

47. Nigro, "Beware of Zombies."

48. Ibid.

49. Tucker, "Hidden Cemeteries."

50. "James J. Walker Park," History, City of New York Department of Parks & Recreation, accessed August 5, 2018, https://www.nycgovparks.org.

51. "The Firemen Tomb in a Former Village Cemetery," *Ephemeral New York* (blog), September 15, 2014, https://ephemeralnewyork.wordpress.com.

52. Ibid.

53. "James J. Walker Park," Department of Parks and Recreation.

54. Tom Miller, "The Burial Ground Beneath the Ballfield—James J. Walker Park," *Daytonian in Manhattan* (blog), May 13, 2010, http://daytoninmanhattan.blogspot.com.

55. *Holy Bible, Zondervan New International Version Study Edition* (Grand Rapids, MI: Zondervan, 2008), 521–2; Miller, "Burial Ground."

56. Tucker, "Hidden Cemeteries."

57. Miller, "Burial Ground."

58. "James J. Walker Park," Department of Parks & Recreation.

59. Ibid.

60. Ibid.

61. "The Mummy in Trinity Church," *Voices from the Trinity Community* (blog), Trinity Church Wall Street, April 1, 2009, https://www.trinitywallstreet.org.

62. "James J. Walker Park," Department of Parks and Recreation.

63. "Imagine Walking Through the Park…," New York Historical Society, accessed August 6, 2018, https://www.nyhistory.org.

64. "Imagine Walking," New York Historical Society.

65. "Churches, Cemeteries, and Schools," Seneca Village and the Making of Central Park, New York Historical Society, accessed August 6, 2018, https://www.nyhistory.org.

66. Landmarks Preservation Commission, *Mother African Methodist Episcopal Zion Church*, July 13, 1993, http://www.neighborhoodpreservationcenter.org.

67. "Churches, Cemeteries, and Schools," New York Historical Society.

68. "Our History," All Angels' Church, accessed August 6, 2018, https://allangelschurch.com.

69. "Churches, Cemeteries, and Schools," New York Historical Society.

70. Tucker, "Hidden Cemeteries."

71. All Angels' Church, "Our History."

72. Landmarks Preservation Commission, "Mother African."

73. Tucker, "Hidden Cemeteries."

74. Ibid

75. Ibid

76. Paul Mullins, "The Disturbed Tomb: Memorialization and Human Remains at the 9/11 Museum," *Archaeology and Material Culture* (blog), accessed August 6, 2018, https://paulmullins.wordpress.com.

77. Ibid.

78. Stephen, Farrell, "New York City Gives Families of 9/11 Victims One-Week Notice That Remains Will Be Moved," May 5, 2014.

79. Mullins, "Disturbed Tomb."

80. Ibid.

81. "Promises Not Kept," Respect Human Remains at the 9/11 Memorial, accessed August 6, 2018, http://www.respecthumanremainsatthe911memorial.com.

82. Farrell, "New York City."

83. Ibid.

84. "Remains Repository at the World Trade Center Site," 9/11 Memorial & Museum, accessed August 6, 2018, https://www.911memorial.org.

Chapter 4

85. "Who Was Dawn Powell?" Diaries of Dawn Powell, http://dawnpowelldiaries.com.

86. Page, *Dawn Powell.*

87. Victoria Patterson, "Minding Other People's Business: On Dawn Powell," *Los Angeles Review of Books*, April 14, 2015, https://lareviewsofbooks.org.

88. "Dawn Sherman Powell Gousha, Memorial No. 81772519," Find A Grave, December 10, 2011, https://www.findagrave.com.

89. "Dawn Powell," Ohio History Central, https://www.ohiohistorycentral.org.

90. Gore Vidal, "Dawn Powell, the American Writer," *New York Review of Books*, November 5, 1987.

91. Rachel Syme, "Dawn Powell's Masterful Gossip: Why Won't it Sell?" *New Yorker*, July 23, 2012.
92. Encyclopaedia Britannica Online, s.v. "Dawn Powell," https://www.britannica.com.
93. "Powell Diaries," *New York Review of Books*, https://archives.nytimes.com.
94. Encyclopaedia Britannica Online, s.v. "Dawn Powell,"
95. Ibid.

Chapter 5

96. *The Life and Battles of Yankee Sullivan* (Philadelphia, PA: A. Winch, 1854), 24.
97. Ibid.
98. Barbara Maranzini, "After 168 Years, Potato Famine Mystery Solved," *History Stories* (news), A&E Networks, last modified October 19, 2018, https://www.history.com (accessed Aug 21, 2018).
99. Ibid.
100. *The Life and Battles of Yankee Sullivan*, 24.
101. Ibid.
102. Ibid, 26
103. Ibid.
104. Charles Dickens, *American Notes for General Circulation* (London: Chapman and Hall Limited, 1891), 72.
105. Ibid.
106. "Coffin Ships: Death and Pestilence on the Atlantic," Irish Geneology Toolkit, Claire Santry, accessed August 22, 2018, https://www.irish-genealogy-toolkit.com.
107. William Bryk, "Bill the Butcher: He Died a True American Hero, But Not How You Think," *New York Press*, March 11, 2003.
108. Leslie Harris, *In the Shadow of Slavery: African Americans in New York City, 1626–1863* (Chicago: University of Chicago Press), 279.
109. Ibid.
110. Linda Wheeler, "The New York Draft Riots of 1863," *Washington Post*, April 26, 2013.
111. Ibid.

Chapter 6

112. "Bobby Driscoll," Disney Wiki, Fandom Movies, http://Disney.wikia.com.
113. Tom Longden, "Bobby Driscoll," *Des Moines Register*.
114. "Movie Roles," http://bobbydriscoll.net.
115. Ibid.
116. Longden, "Bobby Driscoll."

Chapter 7

117. Aaron Rothstein, "Bellevue: The Best and the Worst of America," *Public Discourse* (blog), Witherspoon Institute, April 7, 2017, http://www.thepublicdiscourse.com.

118. Edwin Knights Jr., "Bellevue Hospital," *History Magazine*, accessed August 16, 2018, http://www.history-magazine.com.

119. Rachel Bergstein, "Bellevue's Doctors Invented Procedures You Take for Granted," *New York Post,* December 3, 2016.

120. Ibid.

121. Greg Young and Tom Meyers, "The Startling History of Bellevue Hospital, Beyond the Horror Stories, the Last Resort for the New York Unwanted," May 31, 2013 in *Bowery Boys*, podcast, transcribed audio, http://www.boweryboyshistory.com.

122. George McGrath and John Lindsay, *A Historical Resumé of Potter's Field: 1869-1967* (New York: Department of Correction, 1967), 4.

123. Christina Stiehl, "The Most Bizarre and Amazing Stories from America's Oldest Public Hospital and Psych Ward," *Thrillist,* January 10, 2017, https://www.thrillist.com.

124. Lewis Sayre, "Lecture III: Deformities," in *Lectures on Orthopedic Surgery and Diseases of the Joints: Delivered at Bellevue Hospital Medical CollegeDuring the Winter Session 1874–1875* (London: J&A Churchill, 1876), 19.

125. Bergstein, "Bellevue's Doctors.

126. Ronald Sullivan, "AIDS: Bellevue Tries to Cope with Disease It Cannot Cure," *New York Times,* December 23, 1985.

127. Ibid.

Chapter 8

128. "Sheila Terry," Glamour Girls of the Silver Screen, https://glamourgirls ofthesilverscreen.com.

129. Ibid.

130. Steve Vaught, "This Week's Mystery House Comes with a Little Bit of Tragedy," *Paradise Leased* (blog), April 3, 2012, https://paradiseleased.wordpress.com.

Chapter 9

131. Jacob Riis, "Men or Money," *Harvard Crimson,* January 26, 1907.

132. Sam Roberts, "Jacob Riis Photographs Still Revealing New York's Other Half," *New York Times*, October 23, 2015.

133. Jacob Riis, *The Children of the Poor* (New York: Charles Scribner's Sons, 1908), 27.

134. Robert Hughes, *American Visions: The Epic History of Art in America* (New York: Knopf, 1997), 326.

135. Kevin Baker, "The First Slum in America," *New York Times*, September 30, 2001.

136. "1650–1829: Early New York," History of Poverty & Homelessness in NYC, Institute for Children, Poverty and Homelessness, accessed August 5, 2018, http://povertyhistory.org.

137. Leanne G. Rivlin and Lynne C. Manzo, "Homeless Children in New York City: A View from the 19th Century," *Children's Environments Quarterly* 5, no. 1 (Spring 1988): 26–33.

138. Jacob Riis, *How the Other Half Lives* (New York: Charles Scribner's Sons, 1914), 267.

139. Eva Kolb, *City of Nations: The Evolution of New York City's Multiculturalism* (Munich, Germany: Books on Demand), 56.

140. Riis, "Men or Money."

141. Jacob Riis, "The Potter's Field, the Common Trench," circa 1890, gelatin dry plate negative,6000 px x 4806 px, Museum of the City of New York, New York, http://collections.mcny.org.

142. Riis, *How the Other Half*, 178.

143. "Basic Facts About Homelessness: New York City," Coalition for the Homeless, accessed August 7, 2018, http://www.coalitionforthehomeless.org.

144. Roberts, "Jacob Riis."

Chapter 10

145. Wikipedia, s.v. "Leonard Melfi," last modified August 17, 2018, https://en.wikipedia.org.

146. Kenneth Jones, "Playwright Leonard Melfi to Be Remembered at May 5 NYC Memorial," *Playbill* (news), May 5, 2002, www.playbill.com.

147. "Playwright Leonard Melfi," Mdclayton.

148. Ibid.

Chapter 11

149. Clara Lemlich, "Life in the Shop," Testimonials, Cornell Primary Source Collection, accessed September 5, 2018, http://trianglefire.ilr.cornell.edu.

150. Leon Stein interview with Sarah Friedman Dworetz, June 12, 1958, Cornell Primary Source Collection, http://trianglefire.ilr.cornell.edu.

151. Ibid.

152. Douglas Linder, "The Triangle Shirtwaist Factory Fire Trial: An Account," *Elsevier*, October 25, 2007, https://ssrn.com.

153. David Von Drehle, *Triangle: The Fire That Changed America* (New York: Grove Press), 126.

154. Linder, "Triangle Shirtwaist Factory Fire."

155. Leon Stein interview with Mary Domsky-Abrams, June 12, 1958, Cornell Primary Source Collection, http://trianglefire.ilr.cornell.edu.

156. "Chesed Shel Emet," Hebrew Free Burial Association Conference Notes, 2010, https://www.jcana.org.
157. Elissa Sampson, "Chalking Back Through Time: The Triangle Shirtwaist Fire," *Jewish Currents* (blog), March 18, 2011, https://jewishcurrents.org.
158. Ibid.
159. Michael Kaufman, "Bessie Cohen, Survivor of 1911 Shirtwaist Fire Dies February, 24, 1999," *New York Times*, February 24, 1999.
160. Annelise Orleck, *Common Sense and a Little Fire: Women and Working-Class Politics in the United States, 1900–1965,* 2nd ed. (Chapel Hill: University of North Carolina Press), 130.

Chapter 12

161. Wikipedia, s.v. "Leo Birinski," last modified June 30, 2019. https://en.wikipedia.org.
162. Wikipedia, s.v. "Lincoln Hospital (Bronx)," last modified July 30, 2019, https://en.wikipedia.org.

Chapter 13

163. "America 'Dry' To-Night," *Manchester Guardian,* January 17, 1920.
164. Susan B. Anthony, "On Women's Right to Vote" (speech), 1873, Monroe County, New York, https://www.saylor.org.
165. Gary Regan, *The Joy of Mixology* (New York: Clarkson Potter, 2003), 25.
166. Ibid.
167. James Nevlus, "The Ever-Changing Bowery," *Curbed New York* (longform), October 4, 2017, https://ny.curbed.com.
168. "Jacob Riis," Biography, last modified April 15, 2019, https://www.biography.com.
169. "Sammy's Bowery Follies," *Life Magazine*, December 4, 1944.
170. Bob Cromwell, "Single Room Occupancy Hotels," *SRO Hotels, Dormitories, and Flophouses on The Bowery* (blog), https://cromwell-intl.com.
171. Ibid.
172. Gina Kolata, "Decades Later, Condemnation for a Skid Row Cancer Study," *New York Times,* October 17, 2013.
173. Ibid.
174. Arthur Schatz, "Prisoners Bury Bowery Men Who Were Poisoned by Drinking Wood Alcohol," *The LIFE Picture Collection/Getty.*
175. Mark Santora, "The Skids? Not Hardly," *New York Times*, March 18, 2011.

Chapter 14

176. "Leola Maddox Dickerson, Memorial No. 109796861," Find A Grave, May 1, 2013, https://www.findagrave.com.

177. Nina Berstein, "Unearthing the Secrets of New York's Mass Graves," *New York Times*, May 15, 2016.

178. Ibid.

179. Kathleen Mears, "Burial Plans Gone Awry," *I Advance Senior Care* (blog), August 8, 2016.

Chapter 15

180. Tess DeCarlo, *Trans History* (Morrisville: Lulu Press, 2018), 167.

181. Maggie Fox, "New Study Shows HIV Epidemic Started Spreading in New York in 1970," *NBC News* (Health), October 26, 2016.

182. Ibid.

183. Ibid.

184. James Gallagher, "AIDS: Origin of Pandemic 'Was 1920's Kinshasa,'" BBC News (Health), https://www.bbc.com.

185. Ibid.

186. Diane Anderson-Minshall, "Freddie Mercury's Life Is the Story of HIV, Bisexuality, and Queer Identity," *HIV Plus Magazine* (Entertainment), October 26, 2018, https://www.hivplusmag.com.

187. Jane Gross, "For New York AIDS Patients: Few Places to Ease the Dying," *New York Times*, June 12, 1987.

188. Ibid.

189. Ibid.

190. Corey Kilgannon, "Dead of AIDS and Forgotten in 'Potter's Field,'" *New York Times*, July 4, 2018.

191. Andrew Boynton, "Remembering St. Vincent's," *New Yorker*, May 16, 2013.

192. Joseph Neese, "New York City AIDS Memorial Honors 'Community of Heroes'" *NBC News* (Out Health and Wellness), December 1, 2016.

193. Ibid.

194. Ibid.

195. Kilgannon, "Dead of AIDS and Forgotten."

196. Ibid.

197. Gallagher, "AIDS: Origin of Pandemic."

Chapter 16

198. Ecclesiastes 9:1–18 (New International Version).

199. "NYU Med School Buried Donated Bodies in Mass Graves," *Daily Freeman*, May 28, 2016, http://www.dailyfreeman.com.

200. Nina Bernstein, "Bodies Given to NYU Ended Up in Mass Graves, Despite Donors' Wishes," *New York Times*, May 27, 2016.

201. Miranda Katz, "NYU Sorry About Dumping All Those Donated Cadavers into Mass Graves," *Gothamist* (News), https://amp-gothamist-com.

202. Bernstein, "Bodies Given to NYU."

203. Kelli Conlin, "Ruth Proskauer Smith, 1907–2010," *The Blog* (blog), *HuffPost*, December 6, 2017, https://www.huffingtonpost.com.

204. Margalit Fox, "Ruth P. Smith, Abortion-Rights Pioneer, Dies at 102," *New York Times* (NY Region), January 26, 2010.

205. Emily Kadar, "Celebrating Ruth Proskauer Smith, an Unheralded Champion of Women's and Human Rights," *Jewish Women, Amplified* (blog), Jewish Women's Archive, January 28, 2010, https://jwa.org.

206. Stephen Miller, "Smith Was a Crusader on Issues of Cradle and Grave," *Wall Street Journal*, January 26, 2010.

207. "Ruth P Smith Tribute," Stephanieonv, March 11, 2010, video, 8:44, https://www.youtube.com.

208. "US Medical School Scandal Over Donated Cadavers," *Medical Brief* (Bio-Ethics), June 15, 2016, https://www.medicalbrief.co.

209. Bernstein, "Bodies Given to NYU."

210. Nina Bernstein, "Paupers' Burial for Donor Cadavers," *TimesUnion*, May 27, 2016, https://www.timesunion.com.

211. "NYU Med School," *Daily Freeman*.

212. Ibid.

213. Nina Bernstein, "New York State Bans Use of Unclaimed Dead as Cadavers Without Consent," *New York Times* (NY Region), August 19, 2016.

214. Nina Berstein, "Bodies Given to NYU."

215. Ibid.

216. Ibid.

Chapter 17

217. Bob Drogin, "Infant Burials Depict Their Lives: Brief, Crowded, Anonymous: Potter's Field: A Tale of Life, Death," *Los Angeles Times*, June 7, 1986.

218. Niamh, O'Sullivan, "Scary Tales of New York: Life in the Irish Slums," *Irish Times*, March 23, 2013.

219. Tyler Moss, "The 19th-Century Swill Milk Scandal That Poisoned Infants with Whiskey Runoff," *Atlas Obscura*, November 27, 2017, https://www.atlasobscura.com.

220. "A Desperate Appeal to Save the City's Sick Babies," *Ephemeral New York* (blog), July 25, 2016, https://ephemeralnewyork.wordpress.com.

221. Richard Menkel, *Save the Babes: American Public Health Reform and the Prevention of Infant Mortality.* (Ann Arbor: University of Michigan Press, 1998), 63.

222. M.B. Katz, *In the Shadow of the Poorhouse: A Social History of Welfare in the United States* (New York: Basic Books, 1986), cited in "Late-Nineteenth and Early-Century Pediatrics," University of Pennsylvania School of Nursing, https://www.nursing.upenn.edu.

223. "Late-Nineteenth and Early-Century Pediatrics," University of Pennsylvania School of Nursing, https://www.nursing.upenn.edu.

224. Mary Garrigan, "Rapid City Woman Haunted by Hart Island Burial Ground," *Rapid City Journal,* November 15, 2011.

225. Ibid.

226. Stephen Rex Brown, "Cemetery on Hart Island Dead Wrong: Suit," *New York Daily News*, December 3, 2014.

227. Marcela Rojas, "NY Doctor Sues for Right to Visit Stillborn's Grave," *Westchester Journal News* Dec 22, 2012.

228. Ibid.

229. Nina Bernstein, "Mourners Make First Visit to New York's Potter's Field." *New York Times*, July 19, 2015.

230. "Victory Allows Families to Visit Hart Island Graves," NYCLU (press release), June 8, 2015, https://www.nyclu.org.

231. Nina Bernstein, "Mourners Make First Visit to New York's Potter's Field," *New York Times*, July 19, 2015.

Chapter 18

232. Wikipedia, s.v. "Jug band," last modified August 2, 2019, https://en.wikipedia.org.

233. Wikipedia, s.v. "Nose flute," last modified March 7, 2019. https://en.wikipedia.org.

234. Joslyn Layne, "Whistler & His Jug Band Biography," All Music, https://www.allmusic.com.

235. "Buford Threlkeld, Memorial No. 118775837," Find A Grave, May 1, 2013, https://www.findagrave.com.

236. L. Lucciola, "Sebastian's Musical Journey Brings Him to Narrows," *Standard Times, May 15, 2003.*

237. "Whistler's Jug Band, 'Folding Bed' (c 1930)," Emily Bingham, http://emilybingham.net.

Chapter 19

238. Laurie Lindquist, "Melinda Hunt '81, Bringing the Dead to Life," *Reed Magazine,* March 2011.

239. Susan Hodara, "Giving Voice to the Legions Buried in a Potter's Field," *New York Times*, December 30, 2011.

240. Dana Schulz, "Interview: Melinda Hunt Memorializes the Unclaimed New Yorkers Buried on Hart Island," *6SQFT*, March 25, 2013. https://www.6sqft.com.

241. Ibid.

242. Hodara, "Giving Voice."

243. Lindquist, "Melinda Hunt."

244. Hodara, "Giving Voice."
245. Ibid.

Conclusion

246. Emma Lazarus, "The New Colossus," Poetry Foundation, https://www. poetryfoundation.org.
247. "If You Die Poor or Alone in New York City, You'll Be Buried By Prisoners in a Mass Grave," *Nation*, March 31, 2015, https://www.thenation.com.
248. Wilmers, "Hart Island."
249. John Ray, "New York's Secret Graveyard: One Woman's Search for Baby Girl's Grave Uncovers a Grisly Truth," *Mirror*, April 29, 2014. https://www.mirror.co.
250. "City Cemetery," Correction Department.
251. Casey Hedstrom, "The Burial Crisis of 1822," *Atlas Obscura*, October 22, 2015.
252. Madeline Diamond, "The 20 Most Crowded Cities in the World," *Time*, October 31, 2017.
253. Amy Biegelsen, "America's Looming Burial Crisis," *City Lab*, October 31, 2012, https://www.citylab.com.
254. Wilmers, "Hart Island."
255. Lisa Visentin, "Government Searches for Cemetery Space as Plots Set to Run Out in 34 Years," *Sydney Morning Herald*, November 17, 2017. https://www.smh. com.au.
256. John McManus, "The World Is Running Out of Burial Space," *BBC News*, March 13, 2015.
257. Ibid.
258. Sarah Hall, "Crisis Looms as Burial Space Runs Out," *Guardian*, January 17, 2001.
259. Heather Burke, Alice Gorman and Lynley Wallis, "Losing the Plot: Death is Permanent, But Your Grave Isn't," *Conversation*, November 5, 2014, https:// theconversation.com.
260. Toshiko Kaneda and Carl Haub, "How Many People Have Ever Lived on Earth?" Population Reference Bureau, March 9, 2018. https://www.prb.org.
261. Burke, Gorman, and Wallis, "Losing the Plot."
262. Ibid.
263. Brittney Kleyn, "Cemeteries Dig for Solution to Looming Burial Crisis," *Age*, June 11, 2008, https://www.theage.com.au.
264. Ibid.
265. Ibid.
266. Darren Boyle, "High-Rises of the Dead: Israel Turns to Multi-Storey Cemeteries Because Graveyards Are Full," *Daily Mail*, October 18, 2014.
267. "What Happens When Cemetery Space Runs Out?" *CBS Radio*, December 12, 2016, https://www.cbc.ca.
268. Ibid.
269. Ibid.

270. "The Sky's the Limit—Even for the Dead." *My Send Off*, https://mysendoff.com.

271. Peter Beaumont, "'We Revived an Ancient Tradition': Israel's New Subterranean City of the Dead," *Guardian*, December 2, 2017.

272. Ibid.

Appendix

273. Bess Lovejoy, "Islands of the Undesirables: Hart Island," *Atlas Obscura*, June 4, 2015, https://www.atlasobscura.com.

274. Brentin Mock, "The Dark 'Fugitive Slave' History of Rikers Island," *City Lab*, July 23, 2015, https://www.citylab.com.

275. Michael Schwirtz, "What Is Rikers Island?" *New York Times* (NY Region), April 5, 2017.

276. Mariya Moseley, "Rikers Island Was Named After a Judge Who Was Eager to Uphold Slavery," *Essence*, April 6, 2017. https://www.essence.com; Laura Italiano, "How Rikers Island Became the Hellhole It Is Today," *New York Post*, April 4, 2017.

277. James Ridgeway and Jean Casella, "America's 10 Worst Prisons: ADX," *Mother Jones*, May 1, 2013.

278. John Surico, "How Rikers Island Became the Most Notorious Jail in America," *Vice*, January 11, 2016.

279. Wikipedia, s.v. "Randalls and Wards Islands," last modified August 2, 2019.

280. Ibid.

281. "Dancing at the Lunatic's Ball on Blackwell's Island," *Ephemeral New York* (blog), June 25, 2018, https://ephemeralnewyork.wordpress.com.

282. "Mae West Imprisoned on Roosevelt Island for Sex—81 Years Ago Last Saturday," *Roosevelt Islander Online* (blog), April 21, 2008, https://rooseveltisland.blogspot.com.

283. Wikipedia, s.v. "Roosevelt Island," last modified August 27, 2019.

284. "North Brother Island," *Atlas Obscura* (The Bronx, New York). https://www.atlasobscura.com.

285. Wikipedia, s.v. "North and South Brother Islands, New York City," last modified July 2, 2019.

BIBLIOGRAPHY

Printed Material

Anbinder, Tyler. *Five Points: The 19th-Century New York City Neighborhood That Invented Tap Dance, Stole Elections, and Became the World's Most Notorious Slum.* New York: Free Press, 2001.

Asbury, Herbert. *The Gangs of New York: An Informal History of the New York Underworld.* New York: Alfred A. Knopf, 1928.

Bayer, Ronald, and Gerald M. Oppenheimer. *AIDS Doctors: Voices from the Epidemic.* Oxford: Oxford University Press, 2002.

Bourdain, Anthony. *Typhoid Mary, an Urban Historical.* New York: Bloomsbury, 2001.

Buk-Swienty, Tom. *The Other Half: The Life of Jacob Riis and the World of Immigrant America.* New York: W.W. Norton and Company, 2008.

Carrol, Andrew. *Here Is Where, Discovering America's Great Forgotten History.* New York: Three Rivers Press, 2013.

Eisenstadt, Peter, ed. *The Encyclopedia of New York State.* Syracuse, NY: Syracuse University Press, 2005.

Ellis, David M. *A History of New York State.* Ithaca, NY: Cornell University Press, 1957. Reprint, 1967.

Horn, Stacy. *Damnation Island.* Chapel Hill, NC: Algonquin, 2018.

Kaufman, Ned. "Heritage and the Cultural Politics of Preservation: The African Burial Ground and the Audubon Ballroom." In *Place, Race, and Story: Essays in the Past and Future of Historic Preservation.* New York: Routledge, 2009.

Keene, Michael T. *Abandoned: The Untold Story of Orphan Asylums.* Fredericksburg, VA: Willow Manor Publishing, 2014.

Mosley, Leonard. *The Real Walt Disney: A Biography.* London: Grafton Books, 1986.

Page, Tim. *Dawn Powell: A Biography.* New York: Henry Holt, 1998.

Shilts, Randy. *And the Band Played On: Politics, People, and the AIDS Epidemic, rev. ed.* New York: St. Martin's Griffin, 2007.

Szymaszek, Stacy. *Hart Island*. New York: Nightboat Books, 2015.

Von Drehle, David. *Triangle: The Fire that Changed America*. New York: Atlantic Monthly Press, 2003.

Zeitlin, Steve, and Marci Reaven. "On The Bowery." *Voices: The Journal of New York Folklore* 29 (Fall–Winter 2003).

YouTube Videos

Allender, Jordan. "Lost Boy: The Bobby Driscoll Story Teaser." Jordan Allender, November 3, 2012. Video, 4:31. https://youtu.be/yX-wnlKLwgY.

Buford Threlkeld "Whistler & His Jug Band"-Foldin' Bed (Sonido Restaurado: 1930)

Freedman, Bud. "Triangle Shirtwaist Survivors Son Talks." *New York Daily News*, March 20, 2011. Video, 2:12. https://youtu.be/TD34l06ypbQ

"Film Maker Profile: Melinda Hunt." NewFilmMakers, September 8, 2011. Video, 1:42. https://youtu.be/pO8kyHljbfw.

"Interview with Playwright Leonard Melfi." Mdclayton, November 20, 2011. Video, 7:59. https://youtu.be/9OLx3JwrKOU.

Larkin, Trenton. "Bobby Driscoll-(Peter Pan Tribute)-Episode #126" Who Did That Voice, June 29, 2018.Video, 7:34. https://youtu.be/WtEUVG9Mrbc.

Lebowitz, Fran. "Fran Lebowitz on the Best American Writer You've Never Heard of (2002)." The Film Archives, August 24, 2017. Video 17:45. https://youtu.be/Y-4CcHY1nFk.

Leni, Paul, and Leo Birinski. "Waxworks (1924) 1/9." Silent Film Democracy, January 3, 2008. Video 10:00. https://youtu.be/iNTuHjq64RA.

Maltese, Serf. "Remembering Triangle Shirtwaist Fire." WNYC, March 22, 2011. Video, 5:44. https://youtu.be/dvKrkCLl_0U.

"Ruth P Smith Tribute." Stephanievonv, March 11, 2010. Video, 8:44. https://youtu.be/D6ZLrKg6ft8.

"The Sphinx (1933)-Full Movie-Lionel Atwill, Shelia Terry, Theodore Newton." HORDE, December 20, 2016. Video, 1:02:21. https://youtu.be/-beLf27qfy4.

INDEX

ABOUT THE AUTHOR

 Michael T. Keene is the author of eight books about unusual, but true, stories. He is also the producer of the documentary film *Visions: True Stories of Spiritualism, Secret Societies, and Murder*, as well as eight audiobooks.

Although employed for more than twenty-five years as a financial advisor, Michael has combined his interest in local history, writing, music and filmmaking to explore unique and fascinating chapters of nineteenth-century New York folklore and stranger-than-life legends.

The events that bubbled out of this period include the Anti-Masonic Movement, the origins of the modern Spiritualist and Paranormal Movements and the Women's Rights and Anti-Slavery Movements, as well as the founding of seven new religions and utopian communes.

What began as a hobby twelve years ago has now become a grand obsession!

Visit us at
www.historypress.com